Why I Make Art

Contemporary Artists' Stories About Life & Work

atelier
éditions

Hrishikesh, 2007
Acrylic on canvas
9×12 inches
by Brian Alfred

Foreword
by Hrishikesh Hirway

A portrait captures two people: the subject and the artist. To look at a portrait is to learn something about both of them. It's a collaboration between who the subject is and what the artist sees.

Why I Make Art is a collection of portraits of 30 contemporary artists, adapted from the first four years of Brian Alfred's Sound & Vision podcast. These artists' work spans a wide range of mediums and subject matter, while these pages allow a glimpse into each of their lives and creative minds.

Brian Alfred is a brilliant painter himself. I've known his work since the late 1990s when he was a graduate MFA student, and I love the way he looks at the world and interprets it. His paintings capture moments of stillness in the middle of a noisy, industrial reality, through big, flat shapes of color that invite you to imagine that they were made on the computer and not by his own hand. It's only when you get very close that you can start to see the brushwork.

Though we were both studying art, Brian and I first met through music. Our bands played shows together, and I admired the delicate precision with which he played his electric guitar. He carved out geometric lines that were formal and surprising, but still warm and beautiful. Qualities that I see in his visual art too. He was quiet, and usually surrounded by other, louder people, so it took a little while for us to become friends.

In the two decades since then, Brian and I have stayed connected. Our worlds have always overlapped, even as we settled down on different coasts—Brian in New York, and me in Los Angeles. Through texts and emails, we've continued our own conversation about music and art, and, more recently, podcasts.

In 2016, Brian started the Sound & Vision podcast to talk to other artists about how they see the world. In that

conversational context, listeners get to learn more about these creative people in a way that's less formal than any artist's statement or gallery press release. A different kind of truth about who they are is revealed. The casual format of the podcast lets the artists speak about themselves and their work in an unselfconscious way. In conversation with Brian, another artist, they're able to express themselves without worrying about how to translate what they mean for a lay audience. In those moments of warmth and connection, new kinds of insights into who they are and how they think inevitably emerge. In these pages, the wisdom, lessons, and miniature autobiographies that the artists gave to Brian are presented as profiles, offering insight into why these folks decided to (and continue to) make art.

That kind of portraiture is near and dear to me. In my own podcast, Song Exploder, I take conversations I have with musicians about their creative process, edit them down, and fold them into the layers of their songs to make stories told from their perspective. It's my own way of capturing who an artist is, as told in their own words.

Listening to Sound & Vision, there's an intimacy, a close proximity in it. I can imagine Brian and his guest, sitting face to face, knees almost touching. You get to hear two people speaking about the big ideas of art, as well as the small details of their lives.

Why I Make Art doesn't replace the podcast; it's a companion to it. Anyone who flips through this book can stop at a page at random and find something to inspire them, or excite them, or challenge them to think in a new way. For artists of any kind, the book might prove a sage reminder of why they, too, make art.

There are 30 artists featured in this book, officially. But the reality is there's one more: Brian Alfred. Though the profiles of these artists appear in a different shape than on his podcast, and though you don't hear Brian's voice directly, his hand is indelible throughout. If you look closely enough, you can see his brushwork.

Introduction
by Brian Alfred

There are certain themes that recur for many of the artists I've spoken with in my time. For a lot of them, creativity entered their lives early. It often scratches an itch—boredom, loneliness, a desire to connect or entertain, to find validation or a feeling of worth—that children can have difficulty articulating with words. A lot of the time this instinct to create, visually, materially, is only understood in retrospect.

A life story often says so much about how and why an artist works in the way they do—or why they make art at all. In fact, getting to know an artist outside of the particularities of their style, finding out about their childhood, musical tastes, experiences as a parent or traveler, often leads back to their work, illuminating their output in a new, humanistic way.

This book is full of written portraits of artists. It's not about one thing in particular—theory or studio practice or their inspiration. It's about them as people in the world. An artist myself, I wanted to approach this compendium of portraits as an exploration, rather than a place to make definitive statements about the art being made today.

The only reason this book came to be at all is because there is a podcast—a platform that allows artists to meander in their thoughts and get into conversations that have no particular parameters or agenda. And before there was the Sound & Vision podcast, which I initiated in 2016, there was just me in my car.

When I first started teaching painting at Penn State University in 2014, I committed to four-hour commutes to and from my home in Brooklyn. This weekly drive became a ritual in my life. The often mountainous terrain between New York and Pennsylvania is bucolic in its own right, and the commute gave me plenty of

space to enjoy silence and to reflect. I looked forward to the time it afforded me to think and explore without any distractions, untethered from phones, laptops, family matters, etc.

That's when I really started to get into podcasts, especially the ones featuring slow-burn conversations with musicians, actors, and writers. But it was difficult to find those same kinds of exchanges with visual artists. I remembered that when I was a resident at the Skowhegan School of Painting and Sculpture in Maine in 1999, the program had an audio-cassette archive with recorded lectures by past visiting artists from which I learned a tremendous amount. Something about those lectures seemed more casual than the ones I was used to hearing at university. Maybe it was the communal atmosphere or the remote location of the residency, but I was taken by the intimacy of these talks. Most importantly, I felt like I was in the room with the artists as they shared their stories. The desire to recreate that experience in a new way was what prompted me to initiate Sound & Vision. The idea was to give artists and musicians a chance to speak conversationally and candidly —not only about their work but their lives. It was an opportunity for them to tell some pretty strange, compelling, and entertaining anecdotes.

It took me about a year and a half to research and develop the project before the first episode aired in April 2016. I needed to figure out recording software and hardware, hosting platforms, and other logistics first. I knew I wanted to encourage long conversations, so if people were going to be listening for an hour or more, the audio needed to be as good as it could be. Plus, just learning to speak into a microphone is a skill. My days as a jazz DJ in college helped, but it had been a while and there was a lot for me to learn.

At first, I invited people I already knew, so those conversations flowed. Later, as I started to invite guests

onto the podcast that I'd never met before, I had to figure out a way to set them—and myself—at ease. It took me a little while to get comfortable with that process. But the more I spoke with artists, the better I understood how to make it all work. I hope I've succeeded in making my guests feel at home. For the audience, I've tried to keep the podcast as varied, unexpected, and interesting as possible.

For the most part, the conversations were done in one of two places: an artist's studio or my own. Occasionally, the podcast was recorded at an art gallery, shortly after an opening. But what's been essential, for most of the time I've been doing Sound & Vision, is the intimacy you can get from an in-person discussion. After COVID-19 hit, I learned how to pivot by conducting conversations online, which ended up widening the geographic scope of my guests—a silver lining in a difficult time. The first four years of the podcast were more centralized in New York City. It was mostly artists based where I lived or the occasional artist passing through town. Since then, the podcast has opened up to a wider range of voices from all over the world. This broadened scope has become an important aspect of the podcast today.

Sound & Vision has had a significant impact on my life, which is something I hadn't imagined. It bleeds into my other experiences, enriching how I see the world in the same way that my son has done for the 14 years since he was born.

I've done a podcast almost every single week for five years now. Pulling together the episode archives for this book, I started to realize that maybe I was building something that could be as useful to people now and in the future as the cassette archive at Skowhegan had been to me more than 20 years ago.

Coming back to these discussions in written form, I've been able to revisit the ideas and experiences

of others and see how wide-reaching, and yet how similar, they often are. In the moment, when I'm speaking with an artist, the conversations fly by. Going back over the talks has been like watching a complicated movie for the second time; I've seen things more fully, with deeper context and richer understanding. It's also allowed me slow down, reconsider, and ponder what's being said. I hope this book does the same for you.

Diana Al-Hadid

Deluge in the Allegory, 2020
Polymer gypsum, fiberglass, steel, plaster, copper and gold leaf, pigment
54×42×3½ inches

Why I Make Art

From early on, Diana Al-Hadid was determined to chart her own course. She remembers getting yelled at by her sixth-grade teacher for standing instead of sitting in art class. "Everyone else was sitting doing their projects and I literally stood the entire class," she says. "It looked so weird, but everyone just accepted it. I always stood at my area and worked.

"I had this physical energy, a need to articulate my space," she adds. "I think a lot of the restrictions that I grew up with culminated in this, or found an outlet in this need to take up space when I was older."

The narrative of restriction is one Al-Hadid knows well. She recalls being a teenager in 1990s Ohio when she came into contact with MTV culture. "My family was Muslim so we weren't allowed to date, we weren't allowed to go to parties, we didn't drink, I couldn't wear short shorts, I couldn't go to sleep-overs. So that set me apart," she says.

"When you're in middle school and everyone else is wearing short shorts and shaving their legs and you're the weird girl wearing shorts to your knees and you haven't started shaving yet, it's different, when you're a kid those things weigh really heavily."

Her parents weren't especially religious, she explains. "My mom is a moderate and my dad hates religion." It was more, she thinks, a case of them being anxious about their only daughter.

Art was an early love and gave Al-Hadid room to be herself, free of pressures and constraints. Her parents encouraged her to follow her creative pursuits, especially her mother, who was also artistic. "I drew a lot. I feel like every kid draws, of course, like the old Picasso saying —'every kid is an artist.'"

"I was fortunate in that I wasn't steered out of it," she continues. "I remember in sixth grade I got a little wooden star trophy for being the best artist in the class. I was very serious, but it was about cartooning, that was

what I understood as art and I don't think I knew I was going to be an artist in the professional sense. I was just proud that I was the drawer." It was a way, she believes, to get validation despite feeling different to her suburban peers.

She recalls her teen years as a jumble of artmaking and hanging out with the "alternative," "grittier" kids at her preppy school. "I was politically active in my teenager-y way," she says. "But I didn't understand who was who in the government, I didn't keep up with any of that, it was like, free Mumia Abu-Jamal and vegetarianism."

Always a straight-A student and avidly curious about the world—she once printed out the Oslo Accords to better understand the detail of the agreements—Al-Hadid's work is a complex tangle of history, myth, and politics.

"I always had an interest in history, but I think now I can catalog it more easily in my mind, I can understand it a little more. I was anxious then to consume as much as I could, because I wanted to be smarter than I was and more mature, and taken seriously as a teenager," she says, adding, "You're out to conquer the world. I needed my ammunition, I needed backup information to quote."

Abstract and intricate, Al-Hadid's work is informed by a tapestry of interconnecting references that can be traced in part to her upbringing across cultures. Born in Aleppo in 1981, she moved with her family to Saudi Arabia for a year while she was in kindergarten. After that they made the more significant move to Cleveland, and then to the suburbs of Canton, where the family settled. Though she remembers the difficulties of being an immigrant in an affluent pocket of Northeast Ohio, the experience gave her a particular advantage, the ability to appreciate different cultures.

Having jumped grades when she first moved to the States, Al-Hadid was two years ahead of her peers and was accepted to a local branch of Kent State University at just 16, where she gained a BA in art history and a BFA in sculpture in the same year.

Because of what she describes as her more restricted home life, Al-Hadid hatched a plan to get herself out of the house and onto campus as soon as she could. "I took an overload of classes and didn't sleep and got all As. I proved that I was ready to go. I was a 17-year-old junior in college, credit-wise. It was crazy, I went insane. I just remember thinking, 'I am getting out of here.'

"It was not assumed, I think, by my mom, that I was going to leave home and go to college," She continues. "That was not something that she had done, it wasn't the old-world tradition. In Syria, you stay at home with your parents until you're married, otherwise you're just giving them the middle finger. That was a huge fight, for me to move out and go to college."

Al-Hadid thinks that a lot of her early drive to succeed has relaxed somewhat now that she's in her adult years. "It did make me very serious at a young age," she says. "When you're an immigrant, you feel a lot more pressure and a lot more responsibility on your own shoulders. My parents couldn't really help me with my schoolwork, I had to figure it out. So it makes you feel very independent and more confident that you can get things done, but there's a lot of pressure."

At college she was introduced to sculpture, installation-making, and studio practice. "I was into welding right away, because it was almost like drawing in space, you just tack with these little lines and all of a sudden you have a shape and you can go in it and outside. I was making these comfort spaces that had a suburban kind of flair."

Graduating from Kent State University in 2003, Al-Hadid went on to take her MFA in sculpture from Virginia Commonwealth University before studying at the Skowhegan School of Painting and Sculpture. She held an early solo show at the Perry Rubenstein gallery in New York (now closed) in 2007, and currently shows with Kasmin Gallery in New York. Since first coming onto the art-world's radar in the late 2010s, Al-Hadid has shown her work in museums

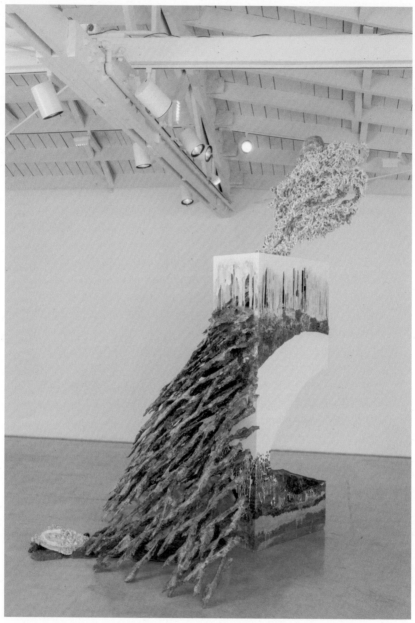

Smoke and Mirrors, 2015
Polymer gypsum, fiberglass, steel, wood, concrete, polystyrene, black mesh, pigment
116 ½ × 149 × 94 inches

Why I Make Art

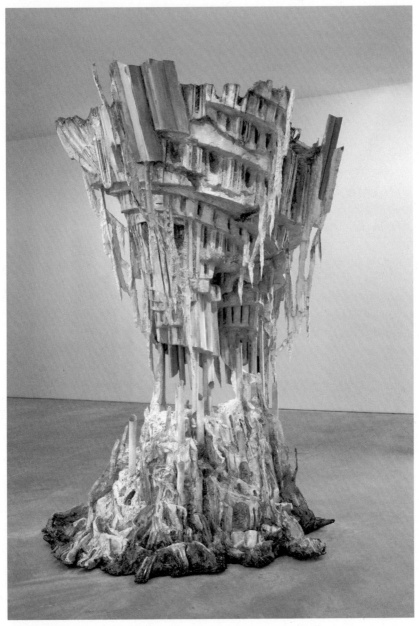

Self-Melt, 2008
Polymer gypsum, steel, polystyrene, fiberglass, cardboard, wax, pigment
58×56×75 inches

Diana Al-Hadid 17

and galleries all over the world, including the Hammer
Museum in Los Angeles, Vienna Secession, MASS MoCA
in North Adams, and the Saatchi Gallery in London.
Her work is held by the Whitney Museum and the Museum
of Fine Arts in Houston, among others.

To this day, her formative experiences can be
read in the language of her installation and sculptural
work, especially in how it has shaped the way she thinks
about space.

"Sculpture is all about space, defining space,
thinking about space, the space the viewer occupies; the
psychological space, projected space," says Al-Hadid.
"When you become all-consumed by spatial studies, then
think about how space was restricted for you... I think a
lot of women relate to that. I can think of a lot of women
who make big sculptures—and there's a relationship to being
constantly asked to take up less space in our society.

"Every day for women around the world their ex-
perience is that they have to get smaller, whether it's 'lose
weight' or 'don't speak up,'" she elaborates. "There's a
conflict of how much space you're allowed to take up, psy-
chologically, socially, physically, how loud you're allowed to
be. I feel free to take up space in my work in a way that
I don't always feel free in other parts of my life. So I'm lucky
that I have that. It does come, I'm sure, from a deep-seated
psychological place but perhaps it's become more than
just a gut, instinctual reaction. It's evolved into an intellec-
tual study, or a more rigorous concern with how space
is divided and how objects do or don't hold space."

Her background has also shaped the way she ap-
proaches materials, as well as the vexed question of
ornamentation. "Adolf Loos' *Ornament and Crime* was very
resonant for me," she recalls of encountering the Austrian
theorist's famous 1910 essay decrying excess, while
she was at graduate school. "Not just in terms of my culture
and not just other 'quote' eastern cultures. Even the
Renaissance and all these Western cathedrals, they're

filled with ornament, and when modernism hit it became this shameful thing, it was excess; not necessary. It's appliqué, it's not integral to the function, you have to pare it down and simplify. Simplicity and whitewashing are more beautiful. Anything unnecessary is just showoff-y—what Loos considered design crime."

Loos' foundational treatise both attracted and repelled the budding artist. "I'm not the only Middle Eastern artist who felt that stir something in them," she says. "It landed in a bad spot in me, because I recognized being of two minds."

It wasn't just the Middle Eastern art tradition—intricate designs and complex patterns notwithstanding—that she felt was being attacked by Loos' pronouncements, but also her experience of growing up in the Midwest, where, she says, "The average non-art-educated American would understand art by way of ornament or technical skill, labor.

"In my home we had a lot of ornamental objects, and my mom loves flowers and things that are beautifully decorated. I think it was such an oversimplified position, an extreme position that turned into, like, fanatical religion. Loos has kind of turned into that. I reacted, I was upset that I was being shamed for also appreciating workmanship and labor and knowing the value of something, feeling moved by it. At the same time, my professors were old-school modernists, they were all about the grid of the canvas and showing the truth to the materials, getting rid of excess and studying the slightest shifts of color and energy. And that's so valuable too."

The stripped-back modernism that Loos and her professors were hawking appeals to the rational mind, she says. "There isn't excess, there isn't overage, everything is used very economically. There's something attractive about that, especially when you're in the suburbs of Ohio, where it's just excess, excess, excess, space is wasted everywhere and it seems too much. You want to pare it down. But there's a huge sociopolitical implication to this cult of modernism.

It tells you that if you can afford to pare things down, if you have the education to know to do that, then you've evolved to an esthetic life."

For her own part, Al-Hadid thinks she falls somewhere in the middle, a direct result of living "in two worlds," though ultimately the work is about how she can "take as much advantage of the most essential properties of certain materials and capitalize on them as much as I can.

"When I break down my own work into its most elemental, smallest forms, almost all of the decisions are based in a study of the materiality and what it can do and its limitations," she explains.

Despite this instinct toward reduction, she says her work isn't likely to be read as minimalist—that influence is a tacit one. "You wouldn't describe my work as pared down at all. It's, I think, very full, but I grew up with that study and awareness and appreciation."

There is an accretive, monumental quality to Al-Hadid's sculptural work. Her structures and environments —whether the ghostly endoskeleton of a palace, or an abstracted pipe organ, or a toppled, broken tower—often seem to be dripping with ever-accumulating stalactites in sublime combinations. Made with building materials like gypsum and fiberglass, her pieces—whether architectural forms or dynamic stratum of human limbs and torsos—are proliferations and overspills of mineral matter running delicately rampant.

Cretan princess Ariadne, Renaissance painter Pontormo, Italian architect Giambattista Nolli, and Mughal courtesan Anarkali are all name-checked in the poetic titles of Al-Hadid's works, and she frequently brings together different myths and histories in complex narratives—often these are tales of cloistered women. Meanwhile, her recent work alludes to her cultural histories in various ways. The panel piece *Al Qa'a* (2020), for example, is named for a reception chamber of a mansion in Damascus. *A Still Life, in Contrast Still* (2020) deals with the complex

mixing of Western and Eastern motifs in the work of 15th-century Flemish painter Hans Memling.

The artist says she is also moved by the energy of particular places, whether a Roman Catholic cathedral, a Buddhist temple, or Antoni Gaudi's unfinished Sagrada Família basilica in Barcelona. In 2016, Al-Hadid installed the sculpture *The Unicorn Escapes*, a kind of three-dimensional panel painting, in a pond on the grounds of the eighth-century Toshodai-ji Temple in Nara, Japan. A unicorn's horn, installed on the bank behind the semi-transparent panel, is framed by an opening that creates an optical illusion, as if the horn is emerging from the pond.

"It's believed that a dragon lived there," she says of this sacred location and natural beauty spot. "Of course I didn't believe that, but I sort of started to feel that something was amiss, there were weird things that would happen. It showed the power of magical thinking.

"I don't subscribe to one religion, I'm not a religious person," she continues. "It would be a stretch for me to even say I'm spiritual. But around objects, I notice a shift in my awareness or consciousness, and that is what art is good for, and what dipping into these sacred spaces is good for."

Collapsing past, present and future into her both sci-fi-ish and ancient-like structures, Al-Hadid likes the idea of art that plays with audience perceptions. "I'm totally into illusion and sleight of hand," she says. "There's a way to do it where it's really cheesy and there's a way to do it where it's really interesting. I think it's fascinating to be confronted with that in art, something very real and very tangible and also kind of smoke and mirrors, an effect or an illusion." (*Smoke and Mirrors* is the title of one of Al-Hadid's works, from 2015, an installation that at once calls to mind hardened volcanic lava, a crashing wave, and a voluminous skirt.)

"I think a lot of art is illusionistic—a lot of old Renaissance paintings play with perception. I'm totally obsessed with it," she says. "It's fascinating because it puts into question what you trust."

As for physical matter, "There's almost nothing I'm not OK with as a material," she says—at least in the work of others. Nevertheless, she maintains certain rules for her own practice, boundaries she is loath to cross. For instance, Al-Hadid is reluctant to use transparent materials, favoring opaque ones instead. "I noticed it not that long ago," she says, of her self-imposed limitations.

Now based in New York, she has applied a similarly fluid yet systematic method to her style of organization, now that her normally flexible schedule is a little more streamlined since having a child. "I'm pile organized," she says. "You have a big picture, an orchestral control over your organizational systems, so you conquer piles at a time. I have a broad sense of what I'm doing." On which note she adds, "My work is pretty mountainous, I think."

Jules de Balincourt

Jules de Balincourt's hypnotic, color-saturated paintings of uncanny scenes can feel like dreamscape, places recognizable but too bright, too beautiful, with an undetermined menace creeping around the edges.

"It's not really about a specific place, it's about this itinerant displacement," he says about his nebulous scenes. "Some of it's the jungle, some the city. It's not specific to one local spot. You could link it to Hawaii, Argentina, or India—it's more global ideas of humanity."

The French-born artist had a peripatetic childhood. After his parents' divorce, for several years the artist's free-spirited Swiss German mother would routinely up sticks with de Balincourt in tow, before making the decision to settle, in the late 1970s, in southern California.

The reality of California at that time, for a little boy from across the Atlantic, was very different to the USA he had in his imagination. "The very first thing I said when we landed at LAX from France was, 'Mommy, mommy, where are the cowboys and Indians?' I had this fantasy." (Cowboys and Clint Eastwood in his spaghetti Western heyday have featured in his work.)

What followed was a period of alienation, with de Balincourt feeling like "an awkward French kid" in his crêpe sole sandals and corduroy culottes, while the local teens were hanging around in half-tops and Ocean Pacific shorts.

"It was interesting, but it was also hard sometimes, assimilating," he recalls. "I remember the first year I got to the new school in America, it was the time of Rambo and Reagan, and kids were telling me that America had won the Vietnam War and that I was a commie. There was some awkwardness of being a ten-year-old and you're French and then it's just the ignorance of people."

De Balincourt eventually managed to settle into California life (and even developed a love of surfing), but his unconventional childhood, including excursions like a two-month camping trip to Mexico in VW buses with his bohemian mother, left an imprint that he now appreciates.

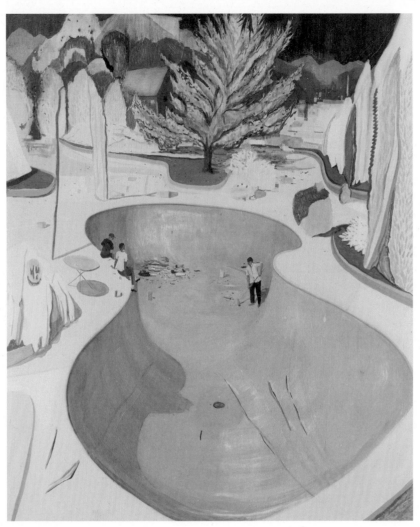

New Arrivals, 2021
Oil on panel
78 ¾ × 65 inches

"My mom met Henry Miller back in her day and she has a painting that he did of her where she's half naked," he remembers. "I'd have parties and I would take it down. Most kids in their living room have that classic 1980s family portrait, the Sears portrait, and here's this gnarly portrait of my mom. It's kind of an intense painting but I love it now."

Though de Balincourt's high school didn't offer much in the way of art classes, he still found a way to express himself creatively, with teachers giving him merits for his illustrated book-report covers. After high school he attended Santa Barbara City College where he was able to take an array of art courses, including painting and ceramics, which he threw himself into, setting up a business making ceramic drums modeled on North African doumbeks.

"I was in this sort of neo-hippie Santa Barbara movement of Phish and the Grateful Dead, this early 1990s moment, but it was also the end of Fishbone and the Chili Peppers. It was an interesting moment of this skate-surf-punk thing and then there was also this hippie thing," he says. "So for a while I was making these ceramic drums and I would sell them on the Venice Beach boardwalk and then I would go to Dead shows and sell them in the parking lots. That was my early twenties. I was always set on never getting a real job and I really never did until I got to New York City and I was art handling. But in California I was able to support myself with my art."

De Balincourt first studied ceramics at the California College of the Arts (then the California College of the Arts and Crafts) in Oakland, moving to New York in 2000, where he studied for an MFA at Hunter College. He was picked up by New York's Zach Feuer Gallery at an open studio while still in graduate school, but, despite this early break, when he first arrived the Manhattan art world seemed an impenetrable fortress. "You first get here and it's really intimidating. You're seeing, like, 25-year-olds getting solo shows and I was already 28. I was like, 'Oh shit, maybe my time's passed.'"

Getting his first 'real' job, as an art handler provided an entry point for him past the gates. "All of a sudden you're working as an art handler and you're behind the scenes, in the gallery in the back, and then you're going to Jasper Johns' house, installing his *Brillo Boxes*, and then you're going to Philip Johnson's house," he recalls.

He describes his time art handling as day school, "which was of an equal education" as his graduate studies, which he calls night school. "Being at the 42nd Street Hunter Grad studios, it was this wild island anarchy. It was this big building and pretty unregulated and we could pretty much do whatever we wanted there."

Some of that anarchic spirit was doubtless channeled into the eventual performance-hub-cum-arts space de Balincourt set up in 2007 in Bushwick, a building that now houses his studio and apartment but for three years was the home to Starr Space, a place for concerts and yoga, fundraisers and church parties. "That was a really fun moment in my life," he recalls. "Eventually I was like, 'I can't run this speakeasy-yoga-studio-movie-theatre-dance place,' it was nuts trying to juggle this thing. But I had great people helping me organize and curate stuff there. That was when there was no yoga studio yet in Bushwick, there was no place to see live music and so I decided, OK! I'll do this. It was kind of naive, I could have got in a lot of trouble for doing it not really with any permits or anything."

De Balincourt still lives and works in Brooklyn, as well as in Malpais, Costa Rica. Starting in the summer of 2020, shortly before getting signed to Pace Gallery, he started to lean away from figurative abstraction and more towards abstraction full stop. "I'm thinking more about painting a painting versus painting a picture," he says. "I want it to somehow become more about paint but I still need some kind of baseline story or some idea, still having it rooted in some kind of figurative narrative. I can't just be smudging around colors and shapes. I still need something to ground it conceptually."

They Come to Get Lost, 2021
Oil on panel
96×76 inches

Why I Make Art

Though he has limited interest in digital platforms and social media, de Balincourt likens his own process to using Photoshop. "I'm actually doing my filters on the painting as far as layers. I'll do one wash and then I'll do another wash on top of it and then it changes the base color. So I'm kind of figuring it out, I'm sort of collaging and cutting and pasting."

His methods are fluid and immersive. "I'm usually starting multiple paintings at once, I start ten paintings and rotate, bouncing around the studio. Eventually I'm starting more and more paintings, and then the problem is all of a sudden I have 30 paintings and none of them are finished. It's hard going, that last 10 or 15 percent in a painting, I can get it to like 80 percent and then I'm like, 'OK, I'm bored now, I'm going to go to something else.'"

But de Balincourt has come to accept that this is the way he works. "After a while you just surrender to become who you are," he says. "Life is hard enough as it is, whatever it is that's happening out there in the bigger sphere. And, yes, art can be a struggle and it's OK for it to be a struggle, but you don't have to make it a battle every day either. Let's soften the road here a little bit."

He also says that he gives little thought to his own legacy. "I did a talk at a school and someone asked me in a Q&A, 'Well, what do you think about your legacy?' I said, '*Legacy?* I don't even know if there's going to be a world 60 years from now, why am I worried about my legacy?'" he says. "As I get older, I just accept; well hey, you want to do another painting of a scene in nature and that's what you're compelled to do? Well, fuck it, do it."

Dove Bradshaw

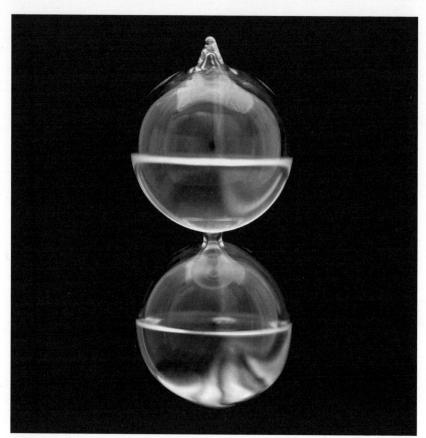

2NO, 1971
Glass and acetone
6×3×3 inches

Why I Make Art

In the late 1960s, chance-led artist Dove Bradshaw was gifted a pair of ring-necked mourning doves, which she proceeded to let fly around her top-floor studio in Boston. "One day I found this abandoned bicycle wheel," Bradshaw says. "I picked it up, strung a steel cable through it and hung it to the ceiling. The birds flew on it and it would spin." The doves made their home in the wheel, eventually hatching a chick, before flying away. Bradshaw documented her winged namesakes' time in her apartment with a series of photos, and by making silver and bronze casts of the chick's shell. Twenty years later, the artist restaged variations of the episode with pigeons, as an installation at the Sandra Gering Gallery and at MoMA PS1 in New York. Entitled *Plain Air*, the piece has come to be one of her best-known works.

While chance plays a part in much of her practice, Bradshaw is also known for her trailblazing work with indeterminacy—though it's taken some institutions time to catch up with her. The Metropolitan Museum of Art vacillated for years on whether to accept the legitimacy of her 1976 guerrilla act, *Fire Extinguisher*, in which she attached a label next to a firehose cabinet in the northwest corner of the museum, then claimed it as a work of art. (Later she made postcards of the firehose and placed them on a rack in the museum's store—Ray Johnson and Sol LeWitt each bought one.) Bradshaw references Marcel Duchamp's famous readymades in relation to the piece: "The difference between Duchamp's found object and mine was that mine was a claimed object, it was already in a museum." In 2007, 45 years after first planting her flag at the Met, the work, now entitled *Performance*, finally entered the museum's collection. (She says that if there should be a fire, she would claim that as her performance—adding, "I'm not going to start one.")

"Duchamp's influence will never die, because he gave artists permission," she continues. "Artists may not know all about his work or all the complexity of it but one thing that we do know is we have permission."

Bradshaw knew early on what she wanted to do when she grew up. "I thought I wanted to be an artist since the age of five," she says. Born Katherine Loveday Bradshaw in New York City in 1949, she earned her avian soubriquet owing to a mispronunciation by her older brother, who called her "Dovedee" and then "Dove." Her father did drawing himself and encouraged his daughter's interest in art and architecture. Her mother (who took up painting when she was 98) worked for the American Craft Council and traveled with avant-gardist Beatrice Wood, aka the "Mama of Dada."

Bradshaw became friendly with Wood and with Alexina "Teeny" Duchamp, Marcel's second wife and the daughter-in-law of Henri Matisse. "Teeny Duchamp was like a grandmother," says Bradshaw, recalling several visits she and her husband, minimalist artist William Anastasi, made to the American-born art-world matriarch's house in Villiers-sous-Grez, in north-central France. "We stayed in the room where just outside was the tall chair that Duchamp was often photographed sitting in," she recalls.

As well as rubbing shoulders with avant-gardists, Bradshaw benefitted from growing up in a city that was full of art—and from having parents who were keen to expose their children to it. "We were taken to museums, the MoMA, we lived near the Met. There was nobody in those days, there were whole galleries that would be empty," she says of the childhood excursions with her parents. That was when it was free to enter, she remembers, "and when nobody was there to crowd you out."

One of four siblings, Bradshaw grew up on East 88th and First Avenue and recalls watching Frank Lloyd Wright's Guggenheim being built just a few blocks away, "I saw the spaceship growing on Fifth Avenue," she says. Half a century later, in 2009, she and Anastasi both showed at the Guggenheim as part of the group show The Third Mind: American Artists Contemplate Asia, 1860–1989. Bradshaw exhibited $2\sqrt{0}$, a piece from 1971 that works as both a spirit

level and a timer, depending on whether it is held horizontally or vertically. Composed of two linked glass globes containing acetone, the piece can measure both space and time. A poetic, meditative object, $2\sqrt{0}$ has baffled many. "What was amusing was that it was shown as a level and, of course, it bedeviled sculptors forever to be showing it on a curved rotunda that's sloped," she says, referencing the way the work was exhibited, neither horizontal nor vertical. "It kind of defies a lot of sculptural ideas."

As far as she is aware, the level is an original invention, made in collaboration with a lab technician at MIT when she was still a student at the Boston Museum School of Fine Arts/Tufts University. It's akin to much of Bradshaw's work, which exploits the element of chance in scientific experimentation, including her series of works that feature cone-shaped salt sculptures that disintegrate over time beneath slowly dripping water (for example 2003's *Six Continents*), or sculptural works that metamorphose when exposed to the elements. Bradshaw's friendship with fellow artist and composer John Cage, whom she met when she was 27, further cemented her interest in chance processes. "We were very close, like family, for 15 years," she says of the pioneering multidisciplinarian. "John said to my mother that I was the daughter he never had."

Speaking about the spiritual elements of his work, Bradshaw recalls that Cage, who celebrated the role of indeterminacy, had wanted to be a minister when he was young. "At one point he thought he would be," she says. "There's an evangelical aspect to all of his work because he felt that chance was the only way for us to escape our limited egos. I think that idea of art and the spirit as he talked about it continues; it's a deeper, more profound focus."

Over the years, Bradshaw has exhibited with her husband—also a friend of Cage—many times, and the couple also served as joint artistic advisors for the Merce Cunningham Dance Company. (Cage and Cunningham were life partners.) "Marina Abramovic says that two artists should

never live together," Bradshaw says. "But the advantage Bill and I have is that we're 16 years apart, which I think helps. You're at different stages of your career, so you don't have the expectations."

Bradshaw and Anastasi both featured in Matthew Taylor's 2020 documentary *Marcel Duchamp: Art of the Possible* alongside Ed Ruscha, Michel Gondry, and Jeff Koons, though she explains that her love of the modernist pioneer and focus of that film has faltered over the years. "My allegiance shifted to Cage, and the reason was—not that I would ever discount Duchamp, he's ever-present and will always influence every generation of artists—his focus is puerile in many respects." Still, a replica miniature bicycle wheel modeled on the original remains atop the piano in Bradshaw's home.

Bradshaw subscribes to the idea that, like Picasso, "a real artist does everything. People who just do one thing, it seems to me, are not so wide and deep." And indeed, her career has been long and varied: making inventions, creating jewelry—memorably out of spent bullets—and even dressing windows for Tiffany & Co. For an artist interested in science and chance, she takes umbrage at the notion that every good idea in art has already been done. "It's very annoying to me because the zeitgeist of each time, and our technology, changes, and we're different, and the world is different, so everything is going to be different—how could it be the same? How could every idea be used up, especially when we're working on going to Mars. How could this be?"

This openness to possibility means her working processes often vary. "I don't know how normal people live life," she says. "I'm free every day to determine what I do, I'm totally spoiled." Though she is now her husband's caregiver, Bradshaw says life is not so different from when they were first together; their four decades of partnership have been filled with work, travel, and merriment. (One Halloween she offered to do Bill's taxes if he would come

Negative Ions II at Senzatitolo, Rome, 2007, 1996/2007
1600 lbs salt, 1000 ml separatory funnel, water

trick or treating with her—seduced by the idea that at any
other time of the year, it would be considered taboo to
arrive at someone's home in the city unannounced, unless
you knew them well. "We went to Leo Castelli's and Dorothea
Tanning's, we went around town knocking on doors, it
was great fun and very liberating," she recalls.)

Zen thought influences Bradshaw's art, as it did
Cage's, and she attributes her working mantra to the 17th-
century Japanese poet and Zen master Hakuin Ekaku.
"He has a description of artmaking that is four words: sim-
plicity, clarity, spontaneity, precision. How Zen, how perfect,
it seems to cover everything."

Gregory Crewdson

When photographer Gregory Crewdson was growing up in Brooklyn in the 1960s and 1970s, his psychoanalyst father would conduct sessions with patients in the basement of the family's brownstone in Park Slope.

"That was really significant in terms of my artistic development," says Crewdson, who now lives in the Berkshires, a mountainous region in western Massachusetts. "My brother and my sister, too, we all have distinct memories of when patients came up the street. We knew not to acknowledge them in any way. We were told to be very quiet."

Despite his parents' warnings, Crewdson's curiosity about what was happening behind closed doors would often get the better of him. "One of my earliest memories is attempting to listen to the sessions," he recalls. "As a young child I liked trying to project an image of what I thought I heard. It's the very nature of having secrets, something forbidden and separate from you. When I think back to it, that's one of my defining esthetic memories, or awakenings—that idea of trying to project a story onto something that is slightly removed from you.

"There's something about the formal interplay and the dynamic between domestic life and something that's withheld, forbidden or secret," he adds. "I think that's a defining tension in all of my work."

Known for his haunting, filmic tableaux of mist-wreathed suburban streets and uncanny interior spaces inhabited by enigmatic, forlorn figures, Crewdson presents small-town life through a cinematic lens, full of narrative and intrigue. Emphasizing ambiguity, his photographs present scenes wrapped in allusion and elusiveness—what is seen can be as powerful as what is left out of view.

"Photography is very limited in terms of any capacity to say anything at all," he says. "It's a frozen moment that will never reveal its story in a literal way. That's part of why I'm drawn to it, because of the open-ended nature of all pictures. I'm very much interested in the moment that seems to exist between something before and something after."

Untitled, 2003–2008
Digital pigment print
57 × 88 inches

Before focusing his energies on photography, the teenage Crewdson found a creative outlet playing guitar with his post-punk band The Speedies. The five-piece group had an underground hit with 1979's "Let Me Take Your Foto," which was later used in a Hewlett Packard commercial for portable printers. (A review at the time described The Speedies' style as "sweet pop-rock with a dollop of venom"). Soaking up the punk scene in Manhattan in legendary venues like Max's Kansas City and CBGB was a thrilling, formative ride, and music remains important to Crewdson today—he collaborated with Wilco's Jeff Tweedy on a video and book accompanying his photo series *An Eclipse of Moths* (2020). It was only after The Speedies broke up that Crewdson began to explore photography in earnest. And while he is now the director of graduate studies in photography at Yale University School of Art —where he did his own MFA—early on Crewdson found himself frustrated by his studies.

"I had difficulty academically. I was sort of dyslexic and the nature of test-taking and writing papers and even reading was somewhat painful for me," he says. "I went to SUNY Purchase and I thought I would follow the line of my father and try to be a psychiatrist but I just couldn't, academically. I wound up taking a photo class out of curiosity and from the moment I made my first picture, I immediately knew I could read a photograph in a way that I couldn't absorb other things. Just the frozen, mute nature of it... It became immediately apparent to me that this was something I understood and loved."

Even then, he was captivated by the relationship between still photography and the moving image. "I was taking classes on Hitchcock in the 1950s, melodrama, and horror films—these are things that are defining for me now. What's great about a film like *Rear Window*—I love all of Hitchcock's films but that one particularly—is that it's really about the uncomfortable relationship between being a photographer and being both voyeuristic and impotent at the same time.

"That set beautifully describes the fascination with peering into other people's lives but also the inability to act, to be active," he continues, referring to the mystery thriller's central narrative, of an injured and therefore incapacitated photographer's voyeuristic relationship with his neighbors. "I think all photographers, in a certain way, are drawn to the medium by a similar kind of detachment or remove."

Channeling James Stewart's increasingly haunted character in *Rear Window*, Crewdson imbues his images with the impression of something mysterious, fleetingly caught, which serves as a catalyst for the imagination.

"There's a certain element in my work always—I describe it as being there but not there. You're at a slight remove peering in on a world. When my pictures are at their best, there's a coming together of intimacy and detachment that's an interesting dynamic."

Why I Make Art

Crewdson has been exhibiting for over 30 years, achieving great renown for his series including *Natural Wonder* (1991–95), *Twilight* (1998–2002), *Beneath the Roses* (2003–07) and *Cathedral of the Pines* (2013–14). The expressive titles marry well with images of domestic spaces flooded with shafts of muted light or literally flooded with water, lone suburban figures, and fireflies lighting up landscapes at dusk. Held in collections all over the world, his work is as recognizable as the Americana he lovingly skews, and the majority of his images, though set in an indistinct temporality, are photographed in the US. (One notable exception is his *Sanctuary* series from 2009, shot in Cinecittà, the studios in Rome where famed directors Fellini, Rossellini, and Visconti made their films.)

A sense of timelessness is a signature component of a Crewdson image. Though he sees that making "a document of something directly, that addresses our time" may be the purview of great photojournalism, his focus lies elsewhere. "I'm more interested in making images that are less knowable, less fixed or direct, that are more ambiguous and more, I guess, poetic in a certain way," he says.

"I go through an enormous amount of energy to remove any sign of everyday contemporary life in my pictures," he continues. "There are no cellphones and all the cars and houses and figures, they all feel somewhat outside of time and faded and slightly broken. So there's part of the pictures that feels removed from the moment and then there's also part of the ambience that feels very much of the moment. I like that tension."

As an example, Crewdson's recent series, *An Eclipse of Moths*, which he made in 2018–19 and exhibited in late 2020 at Gagosian, Los Angeles, frames scenes of post-industrial desolation and rural decline. Shot from a distance, figures are pictured alone and diminished on decaying streets, in works with evocative titles such as *Funerary Back Lot*, *Alone Street*, or *Redemption Center*.

Untitled, 1998–2002
Digital C-print
48×60 inches

These plaintive set-pieces portray humanity's relationship with the modern world as a struggle that extends back and forward in our collective memories.

"I always want to make pictures that feel first and foremost beautiful and mysterious," Crewdson explains. "Certainly some of the central themes of *An Eclipse of Moths* include alienation and brokenness, and some hope of redemption, I would say. I very deliberately made them all in these anonymous and somewhat nondescript locations. I wanted them to have a vast scale with smaller figures inhabiting these places."

Whatever the series, Crewdson's work immerses the viewer in a world that seems culled from a film—a freeze-frame as opposed to a still, or a moment in a dream somehow crisply remembered. "Clearly my pictures have been shaped by the way movies look," he says. "I love going to a

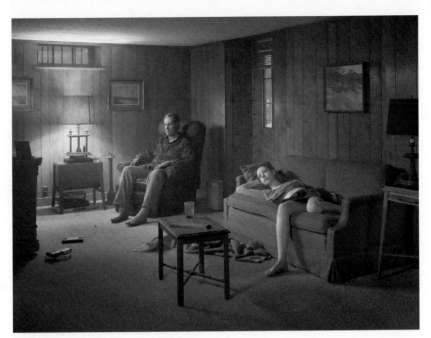

The Basement, 2013–14
Digital pigment print
40½×63 inches

movie theatre and being part of that collective dream of
seeing light projected on a screen, which is just such a
beautiful dreamlike state."

His process is another aspect of his work that reso-
nates with the labor- and time-intensive nature of film pro-
duction. Each location in Crewdson's dreamily suggestive
images is meticulously scouted before being staged, lit,
and photographed. Employing a crew of up to 50 people
—including lighting, scenic, and location crews—it often
takes years to complete a body of work, and Crewdson com-
pares the process with that of making an independent film.

"It's a very similar arc," he explains, in that it goes
from "conception, pre-production, production, and post-
production and finally, at the very end, having the premiere
of the work. And then you start the process again. It's very
challenging. Fortunately I have galleries that help support

the venture. But it is never easy, and you also have to be incredibly inventive in terms of ways to cut costs and depend on the kindness of others. There are ways to do it."

It begins with the artist searching for the right place to shoot. "That can take months, finding locations that I feel can accommodate one of my pictures, looking for something that feels ordinary and nondescript but also like it can have a certain kind of formal beauty," he says.

Through that process, he explains, images begin to appear to him. Then he starts working with his partner, Juliane, on writing the descriptions for each photo. Closer to production, he is joined by a line producer and his longtime director of photography, Rick Sands, and the rest of the team. It then takes about a year to work in post-production, which is done in the Berkshires alongside Crewdson's printer, who comes out to live there for the duration of this part of the process. Working together, bit by bit they composite the images, spending much time and effort trying to recreate "what it felt like to make the picture," Crewdson explains.

"Altogether, it's about a two- or three-year process, beginning to end," he adds. "The shortest period of time is the time where we're actually making the pictures, unfortunately."

An Eclipse of Moths was made in a town near the artist's home in the Berkshires in Western Massachusetts, where he lives in a former Methodist church dating from the 1890s. Crewdson is something of a "known figure" with the locals, who prove to be extraordinarily supportive of his shoots.

"We actually asked a lot from them in this body of work. We needed to change lightbulbs in streetlamps and try to have them not mow or pave, so there were a lot of things that they helped us with," he says.

But while the mechanics and phases of production are critical to the process, ultimately they are all in the service of the final image. "I do really love production and I

love the hectic quality of it—things are going wrong and we're losing the light and there are weather problems and some neighbors aren't being cooperative, or we have a technical issue, this lift doesn't work, or the fog machine is down," he says. "But in the end, if the picture works, all of that recedes and there is this moment of grace where it all makes sense and that makes it all worth it to me. At the core of it, the vision is the most important thing, the story that you want to tell and will into existence in one way or another."

His aim is for all of that production to be invisible. "What I really want is for it all to disappear; to create a world that feels convincing and real and lived in. I want the viewer to feel like they could enter into that world and be part of it."

And though his work and process are meticulously considered, the making of a Gregory Crewdson image is also an alchemy of different intuitions. "When I'm making pictures, again not consciously, there are at least three competing forces that kind of exist and create tensions," he explains. "One is that, just by their very nature, pictures have to refer to other pictures. There's always a relationship between pictures I've made and the tradition and history of the medium. So they are always looking backwards in one way or another and playing off that lexicon. And there's also your personal story, your own obsessions and desires and fears and complications, expressed in the pictures. And then, ultimately, the pictures take on relevance to the moment that they exist in, so that's another set of dynamics. I think that when art is functioning at the highest degree, those three competing forces have absolute balance, and that's always my hope or my ambition."

Crewdson was the subject of a 2012 documentary, *Brief Encounters*, which traced a ten-year period in the artist's life, and he has contemplated getting behind a film camera himself. The main challenge, as he sees it, would be to extend the singular world he has created, with its ambiguity and strong sense of story, into a feature-length form. "If everything felt right, I would like to try it. But in the

Funerary Back Lot, 2018–19
Digital pigment print
56 ¼ × 94 ⅞ inches

meantime, I'm very happy doing what I'm doing, which is continuing to make the still photograph feel powerful and important and mean something in this time."

Crewdson's intensive process and his quest to make each image meaningful in multiple ways leaves him less inclined to take photographs when he's not working on a specific project. That time is spent with family or teaching and on other passions—whether going to the movies, listening to music, or open-water swimming.

"I am by nature sort of uncomfortable with cameras, and even when we're shooting I frame the scene but I have a cameraman making the actual exposures," he says. "I want to have a direct relationship to what I see in front of me. What's most interesting is that thing, the world that we've created that only comes to life for fractions of a second. So I don't tend to take many pictures outside of being an artist, I actually don't even own a camera. On occasion I'll take some cellphone pictures of my kids or something, but I have a weird, disconnected relationship to the actual medium."

The digital world, with its surfeit of imagery, underlines just how important the photograph-as-art-piece remains to the cultural landscape. Crewdson elaborates that "pictures have a very short life in the virtual space. All photographers have to think about that and their relationship to it, and acknowledge that's how 99.9 percent of images work now, as instantaneous and disposable. The real challenge is to make pictures that feel lasting and permanent and physical; like a physical thing that exists on a wall that's an object rather than a mirage."

He is an admirer of Japanese photographer and architect Hiroshi Sugimoto's ongoing *Theaters* series, the years-long body of work comprising photographs of entire movies captured within a single photographic exposure. Shot in the US, the project includes images of luminous blank screens framed by the architectural and topographical features of a cinema or drive-in. It's a project that neatly dovetails with Crewdson's own interests. "They're beautiful meditations on the nature of time and the landscape and the photographic image," he says. "I think they're really powerful pictures."

Sugimoto's images also speak to Crewdson's love of the cinema experience, itself akin to his belief in the importance of the gallery show, which "really fulfils an important need that we all have, and that is to connect to something outside of ourselves and have that moment of deliberation and clarity," he says. While the reliance on digital imagery of all kinds has only increased of late, Crewdson believes it is the job of the photographer to make pictures that cut through.

"What's powerful about photography in general and why I am drawn to the medium is that it's democratic in a certain way. It's the currency of our culture. We all inherently understand how to read pictures and are confronted with pictures on a daily basis," he says. "And that's very different from other forms of art, which are by their nature more hermetic and kind of privatized. In a way, the challenge of

being a photographer is trying to create a singular vision in that enormous and overwhelming network of images. But if you can figure out a way to do it, or at least attempt to, it could be meaningful to a much larger audience because of the inherent way we can connect to a photograph."

Heather
Day

Heather Day has an unusually complex relationship with color. Her experience of synesthesia, a little-understood neurological condition that merges sensory pathways, means she "sees" sounds and experiences tastes as if they were different shades.

"I was at a winetasting and everyone was talking about the cliché things they say about wine. I think one description was, 'Oh, it's like fresh-cut grass.' And I said, 'Oh, yeah, it's very *blue*,'" she recalls. "Red wines, steaks—those are always very blue. Salmon is always a fuchsia color. If I'm really upset about something, I'll see different neon colors. It's very strange."

The artist barely recognized the phenomenon until she was in her twenties, having previously believed that everyone else saw the world the same way. It's little surprise, therefore, that her hugely popular abstract paintings are defined by color. From ethereal pastel splatters to saturated brushstrokes in deep blues and teal, her large-scale works come alive with vibrant expressions of movement and compulsive energy. But while the condition has undoubtedly shaped Day's art, the intrusion of color can, she admits, be distracting.

"When I hear a certain sound on my peripheral, it's almost like someone's pulling up a colored lens," she says. "And it's like a smudge of a color is actually there, to me. Often, when it's happening, I look around the room to see if I'm just pulling it from a painting in the room, or something else that's there," she says, adding: "[I'll be] trying to focus on something that someone's saying, and seeing strange washes of color... I'll be in a serious conversation with someone and be like, 'I'm so sorry, there's just so much color!'"

Sounds come with distinct color connotations, too. For Day, classical music appears green, while higher pitches are experienced in shades of red. As such, she often listens to—and is inspired by—music as she paints. But this element of her practice is, she says, still in flux.

The Persistence of Memory, 2020
Mixed media on canvas
56×72 inches

"Music gives you an energy," she explains. "When I'm not feeling motivated but know I need to be in the studio, some form of sound is usually how I get going. But the good moments in the studio are when NPR is over, or the music stops, and I'm still working for a few hours. Sometimes those moments are really hard to come by, you have to really work for them—to get into a flow state and learn how to do that, and how to keep recreating those moments.

"I'm a little bit skeptical that I listen to too much music," she adds. "So I've been trying to work more in silence lately."

An unashamedly spontaneous artist, Day employs a carefully controlled disorder in her work. The act of doing has, she says, always come more naturally to her than planning things out.

"For a while I was hiding behind the process, and not totally realizing that process and concept are two different things," she explains. "But it does start there, just the idea of exploring and learning through doing. And that's pretty much how I live. If I'm learning a card game, and someone is trying to explain it, I'm always like, 'We have to just *do* it, and then I'm going to figure it out.' It's the same thing with paint. I figured out what different types of paints do, how they react and what you should—and shouldn't—do."

This hands-on approach can be traced back to the artist's childhood. Born in Hawaii, she moved to Okinawa, Japan at the age of two before relocating to the East Coast and spending much of her youth in the Washington, DC, area.

"When I was really little, I was building things with cereal boxes and scotch tape," she recalls. "I was almost more of a sculptor as a kid. Then that evolved into drawing. Later, when I was about 10, I found out that I was dyslexic. Things started to make more sense, as I figured out how I learn and how I could find the tools to help me continue in school. It started to all make sense, in the way I see the world and how I draw to come to terms with things. Art was the one place where I found it wasn't matter of fact. It was something where I could come up with my own rules, my own questions—and the answers, too.

"My drawings were always very quirky," she adds. "If I was doing a portrait of someone, it never looked just like them. I was really fascinated by the textures of their face, the angle at which they were standing, the contour of them or the negative space around them, rather than, for instance, getting the eye just right."

Day moved again for high school, this time to Chicago, where she began exploring her interest in human move-ment. "I would just go sit in the dance department for hours on end and draw the dancers," she recounts. "I soon real-ized I was really fascinated by movement and the negative space between the dancers' arms as they moved, and what that looked like. I was really studying De Kooning's

work at the time. That had a huge impact on how I started approaching abstraction."

By the time she arrived in Baltimore for a BFA at the Maryland Institute College of Art, Day was adept at finding "people that could be encouraging" toward her way of learning. An almost nomadic childhood had left her able "to adjust and acclimatize a lot faster" than other people. She also began diving into new artistic influences, citing Agnes Martin and Joan Mitchell as art historical figures she still looks up to.

As a young artist, however, being compared to those you admire can be a burden as well as a compliment, Day says. "It can be flattering but also so frustrating, because I realized there was a point where I needed to step away from Joan Mitchell and De Kooning and try to find my own voice within that."

Her distinctive style emerged over the following years, though translating kinetic forces into still forms remains central to her art, which has been shown at the Urban Institute of Contemporary Art in Michigan and the Massachusetts Museum of Contemporary Art. Now living and working in San Francisco's Dogpatch neighborhood, Day staged her first solo exhibition in New York in 2019 and has more recently presented shows in Seattle and LA. Her work can be found in the collections of many corporations and public venues, including Facebook, J. Crew, the Ritz-Carlton, Airbnb, Snapchat, Dropbox, Warner Brothers, and the Chicago Philharmonic Orchestra. It's a list of supporters that speaks to her contemporary appeal.

Though Day primarily works on canvas—large backdrops that are intentionally worn, stitched, or both—she is also a prolific mural painter. Her creations have not only graced urban walls but also a Napa Valley winery, a Sausalito beer hall and the inside of YouTube's headquarters in San Bruno.

"It's so challenging," Day says of her mural practice. "It's physically and mentally exhausting, but I love it. It gets

Static Film, 2021
Mixed media on stitched canvas
47 × 55 inches

me out of the studio and thinking differently, because with my canvases I'm pouring the paint and manipulating it, in the way I'm able to tilt the canvas and lift it up and transport it. But I obviously can't tilt a wall, so that has created interesting obstacles and made me try new mediums."

Making murals also offers new opportunities for dialogue. "Public art is so important," Day says. "People that wouldn't have interacted with your work otherwise are talking to you personally. It's interesting to think about how to get people who wouldn't otherwise interact with art into those spaces, how to bring them in."

Beyond painting walls and canvases, Day has also worked on digital animations, produced her first NFT, and

designed a series of abstract phone cases based on her art. "If I was going to be critical in my career, I would say things are moving a little *too* fast," she reflects. "You can start to lose something in your work and the process when you're moving that fast. I think my paintings need to sit for long periods of time before I can decide they're actually done and even show them."

Taking things slowly can be difficult in the digital age. Realizing that the urge to constantly look at her phone was a "weird, dirty habit" that needed breaking, Day says social media has become a sort of "factory for instant art."

"It's of course very gratifying to get the likes on Instagram," says Day, who uses the platform to share a steady stream of new paintings, installation shots and studio insights with thousands of followers. "And I don't know that all the art I'm seeing on there is of quality. So it's really important to curate what we're all looking at and understand why we like it and to make sure to see it in person, too, and see the difference."

Despite her reservations, Day broadly welcomes the arrival of social media as a way to share her work and discover new artists. "Instagram, Facebook, Pinterest—they're all really great tools to leverage to share your work," she says. "It can be kind of daunting at first kind. Self-promoting is crazy, and so is how much we need to do it, as artists. But it's been really incredible to find ways to use social media to connect with larger, or smaller, communities that wouldn't otherwise see my work.

"It's great that we're living in a time where art is more accessible. Although I think having an art degree and an art education was really important to my career, it's not necessarily required anymore. Social media creates other options and other ways to view art, and you don't need to purchase a magazine or buy a textbook anymore."

On Time, Space, and Place

What we do is engage in a form of material and visual philosophy. We're having conversations with cohorts who sometimes aren't even alive. We're in a swirl of call and response.

—Stephen Westfall

I'm really interested in the desire for universal experience, and the fact that it's impossible to achieve.

—Ellen Harvey

Ever since I started paying my own rent, I've dreamt about space.

—Andrew Kuo

When you read in Artforum that so-and-so is not alive anymore, you realize that your world is leaving the stage, and your time now is important.

—Alice Aycock

It's OK not to know.

—Chris Staley

It's funny to be a person sitting with a brush and paint. But it anchors us to this important, tactile experience of being a human.

—Jenna Gribbon

Getting your first show and getting a little heat is great but doing it 10, 20, 30 years is another thing altogether.

—Ridley Howard

Inka
Essenhigh

When Inka Essenhigh was a child, she didn't have pop stars on her walls. Instead, she had posters of paintings: Van Gogh's *Almond Blossom* (1890), Manet's *A Bar at the Folies-Bergère* (1882), and Picasso's *Bouquet of Peace* (1958) among them—what the artist fondly calls "the greatest hits."

Essenhigh's own greatest hits could perhaps be more readily compared to other canon-forming artists such as Dalí and Magritte. The renowned New York-based painter's dreamlike works draw as much on science fiction, myths, and fables as they do from the formal tenets of Surrealism, to imagine epic scenes of both bucolic plenitude and the urban sprawl. At once otherworldly and close to home, idyllic yet disturbing, Essenhigh's atmospheric spaces don't so much provide an escape from reality as bring forth the unseen within it. "I respond to things that are a fantasy, but I don't see it as an escape—I see it as part of how we inform how we're going to move forward," the artist says.

"I can't remember a time when I didn't want to be an artist. There was never a plan B," she recalls of her early years, first in Bellefonte, Pennsylvania (where she was born in 1969), and then in Columbus, Ohio. "My mom got me extra art tutors and bought me art books—Mary Cassatt, Georgia O'Keeffe. We'd go to a lot of museums and I liked the old masters."

She puts this level of encouragement for an uncertain and hard-to-follow career path down to her maternal family's difficult history. "My grandmother painted, she was from Ukraine and came to the US as a refugee from World War II. Sometimes it's been said that when you're a child of immigrants, you're trying to take back status, and my mom was very snotty like that. On some level, she wanted me to have a status that couldn't be taken away."

Soon enough, an interest in music began to influence Essenhigh's tastes. She was drawn to alternative rock and goth, the visual culture surrounding subcultural bands

such as 'Til Tuesday, The Pixies, and Love & Rockets, which speak to her appreciation for the intense and hyperbolic. "I really loved old-fashioned painters, so maybe goth appealed to me because it has something to do with a history, a romanticism. I can't say I looked at album covers and thought, 'I want to be like that,' but it informed how I went through life in that you were supposed to be questioning of The Man. You were supposed to be impassioned, go all out, be completely sincere and unashamed. Also, with punk and goth there's a show and there's costumes that can go into fantasy, which I obviously respond to."

She received an undergraduate scholarship to study at Columbus College of Art & Design, where she enjoyed a relatively traditional education, taking in everything from printmaking to ceramics. "I knew you were supposed to be an Abstract Expressionist, but I was scared of that. I didn't really get it. The local art school had a program that was Bauhaus related. It gave a foundation in figure drawing and color theory. I felt much happier going down that road. And it's still with me today. I think of it as wearing a badge of honor, but also of provincialism. It's my Midwestern-ness that makes me want what I make to be 'good.'"

Essenhigh earned an MFA from the School of Visual Arts in New York, graduating in 1994 and going on to form part of the generation of young artists in the city that led the contemporary return to figuration, alongside the likes of Rachel Feinstein, Will Cotton, Lisa Yuskavage, and Cecily Brown. Her early work was dubbed Pop Surrealism, and she was part of the influential 1998 show of the same name at Aldrich Museum of Contemporary Art, Connecticut. At that time she was leaning into cartoon-like forms and simple colors realized in enamel on canvas to create slick, bright, and flat surfaces that had an insatiable viscosity. She also established a forceful breakdown of perspective, putting the viewer up into the air as if floating above the scene at hand, adding another element of intentional oddness.

Dawn's Early Light, 2019
Enamel on canvas
40×50 inches

Over the next decade, Essenhigh continued to rise in prominence and in 2007 was included in another landmark show, Comic Abstraction: Image-Making, Image-Breaking, at the Museum of Modern Art, NYC. More recently, her solo exhibitions include Miles McEnery Gallery in New York; Susquehanna Art Museum in Harrisburg, Pennsylvania; Kavi Gupta Gallery in Chicago; and MOCA Virginia, Virginia Beach.

She's now represented by Victoria Miro in London, and her work is also in the collections of major museums including the Albright-Knox Art Gallery in Buffalo, Denver Art Museum, the Museum of Contemporary Art in North Miami, MoMA PS1 in New York, the San Francisco Museum of Modern Art, the Seattle Art Museum, the Tate Modern in London, the Virginia Museum of Fine Arts in Richmond, and the Whitney Museum of American Art in New York.

Queen Anne's Lace, 2020
Enamel on canvas
40×50 inches

"There's something about the city, it's a stage," she reflects of New York and of her success there. "You can walk down the street and run into the person you need to run into. And when the time is right, it feels like your work can go down to the center of Manhattan like a chiropractic adjustment and, after that, it can go everywhere all over the world, all at once. And it still has that ability today. I mean, New York sucks to live in, but it still can do that. Not a lot of places can. Somehow, it's too diffuse elsewhere. But here there's an alignment to the whole thing."

Essenhigh still occupies the same Lower East Side studio space she shared with two artist friends and her then boyfriend, now husband, realist painter Steve Mumford, straight out of grad school. "Back then we all made a pact that whoever we managed to drag back here to the studio,

we'd show them all of our work. That was the goal," she remembers fondly. "The idea was that, even if they didn't like your work, we'd all be better off if they liked your friend's work. And it paid off because I think the way people come to your work as a young artist is through your friends. What's the vibe, what's the scene, what are you talking about?" She misses the frisson of those early years but does not underestimate the value of being more assured in her own skin, especially in an industry driven by trends and market forces. "One of the problems of ageing as an artist is that you lose your context, and then people don't know how to place you. But going forth, the story changes. It doesn't have so much to do with anyone else out there. You become more you. And it becomes about whatever the truth is for you. Whether you want to be ironic or sincere, you have to find the path. Now when I see a work that's great, I won't want to crib a mood or jump on board. I just enjoy the fact that that artist figured it out and I will figure it out differently."

Throughout her career, Essenhigh has displayed a healthy disregard for consistency by changing up her materials (from enamel to oil and back again) and esthetics to best suit her ceaseless quest for originality. While her work is clearly steeped in an in-depth knowledge and care for both art history and pop culture, she is not interested in using exact source materials. Hers is a fusion of figuration and abstraction, landscape and narrative, all drawn entirely from her imagination. "There are no sources. It's totally invented. I have a good visual memory and feel like I can sense when things are cribbed. And there's nothing wrong with that but what I'm interested in is looking for the new. I have tons of art books and get them out at different times, but more just to prop me up and tell me, 'It's OK.' I need voices to say, 'You can do that, it's legal.'"

In keeping with Surrealism's championing of the unconscious and rebellious mind, for a long time Essenhigh relied on automatic drawing, applying initial brushstrokes intuitively that imbued her work with a liberated fluidity.

Then, through a process of free association, a story would unfold to her, steeped in symbolism and observation. Myriad interests are apparent, ranging from Greek and Roman mythology, such as her paintings *Daphne and Apollo* (2013) and *Diana* (2010), to fairy tales, anime, and graphic novels, as can be seen in *Stubborn Tree Spirit* (2012) and *Green Goddess II* (2010). She has long embraced disquieting fairy and god-like beings, but they are as likely to pop up floating in a moody, blackened sky or riding a green ocean wave as they are to be downing drinks in a Midtown bar at happy hour or spicing up the subway at rush hour.

Indeed, her adopted home has proved a strong and recurring playground in her work. The way a golden sunset hits Seventh Avenue just so can, for Essenhigh, turn the West Side into an anthropomorphic, moving being, as depicted in *Manhattanhenge* (2018). Her site-specific work at NYC's The Drawing Center presented a posturing stand-off between the city's classic cast-iron façades and the shiny, glassy newcomers on the block.

"One thing that is a constant is that it's got to be new. I'm looking for a way forward," she explains of her shape-shifting sensibilities. "I do have a recognizable touch. It's a gift to do something that looks like my work no matter what I do. So, I've given myself full permission to abuse it and have made a lot of different types of work. For some people it can be confusing, but the problem with sticking to one thing is that your truth can change."

More recently, Essenhigh has moved away from both the cityscape and automatic drawing to focus on a natural world steeped in heart-melting perfection. For Uchronia, her 2019 solo show at Kavi Gupta Gallery in Chicago, she created a pastoral utopia that reminds us of our own fast-fraying coexistence with our planet. Each painting presents a vision of a potential future, filled with faun-like humans and luxurious vegetation. In *Welcome to the Gather-n-Hunt, a Family Restaurant, 3500 CE* (2018) we step into an eatery mimicking the lifestyle of our

Midsummer Night's Dream, 2017
Enamel on canvas
32×80 inches

Mesolithic ancestors. In *New Jersey 2600 CE* (2019), living creatures are absent but the golden underground domes they inhabit remain, surrounded by huge blooms in accentuated colors. And in *Fragments from a Nature Cult, 2087 CE* (2019), we see elements of what's left from an ecological movement we could only dream of in the present day. Are these glimpses of an idealized yet plausible tomorrow, or realities that what will only come to pass once our current epoch has achieved extinction? Either way, the works are not meant as portals to abscond from reality. On the contrary, they're the change she wants to see.

"It's not escapism," the artist says, referring not just to this series but to her work more generally. "My husband used to go to Iraq during the war to make art about it. That's when I started to withdraw even more into my own imagination. I always wondered if this was escapism, and it may have started out that way, but for me it's the only way to create change in the world. To give an obvious example, can you imagine what peace might actually be like? It would take all of your imagination to work out what that might mean for you, and you'd have to experience it on some level if it was something you wanted to bring forth in a painting. So, on an unconscious level, it becomes a possibility."

Inka Essenhigh

Essenhigh's 2021 exhibition at Victoria Miro Venice ventures further still into an arcadia-like land with an entire focus on flower paintings. Here, humanoids disappear altogether, now personified as botanical forms. Based on real flowers, her flora and fauna are amplified to take on an animated and spiritual energy not found on this planet. These are luminous organisms ripe with personality, their saturated colors lit by a heavenly source. In *Bleeding Hearts* (2021), erotic blooms in a vase drip with baby petals. In *Blue Field* (2021), flowers become galaxies, black holes, and hero characters in their own right, her fine, suggestive lines quivering with potency and divinity.

It's Essenhigh's willingness and ability to indulge in beauty and let go of reality that sets her apart from much of the contemporary art world. And she's well aware that playing with imagination could easily be seen as kitsch. But the artist argues that the fantastical realm has given the world more pause for thought than it's often given credit for. "I bump up against taste a lot. But if your definition of kitsch is something that's fake, a feel-good trinket, then there's so much abstract kitsch out there that means more to me than a lot of figurative paintings today. I would hold that Frank Frazetta is more original than most living painters."

Essenhigh readily admits she has "an axe to grind" on this topic. So, when it comes to her own work, she is resolute in her mission to forget about tired arguments of high versus low and, as always, let her intuition guide her. "Fantasy paintings of fairies and imagined spaces aren't edgy. Sometimes I want to eliminate unnecessary edge, and that can be a really uncomfortable place for people in the New York art world. But I want to find something that feels good. When I was younger, I wanted to have that raw, hitting home thing. But then I questioned that. Why does art have to be gut wrenching to be important? I think there's something else that a work of art can do. If you don't like your world, you can look at a painting that's more chilled out and that will help you to deal with it."

Orange Fall, 2020
Enamel on canvas
72×96 inches

Going further still, the artist sees her practice as moving way beyond getting in the zone. It's a deep dive into her own self where the line between real and unreal, or even you and me, becomes entirely blurred. "It's hard for me to talk about because it can seem so meaningless to use words like 'surreal' or 'collective unconscious.' William Blake would call it 'the realm of the true imagination.' I don't have a better way to describe it than that, but sometimes I feel like I can go into an imagination that has a physical-like aspect to it. It can physically alter me."

While she does not pretend to believe that the viewer of her works will necessarily experience or even understand them in the way she might, Essenhigh does think that the ultimate measure of a painting's worth is its ability to let you in, to see beyond it, and to feel. This is a quality she looks for in other people's work as much as her

own. "Some artists have a beautiful touch and I love how they move paint around. But if you couple that with something that they're bringing through from the unconscious, that's what really does it for me. That's when a painting I'm looking at feels genuinely sacred. It's a moment that passes through you for a split second—and then it's gone. Your critical brain takes over and breaks it down. I can even doubt myself that it happened."

Putting it another way, and coming back to the idea that art should lead you towards the light, or even just make you happy, Essenhigh hopes her gut is now finely tuned to that higher frequency. "There are so many ways a painting can talk to you. One way is that it can make your eyeballs soften so that you can drink it in. There'll be a quality to the creativity of the work that has nothing to do with the content, and when you see that it has that *thing*, your whole body gets drawn forward and relaxes. I've come to trust those sensations more than my brain."

Amir H. Fallah

"It's scary, man. I've never been this scared my entire life. And I was born during the Iranian revolution," says Los Angeles-based artist Amir H. Fallah about the years-long coronavirus pandemic. "I was talking to my mom and she was like, 'this is exactly how it was before the revolution. It was complete chaos. Nobody knew who to trust and there were different factions of people fighting each other, even if they were on the same side.'"

Although *Science is the Antidote, Superstition is the Disease* (2020) was started before COVID-19 became an all-encompassing reality, it is one of Fallah's most prescient works to date. The monumental 7 × 20-foot diptych is a collage of energetic vignettes that negotiate images of truth and denial, words that are likely to resonate with his audience. Unfolding across the center of the painting, like a hinge holding two panels together, is a 17th-century map of the world. On close inspection, this antiquated illustrated world bears little resemblance to the satellite images of Earth today—early cartographers thought California was an island. But Fallah does not want us to dismiss the map for its inaccuracies. Instead, he encourages us to embrace it in the context of its scientific pursuit of truth.

"I painted it because a lot of people's frustrations with science is that it's not static," says the artist. "It is always changing. It's never the one truth. It's a truth that's being added to, revised, and is evolving. And I think a lot of people don't like that because they want science to be like religion.

"In Los Angeles, I feel like everyone I know is a healer or an empath. They've all turned into shamans overnight. And these are super-liberal people who, I guess, used to believe in science, but now everybody's fixing cancers with crystals. Nobody believes in science anymore. But then, halfway through making this painting, I realized that there was this other group of people that literally don't believe in anything that science says. They don't believe in scientists."

Haunted And Hunted, 2018
Acrylic on canvas
36×24 inches

Amir H. Fallah

A devout atheist, Fallah treats religious and spiritual iconography as material history in his graphic-art-style paintings. An ecclesiastical stained-glass window or meandering minaret is as likely to appear as a microscope or double helix.

Born in Tehran in 1979, Fallah moved with his family to Turkey and then Italy before settling in Fairfax, Virginia, in the late eighties. His experience of displacement as a young child, codified by the immigrant experience, is a theme that underwrites many of his large-scale works. The artist became interested in portraying the experiences of people like him, who moved to the US from elsewhere, a theme he explores in his *Veiled Portraits* series. For these works, initiated in 2011, he visits the home of a subject and covers their head in a blanket or sheet to conceal their age, gender, and ethnicity. Through this process of anonymization, the artist shifts the gaze from his subject's physical appearance onto the narrative clues he scatters across the rest of the image—and his paintings reward diligent inspection. A gold ring, potted plants, sports trophies, porcelain plates, and other memorabilia and heirlooms signal the identity of the person beneath the sheet, or leave us guessing. Operating in contrast to traditional Western art, the artist-biographer presents an alternative vision of portraiture that uses personal artefacts without facial representation to confront themes of trauma, immigration, and race.

Considering that every portrait Fallah makes is accompanied by hours of careful interrogation into the lives of his subject, the artist will be the first to admit that he has a problem leaving out the details. "With painting, there's no speeding up the process. It's going to take a long time," he says. "So, during the pandemic, I started making drawings. I was thinking it'll be looser, faster, and finally I can make some work that I'm not spending a month on. By the end of the quarantine, I had managed to make these tiny drawings super tight, super anal, super embellished. And I was back to square one. I was spending two weeks on a little drawing."

Why I Make Art

He says he is constantly trying to channel his inner Abstract Expressionist—albeit to no avail. "I love abstraction. I love loose gestural work and I'm just so jealous of those artists that can go into a studio and start and finish something in one day," he explains. "I know they have to make multiple pieces that they have to scrap. I know that it's a process of editing, but I'm still jealous because I have to wait at least a month to get that dopamine effect of 'Oh, I finished something today.'"

Over the last decade, Fallah's prolific body of work has joined the permanent collections of the Los Angeles County Museum of Art, the Xiao Museum of Contemporary Art in Rizhao, China, the Microsoft Art Collection in Washington, and the Salsali Private Museum in Dubai, among others. He has exhibited extensively in solo and group exhibitions across the US and abroad, and has been the winning recipient of multiple California public art commissions.

"That's something you can't teach anybody," says the artist of his work ethic. "People are either hungry for life, in all respects, or they're not. I watched my parents rebuild their lives three times before they were even 40 years old. I saw what hard work looked like. My father is one of the hardest working people I know. He came to America with $72, a five-year-old, and his wife, and literally in one generation my parents did what most people would take many generations to do."

His parents' resilient commitment to achievement took root in the young Fallah. "When I got more into art, I was around 12 years old. I wanted to get better at graffiti so I started taking art classes in junior high. I realized I was a little bit good at it. I made a banner for school, I won some sort of art prize for it, and it gave me that little boost of motivation I needed to take it more seriously. By the time I was in eighth grade I knew exactly what I wanted to do. I knew which college I wanted to go to. I was like, 'I'm going to be an artist. I'm going to sell artworks and show in galleries.'"

Science is the Antidote, Superstition is the Disease, 2020
Acrylic on canvas
84×240 inches

By the time Fallah switched coasts to pursue an MFA
in painting at UCLA (having received a BFA from the Maryland
Institute College of Art in Baltimore in 2002), the contem-
porary art scene in Los Angeles had just come off a wave of
fin de siècle creativity. There was a re-punking of the art world,
led by radical figures such as Paul McCarthy, Lari Pittman,
Catherine Opie, John Baldessari, and Chris Burden. All of
whom, as luck would have it, happened to be Fallah's tutors.

"You have the dream team of artists teaching you,
you know? It was insane—and that was just the full-time staff,"
he says. "There were others. Visiting teachers included Laura
Owens, Elizabeth Peyton, Matthew Barney... To be 23 years
old and literally have your art history book come alive with all
these people giving you their two cents, I couldn't handle it."

The way Fallah tells it, he struggled to find his artistic voice under the "quiet pressure" of the world-renowned artists who frequented his classes. Their disparate fields and contrasting approaches confused him. Eventually, he decided to "just listen to everybody. What I ended up with for my thesis show were these horrible paintings of piles of rocks and empty rooms. The work was devoid of all creative content. I was the textbook definition of how not to do grad school."

Arguably, another way not to do graduate school is to helm a magazine with nine full-time staff and 50 free-lancers. But by the time Fallah reached university, *Beautiful/Decay*, the art and design publication he had co-founded in high school, had taken on cult status. "It was also a big

distraction. It was an art project that just got out of control and turned into a real business. So a lot of the people that I met through grad school started seeing me more as a publisher than an artist." He asked himself: "Do I want to promote other people's work or do I want to work on my own?"

In the years since, Fallah has honed a distinctive style and regularly cites Francis Bacon, Henry Rousseau, and Dutch and Flemish Golden Age painting as esthetic influences. Suspended in a cultural limbo, his paintings borrow from high and low art. Byzantine mosaics and lavish arabesques feature as heavily as comic book characters, a logo from a vintage matchbox, or newspaper headlines; the decorative legacy of Persia is met with a color palette straight from the Pop Art playbook.

These cultural dialogs that Fallah playfully sweeps into singular bodies of art culminate in *Remember My Child...* (2020), *a* series of ten paintings that touch on social issues, environmental concerns, immigration, and animal welfare. Each work takes its name from a set of guiding principles that Fallah wrote for his young son.

Remember My Child... marks a new chapter for an artist who has never seen his work as overtly political. "That's been the balance of this work. How do you make something that's addressing these issues but not being overly preachy?" Asks Fallah. "I don't know if I'm striking the right chord, but I'm thinking about that a lot. Because sometimes you just want to shake people and be like, 'Wake the fuck up.' But then you don't want to be the asshole. It's a fine line."

Louis Fratino

Louis Fratino's autobiographical work challenges conventions in a discreet way—they're fairly small. For his first-ever solo show in 2016, he presented paintings that weren't much larger than US letter size (8.5 × 11 inches). "When I moved to New York City I was working on the dining table of our sublet and that's sort of why I made that first show with such tiny paintings," says the artist. "Which was fortuitous in a way, because that's all I had. I think that's part of what made that show really good, it's the part that people liked. It made me take a step back and say, 'This tiny work is really important and maybe it's actually a bigger part of who I am as a painter.' Whereas before, in school, I was making these large paintings and beating my chest."

Since graduating with a BFA in painting from Maryland Institute College of Art in 2015, Fratino has made quick work of getting his sensitive oil portraits of gay male life shown in galleries across the US and Europe. The Brooklyn-based artist plunges the viewer into emotionally charged scenes that portray his interactions with family, friends, and lovers. Most notable are his visions of domestic bliss. Lovers recline in each other's arms under dappled sunlight; a tangle of shaggy legs emerges from a rumpled comforter; a discarded jockstrap and gym socks hint at sexual satisfaction. Fratino adeptly works the male body into arresting landscapes of fleshy, geometric forms that critics have likened to the works of Picasso and Matisse. But, importantly, he inverts the heteronormative gaze of these twentieth-century masters by foregrounding the young male nude.

To this point, the artist sees his quasi-miniatures as a rejection of what he describes as the "macho quality" of Picasso's work, in how it depicts female bodies and also how large-scale works tend to flirt with self-aggrandizement more generally. In contrast, Fratino sees the small painting as a queer object in itself, intimate and demanding legitimacy without taking up space—though he didn't always see it that way. "I thought smaller paintings were secondary or

Metropolitan, 2019
Oil on canvas
60 × 94 ¾ inches

studies," Fratino explains. "But after that show, it affirmed that they were super powerful. I realized that it was almost political to choose to make work so small."

Good things may come in small packages, but Fratino is aware that "It's harder to make a really good small painting because you're not just relying on visual impact." He figures that miniature works must be of substantial artistic value in order to overcome their perceived size disadvantage. "Paintings I love throughout history do that. Like Vermeer. I don't think I've ever seen a large Vermeer painting, and his are the best paintings I think I've ever seen."

Much of the iconic work for which the Dutch old master is known, such as *Girl with a Pearl Earring* (c.1665), stand no taller than 18 inches. It has also been calculated that the total surface area of Vermeer's artistic output is almost identical to Rembrandt's ambitious masterpiece, *The Night Watch* (1642).

In the same way that Vermeer poured years into capturing the interstitial moments of everyday life, Fratino deftly

executes small details throughout his work. In *My Meal* (2019), a wooden dining table fills the canvas. Laid across its surface is an artist's potluck of painting utensils, writing implements, a still life, and a few sketches. What sets this piece apart from the artist's usual work is that there is no human subject matter, only the detritus of human activity. Even without a person in the frame, *My Meal* maintains the artist's characteristic sense of intimacy by letting the viewer in on a secret: the camera, photographs, and studies scattered across the table are narrative clues about his artistic process.

"I like drawing more than painting in a way—it's so much more immediate and I've been doing it for longer," he says. "I make scores of drawings per day and then maybe one or two of the drawings I make into a painting. A lot of the time I'm drawing from my memory, imagination, other paintings, or photography. Not even necessarily photographs I've taken but from artists I like, such as George Platt Lynes or Peter Hujar."

In 2017, Fratino exhibited his charcoal sketches for the first time alongside his painted work. The drawings, which pulsated with the same sensual candor, proved to be the cornerstone of an artistic process that goes back to his school days. "I feel like my teachers were always really irritated by how much I was drawing, but it helped me remember what they were talking about during lectures," he says. "You know, you can have a phone conversation and doodle and not be absent from the conversation. I love drawing on the phone because it's a little bit more re-moved. I'm less in control of the subject matter because I'm paying more attention to the phone conversation. So the drawings are often strange and even surprising."

By letting his unconscious mind guide his hand, Fratino is able to render concrete experiences into evoc-ative vignettes that look as if they were taken from a half-remembered dream. The artist continues to extol the virtues of the subconscious mind by drawing attention to

a pioneering American abstract painter. "Agnes Martin talks about getting to this place where you're not thinking at all, which for me, outside of artmaking, is difficult," the artist says. "It's hard for me to fall asleep because I'm thinking about so much but when I'm drawing or painting, the thoughts disappear. I had this experience so much more before I had a smartphone. I could be working on something for four hours and it would feel like 25 minutes. A lot of people have a spiritual practice that's about getting to that place."

And when inspiration does strike, it is all-consuming. "What I relate to more is when you get so hungry that you're not hungry anymore. It's like you're numb to your hunger," says the artist. "This happens to me a lot in the studio because I'm like, 'I really need to eat lunch but this painting... Maybe I'll just do a little bit more.' Then it's 4.30 p.m. and I haven't had a meal since 8 a.m."

Fratino may spend most days painting in the industrial crush of Bushwick, where his studio is, but his thoughts are never far from his home state of Maryland. "I think I developed an appreciation for cities that are not always in the forefront," Fratino says, recalling his student years in Baltimore. "I feel like a lot of cities on the East Coast have this feeling that they've been left behind a little bit or like at one point they were so much wealthier. There are so many problems associated with that but they're extremely beautiful. There are these mansions along the reservoir in Baltimore that are sort of neglected and you feel like you're traveling in time."

The artist in fact uses painting as a time travel device to revisit landscapes and people from his past. Drawing inspiration from his local environment, his multiple relocations—from his hometown in Annapolis to Baltimore, then a Fulbright scholarship year in Berlin to New York City —have affected his work over the years—though he's hard-pressed to say how.

"I think it's hard for me to notice how my work changes," says Fratino. "It's like growing up. I have a lot of

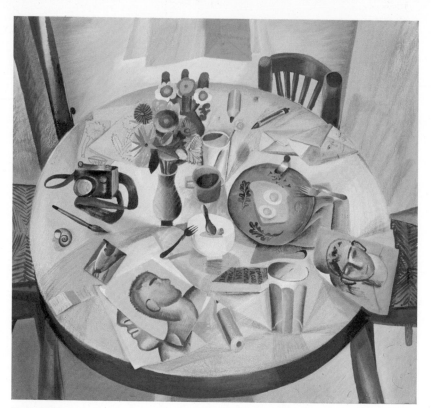

My Meal, 2019
Oil on canvas
43×47 inches

siblings and they obviously have changed so much. All being kids together I don't notice them changing until someone points it out. I feel the same way about the paintings. Bit by bit, painting by painting, from point A to point B, they're dramatically different but it's really hard for me to know how or why."

The painter's 2019 solo show, Come Softly To Me, was a visual ledger of how his life and art have transformed over the years. Fratino's typical figurations of domestic spaces gave way to paintings of a more urban design; outlines of Manhattan Bridge and the Chrysler Building exemplified his new environs. The contrasts did not end there.

On the gallery floor, an image of his mom trying on a velvet dress hung a few feet apart from an image of the artist enjoying penetrative sex. In addition, a pearlescent painting of his newly born niece shared the same corner as a fluorescent depiction of a hedonistic nightclub scene. These false juxtapositions are telling of an artist who sees family and his sexuality as part of the everyday, or, rather, as celebrations of the everyday. Fratino does not believe the teardrop pre-ejaculate or swollen members that court his canvases are irredeemably salacious, but he is not oblivious to the effect his work has on some viewers.

"I watched *The Decameron* by Pasolini and I made a couple of drawings from just the stills because it was so good," says Fratino. "I want my paintings to be like the film, charming and sweet but also really disgusting and super perverse. I don't think my work does that all the time, or maybe at all, but I think there's a clash. Sometimes it's easy to digest and you could show your mom, but the subject matter or the subtext is not something you want to talk about with your parents or show your children."

While the imagery that catapulted Fratino's work onto the international stage may be of intimate moments from his private life and thoughts, the viewer never feels like an intruder. His oil paintings resonate across the emotional register to create a consensual ménage à trois between himself, his partner, and any gallery-goer who might pass by his work.

"It's very accurate to how I feel in the world sometimes," Fratino continues about the contrasting nature of his art. "Like, you're presenting yourself in a certain way all the time but you also lead your life, which is not always charming, not always beautiful. It's sometimes ugly, sometimes embarrassing. I want the work to be like that."

Dominique Fung

Dominique Fung's sensuous and surreal oil paintings take the tropes of orientalist art in unexpected and darkly delicious directions. Her practice is an alluring critique of the fetishization of Asian women and Asian cultural objects by the Western gaze, and a zone for her to explore her own experiences as a second-generation Chinese Canadian. Simultaneously decadent yet confrontational, her large-scale works bring together a bricolage of the ancient and the contemporary to create new metaphysical allegories.

Fung was born in 1987 in Ottawa to parents from Shanghai and Hong Kong who hoped for her to become a classical pianist, but her interests did not match their aspirations. "There's this prestige to playing music but I found it super dull," she recalls. "I wasn't a good pianist." Her passion lay in drawing, so she spent more time making art than improving her scales. "I remember practicing the double clef with one hand while sketching with the other."

She attended an arts high school where she learnt ceramics and printmaking and fell in love with painting. Soon enough she'd convinced her parents to turn their basement into a studio, but was still only doing art as a hobby. "I'd be painting this seven-foot dragon on the floor on a mason board and they'd be like, 'What are you doing down there? You should be playing piano.' I don't think I was super talented at art but I had the drive to get better. Being in the sort of school environment where everyone is so talented was very motivating."

Fung went on to study illustration at Sheridan College Institute of Technology in Oakville, and after graduation in 2009 she worked in quality assurance for a tech company in Toronto. "It was my job to go through the system and log the bugs. I did that for a year of my life until I was like, 'I can't do another minute of this,' and quit. After that, I focused on getting freelance graphic design gigs so that I could afford to paint, because I've always known I wanted to paint. I was able to get my first little studio and met my first group of friends in the art world. And that's when I realized I could

Why I Make Art

Will you keep singing?, 2021
Oil on linen
94×78 inches

actually be a painter; that people do this. We were all around the same age and working together toward getting shows."

The artist developed her practice with a focus on figurative painting. Early Baroque and Rococo influences such as Vermeer, Rembrandt, and Goya collided with an interest in women Surrealists including Leonora Carrington and Dorothea Tanning, as well as Louise Bourgeois and Frida Kahlo. "I painted a lot of portraits. My style was very tight. I wasn't trained in an institution of fine arts, so it was a free-for-all from the beginning, and I thought really tight artwork meant fine art, right? Then over time I've loosened that up." Eventually Fung felt she was getting too comfortable, and so she and her husband relocated to Brooklyn in 2016. "I wanted to expand, so I took a leap of faith to come here, and the number of artists I've met is incredible. The art scene is just so big. I had no idea."

Since then, Fung has enjoyed solo shows at Taymour Grahne in London, Ross + Kramer and Jeffrey Deitch in New York, and Nicodim Gallery in Los Angeles. Her numerous group shows include the Galeria Nicodim in Bucharest, Romania; Schlossmuseum Linz in Austria; Woaw Gallery in Hong Kong; Asia Art Center in Taipei, Taiwan; and Project Gallery in Toronto. Her work is in collections that include the Cantor Arts Center at Stanford University, California; Los Angeles County Museum of Art; the Institute of Contemporary Art in Miami; X Museum in Beijing, China; and the Yuz Museum in Shanghai, China.

"My work has always been identity-based. I'm just navigating the waters and slowly piecing together bits of my identity through painting," Fung says of the journey she's taken to explore how her own view of her Cantonese heritage has been veiled by orientalism. "At 19, I was painting these images of things from China even though I didn't understand why I was doing it. And with the figures, it was these Asian women in these sad pond pools. Looking back, I was trying to grasp at this loneliness. It was coming from a place of feeling like I didn't belong to

Canada or to Hong Kong. I remember visiting Hong Kong for the first time when I was 15 and a taxi driver said to my mom, 'Your children aren't from here.' The paintings always go back to that alienation on both sides. Not being American enough. Not being Chinese enough."

This exploration expresses itself on her canvases in lush, honeyed colors and sumptuous brushstrokes that build into seemingly genteel scenes that draw you in only to unsettle you moments later. A woman's face might be obscured by a decorative fan—or her whole body bloodlessly dismembered. One recurring theme places women in bathhouses and immersed in water. *I'll Tell You a Story But You Won't Listen* (2017) depicts two naked, anonymous women lounging around an inviting blue bath filled with fish. Next to them are two ceramic foo dogs and an ornate rug strewn with fruit. All is calm and beautiful but the viewer senses that something is amiss in their enjoyment of this seemingly romanticized scene.

This painting, and others such as *Jade Dragon Bathhouse and Spa* (2017), *Access to a Warm Space for Bathing* (2019) and *A Half Inch from the Tip* (2019) use the bathhouse to comment on the uninvited and othering gaze focused on Asian women. The bathhouse is traditionally a safe place for relaxation and community and an environment that the artist personally treasures. For Wash Your Corners, her 2019 solo show at Ross + Kramer in New York, she realized a dream by creating a room-sized bathhouse installation. And yet in these works, the viewer risks becoming a voyeur by using these seemingly passive women for esthetic enjoyment.

Elsewhere, the female form disappears to be replaced by comely ceramics, such as *Alluring Vase* (2018), which imagines a peach vase with a vulva-like slit surrounded by falling rose petals, and *Three Legged Vessel* (2020), a porcelain pot decorated by a dragon and adorned with a wig. This reflects Fung's interest in how Asian antiquities are displayed in international museums without accurate

The Largest and Most Formal Meal of the Day, 2021
Oil on linen
78×94 inches

context, and in how they got there in the first place, often the loot of imperialist exploration that has resulted in centuries of misrepresentation.

A key text that has deeply influenced the artist's thinking is *Ornamentalism: A Feminist Theory for the Yellow Woman*, by Princeton professor Anne Anlin Cheng. The essay examines how Asian woman have been simultaneously sexualized, synthesized, and commodified by orientalism. It criticizes the Metropolitan Museum of Art's 2015 show China: Through the Looking Glass for its assumption that tangible presentations of decadent, feminine, ornamental sensuality are the defining attributes of Asia and Asian culture, stripping away the possibility for nuance and complexity in national identity and history.

For Fung, this struck a chord with the ideas she was already investigating. "Cheng talks about how Asian women are perceived as porcelain objects and how our bodies are contained within these objects and being viewed culturally, through media, through images and paintings. I had only come to that reading as I was painting bodies as objects and objects as bodies. Now I'm slowly unravelling my identity through painting these artifacts I'm looking at."

As such, Fung has begun to imagine more fully what lives and agency can be reinstated into these displaced objects. For example, *Vice* (2021) gives a lustrous celadon vase a smoking habit. She has also evolved her practice by making ceramic sculptures that are incorporated into multimedia installations. This expansive approach draws on ancestral memory, historical art such as Dunhuang frescoes, museum artifacts, and contemporary culture to create her own explosive cabinet of curiosities. And if this wasn't dizzying enough, her playful distortions of perceived gravity and perspective further stretch the boundaries of her paintings. "For me now, I'm just painting an amalgamation of things and trying not to put myself in any categories. I'm not having to paint an Asian American woman in a scene. I'm allowing myself to be drawn to specific images or objects and then placing them in the work and figuring it out."

At her 2021 solo show at Jeffrey Deitch in New York, It's Not Polite to Stare, this move into new mediums saw her fill a room with found Chinese birdcages inside which she placed a series of anthropomorphized ceramic sculptures. A nod to the pastime of elderly gentlemen in Hong Kong who take songbirds for a walk in the park, it's also a reminder of how caged and observed the Asian woman can be. Meanwhile, the painting *Double Happiness* (2021) depicts two vases in a glass case that is riddled with bullet holes. This work came as a response to the rise in violence against Asian Americans during the COVID-19 pandemic, and specifically to the 2021 Atlanta spa shootings that

resulted in the murder of six women of Asian descent by a White man who claimed they were a source of sexual temptation.

However, there is also much joy to be found in the crossroads of cultures that Fung explores. The artist is discovering more about herself and wants to celebrate her dual heritage through the rituals that tie her to it. "There's this side of my culture that is amazing and beautiful. That's why I place food in my work. I'm trying to grasp at those connections," she reflects. Hence the monumental painting *The Largest and Most Formal Meal of the Day* (2021), which presents an eerily exquisite feast of lobsters, fish, and tea around a slyly smiling suckling pig in the process of being cleaved in two. While Cantonese cuisine has long been diluted and appropriated for Western consumption, this seditious spread remains tantalizingly untouchable.

Karel
Funk

Karel Funk understands the value of taking your time. The Winnipeg-born artist's paintings are rich with time, humming with the many hours of concentration spent on each work in his basement studio. "I want the paintings to be a very slow narrative," he explains. He'll work on one painting at a time, and each suite of six or seven works, he hazards, can take up to a year and a half to complete. Deceptively simple, Funk's paintings of lone individuals—frequently young people, often pictured from behind or with eyes closed—reference Renaissance paintings in their verisimilitude, reproducing contemporary urban fabrics as faithfully and lushly as a bolt of velvet in a Girolamo Savoldo.

Each of these portraits is untitled and numbered, because, the artist says, "If I gave them too many words it would be like a window into a larger narrative. So I started doing *Untitled* with numbers and now I'm just committed to it."

"In the past it has stressed me out, because I've always worried about productivity, I paint so slow," he says. "I have some friends who paint in watercolors and they produce a ton of work. It's just different, the nature of studio work. So I worry about that, but now I try not to think about it. Sometimes the gallery has to remind me—'Oh, is this number 86 or 87?' And that's good. Fifteen years later, I've done 85 paintings."

Funk did his undergraduate studies at the University of Manitoba in his hometown of Winnipeg and then moved to New York City to attend Columbia University for his MFA in 2001. The city had a profound effect on the fledgling artist and his developing practice.

"The beginning of this project was formed when I lived in New York and it kind of happened by chance that all these pieces came together. I love Renaissance portraits, and coming from Winnipeg there just wasn't the Metropolitan Museum of Art, there wasn't historical paintings like that to be viewed, so I was going to the Met as much as I could," he says.

Untitled #98, 2020
Acrylic on panel
27 × 30 ¼ inches

New York's size and complexity were also instructive, as was the opportunity to be anonymous while still in daily proximity to the city's inhabitants. "You know, the urban density was something new for me," he explains. "Winnipeg is a medium-sized city in Canada, there's 800,000 people, which sounds small but for Canada it's bigger. But the density of New York was just overwhelming. It felt cool to be there. Just being on the subways, that experience of being rammed shoulder to shoulder with strangers and being able for a minute to be a voyeur. You can do it in those moments."

That sense of elevated observation is evident in Funk's portraits. *Untitled #12* (2005), for example, depicts a young man from behind, wearing a jacket and trucker

cap on backwards, the pink of his ear and a few wisps of hair at the nape of his neck deftly rendered in acrylic paint. The combination of the painting's unexpected, intimate viewpoint and meticulous paintwork make the young figure in sportswear seem unexpectedly vulnerable. Other, more recent paintings focus solely on hooded jackets seen from the side or behind without any visible human form, Funk instead telegraphing physical attributes and mood through posture and gait.

The genesis of this particular way of seeing, the artist explains, was a serendipitous meeting with a friend in New York.

"It was a really cold day on Columbia campus and he had his jacket up, and the hood was covering his head," Funk says. "You could just see his nose and his mouth, and I thought it would be a really interesting portrait. So I photographed him and painted it. It wasn't until I started doing a couple more portraits in this format that I realized this could be an interesting combination—a portrait of urban life but also the isolation you can feel in a large, high-density city center.

"And then, maybe there could also be a bridge to the past and to the present through these modern, Gore-Tex, synthetic plastic materials that these outerwear jackets are made from. So it's kind of all of that: isolation but urban density... finding shelter in a busy life in a crazy world. It also strangely reflects the studio environment, too—by myself, six, seven hours a day, a couple of months on one painting to finish it. There's a quiet, contemplative feeling in the studio."

Studio time for Funk has an almost sacred quality; the hours and the labor he puts in are critical to his process, as are trial and error. "This doesn't happen as much as it used to, but I would be working on a painting and sometimes, say, six weeks in, I'd know that it just wasn't working out. So sometimes I would have to just sand down an area or sometimes I would sand down the whole painting—in

the backyard with this palm sander. Off into the wind goes all that work. But you have to self-edit, so it happens." It can be a form of self-acceptance, he thinks, to know "what works for your personality, what's inside of you that is how you see value."

And while Renaissance portraiture has been enormously influential, 20th-century painters have also been significant to Funk's style and practice. His decision to work with acrylics as opposed to oils was an early discovery.

"I painted in oil before I started painting with acrylic. I wanted to paint like Lucian Freud," Funk says. "There was this Lucian Freud book lying around the Art Barn at the University of Manitoba—that's where we painted when I did my BFA back in Winnipeg—and the whole wet into wet process just did not work. I had no control, everything turned into a mess. I couldn't figure out colors that way. So I started using acrylic, and it was really just trial and error, through letting acrylic do what it wants to do—which is dry quickly—and layering it, so I was able to do it in one day. You could do 100 layers if you wanted to. It allowed me to slow things down."

Back in undergraduate studies, he recalls looking at a lot of American Regionalist artist Andrew Wyeth's work, his watercolors in particular. "Some of his watercolor studies were almost half-finished and you could see how he was locating space and how he would build up information. That seemed to work for my personality, so I started to block in things with simple stains. Eventually the painting gets more dense and the information gets a little more thick and pronounced as the painting progresses. It was me finding my way through it."

For Funk, painting is a necessity, regardless of what else is going on in his life. "Even before I was painting professionally, I always had that feeling that I had to be producing. When I graduated from my BFA, I was working part-time as a janitor, and between shifts I was painting because I just had to do it. I loved doing it, so I've always

Untitled #84, 2017
Acrylic on panel
28 × 35 ½ inches

had that drive. There's a business side to it now, which can definitely come into play when it comes to deadlines or commitments. But even if I have a lot of free time, or if I don't have anything coming up, I can only take so much time off before I'm like, 'I should just be back in the studio, this doesn't feel right.'"

Because of the painstaking approach he takes to his work, Funk can often feel concerned when something happens too easily. "Painting these little sportswear toggles on the paintings, and then draw-straps, can be really difficult for me sometimes, because it's a machine-cut hard piece of plastic, it's subjectively painted but I try to make it have certain edges. So in the past when I've painted one and it's come together really quick, I'll go, there's got to be something wrong, there's no way," he says.

When he's working, Funk listens to lectures on YouTube, or will have a well-loved film playing in the background. "It has to be a movie I've seen a million times so I don't really get distracted," he says. It's akin to listening to your favorite song 1,000 times. "You think about how much work goes into a movie, it's insane how much process there is behind that finished product. So I'm OK listening to a movie 30 or 40 times over the course of five years. You go nuts in your studio and you find ways to have fun."

A certain amount of time away from the artworld —whether attending shows or reading the latest issue of a magazine—is also necessary for the artist when he's in the painting zone. But similar to the subjects of his portraits, his moments of cloistered concentration exist in a tension with the outside world and all of its clamor and intrigue. "I'll come out of that period of work for a while and go wow, I haven't been back to New York or to an art center for a long time," he says. Then he'll get out there and reengage, his impressions of the world filtering over time back into the studio.

On Music

I kind of gave up art for a time, especially when I was in the punk scene. I put out some zines with friends of mine. For me art was just too bourgeois. I just couldn't relate to four white walls and Chardonnay.

—Fred Tomaselli

In high school, somebody gave me a Miles Davis record, *Bitches Brew*, and I couldn't hear it. It was too crazy. By the time I got to college, I put it on again and I'd taken LSD and it made perfect sense.

—Chris Martin

Ambient music is so visual. You're able to get a sense of how sound can also talk about volume and mass and fullness and emptiness.

—Jason Stopa

I think about Pete Townsend doing windmills—that's what I feel like when I'm painting.

—Ellen Berkenblit

In the eighties there was this idea that you could make painting that was like rock 'n' roll. And it was a bad idea. Because painting isn't like rock 'n' roll.

—Joe Fyfe

The Talking Heads and Blondie broke through, and it gave me a sense that there was something cooking out there. As soon as I got to art school I immediately got a crazy haircut and went to hard-core clubs and mosh pits and the whole thing.

—Sean Landers

Even as high-school students, we were drinking acid-laced wine and listening to the Grateful Dead. We got an early start on all that.

—Stephen Westfall

vanessa german

When the visual and performance artist vanessa german speaks about the drive to create, she evokes another famed African American artist, turn-of-the-century singer Gertrude "Ma" Rainey, widely regarded as the Mother of Blues. "Ma Rainey tells a story about stealing the blues," german says. "Do you know that story?"

Born in the late 1800s, Rainey came up in the rural South, performing in the raucous Friday- and Saturday-night tent shows that preceded the Sunday morning church services. These were breeding grounds for what would become new musical forms. It was at one of these tent shows that Ma claimed to have witnessed a teenage girl walk through the aisle and erupt into song, talk-singing forlornly about her relationship with a married man. "Ma said it was like the girl was possessed and she had to let the story out of her soul, and Ma Rainey stole the blues, stole the style of talk-singing a story from that girl," german says. "One of the things August Wilson writes in Ma Rainey's voice [in the 1982 play *Ma Rainey's Black Bottom*] is that people think you sing the blues, but you're not singing it: you're bringing it up. You don't sing the blues to feel better; you sing it because you can't not."

For german, artmaking is alternately a source of healing and a mode of connection; a tool for activism and a means of self-understanding. The recipient of the 2015 Louis Comfort Tiffany Foundation grant, the 2017 Jacob Lawrence Award from the American Academy of Arts and Letters, the 2018 United States Artists grant, and the 2018 Don Tyson Prize from Crystal Bridges Museum of American Art, she's made her name with a sprawling multimedia practice that spans sculpture, performance, poetry, in-stallation, and photography, exploring themes of violence, injustice, spirituality, and care, and their intersections with the Black experience. A self-styled "citizen artist," she's assembled colorful, mixed-media effigies modeled on Congolese Nkisi sculptures from materials scavenged near her home in Pittsburgh's Homewood neighborhood

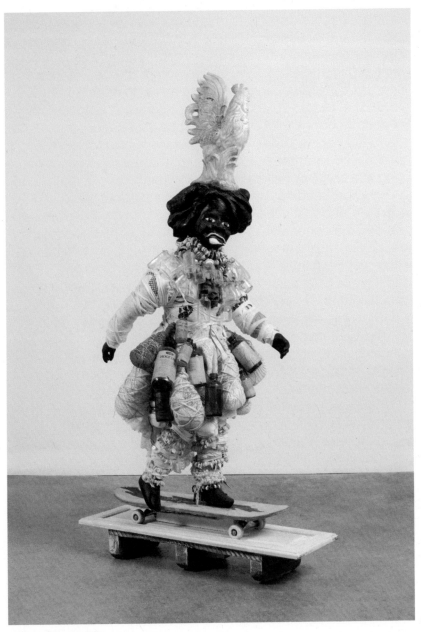

an ease to the sorrow, 2016
Mixed-media assemblage
67×21×36 inches

—bottles and beads, scraps of fabric and sculpted wood. She's led a procession of Black women dressed all in blue down the streets of Pittsburgh, Charlottesville, and Omaha with haunting solemnity to commemorate the loss of Black lives. She's invited strangers to take a seat in front of her and join her in conversation, creating a series of living poems borne from open collaboration, chance, and trust.

But german doesn't divide her work into disciplines, nor does she confine her practice to whatever she can bring to a stage or gallery space, or even the public realm. "I remember reading Anish Kapoor talking about scale and work, and that caused me to really walk into the adventure and the dimension of what scale means. There's scale in material and in the end-product or the work, but what is the grandest scale that I can occupy these ideas on? And the grandest scale that I could find to occupy the ideas was my entire life: my entire life and my relationships with the Earth and my relationships with other human beings and my relationships with the invisible world—the world of soul and spirit, and magic—and the world of everyday making," she says. "And that's the way I think about my life: as a grand sculpture."

The way she tells it, german was destined for the artist's life. Born in Milwaukee, she was primarily raised in Los Angeles. Sensitive and observant, she witnessed the city's inequities first-hand, including the early ravages of the HIV/AIDS epidemic and street violence. One classmate, she recalls, would unwind the bandage around his hand to reveal a healing bullet wound. However, in her school life she was also surrounded by "industry kids... professional, beautiful, shiny, glossy kids" who were models or starred in commercials, including a young Leonardo DiCaprio. Among their peers, german and her siblings (she is the third of five) stood out. "We were a little dusty, a little grubby. I was, I think, the nappiest, grubbiest, roundest, brownest of my mom's kids," she says. "We wanted to fit in, but we didn't. We were weird."

"Ever since I was a little kid I have been deeply sensitive. I would spend a lot of time as a child trying to figure out the origins of cruelty, because I would see people be cruel to each other, and I would try to process that. I would get bullied, and it wouldn't hurt me in the same way. It would just really make me curious. Because, when I was a kid, I was around people who died young, I didn't understand why, if it was possible for your life to just be taken away from you when you were 9 or 10 or 11 years old, you would spend any time at all talking about somebody's tennis shoes, why you would spend any time at all talking about other people. You'd have kids who would go home for the weekend and they would get killed, and so, as a kid, I would try to figure out what it really meant that other kids really were actually creatively cruel to each other."

That thoughtfulness was sparked and encouraged at home: german's mother, Sandra Keat German, who passed away in 2014, was a fiber artist, costume designer, and maker, and instilled her five children with a sense of creative purpose, modeling independence in a way that would prove formative. "My father would leave early in the morning and drive to Long Beach and go to work. A big part of our growing up was following my mom to flea markets and swap meets, and the fabric stores and notion stores and watching her gather materials. She would place them in a specific room that she would close the door to and venture into her own materials and into her own making. So I understood from the time that I was very little that you make your life," german says.

Sandra also made it clear that this life-making would be essential for them, too. "One of the ways that my mother raised us was to be functionally generative kids, which meant we cut out our own patterns for our own clothes, we made a lot of our own toys. You would make things that you wanted. We didn't externalize a lot of our needs, except for food. We didn't go to the mall and buy new clothes or new shoes, we would either adapt things that our parents got

January 17, 1991. (The Day that the First Iraq War Started.), 2021
Mixed-media assemblage
82×32×31 inches

Why I Make Art

from flea markets, or my mom would make stuff. And that's how she sort of kept us safe: she would put stuff all over the dining room table, and we would make books and we would record our own musicals. We were very creative children.

"I would say, 'Mommy, how do you make a braid?' And she would say you have to figure that out. And I would say, 'How do you spell this word?' And she'd say 'Well, get a dictionary and figure it out.' So that way of figuring out materials—like learning the language of material, and learning a language to my own ideas through materiality—has been for a long time like experiencing magic."

german still remembers the Christmas when she discovered that making could be not only practical but spiritually cathartic. At the time the family was living in Monroeville, outside Pittsburgh. Sandra had invited the children who were staying at their house to the stables she'd converted into her studio to make angels for their Christmas trees, and german was unmoved.

"I didn't want to make this prefab Christmas-tree-top angel that my mother had all these parts picked out for. At the time, I was depressed and I didn't understand why I was depressed. I really felt like a lucky person. I thought that I could understand more of what I was feeling, and what the blues and the browns of sorrow that were ensconced in me were about if I made work about that, if I just did something, as opposed to acting like that feeling wasn't there and investing energy into pretending."

Instead of joining the others, german went outside of her mother's studio and noticed an array of rusted nails and other detritus that had been discarded on the ground. Where others may have seen junk, she saw inspiration—even if she couldn't quite explain what for. "I picked up rusty nails and I picked up things that felt right to me, and I let that be OK just to make choices that felt OK to me. I crafted this figure by forming self-hardening clay over my thumb, and I poked holes in it, and strung

seed beads from it, and I used these nails, and after I created that, I felt better. I didn't necessarily feel less depression or less sad, but I felt like I understood my own hands and my own being in a way that was powerful. I recognized that I had tapped into what would be an extra limb of my life in this way of making," she says.

Another breakthrough moment came soon after, when german's figure was included in a show of her mother's work at a summer festival. A passing expert in pre-colonial African history took a look at her piece and remarked on its similarities to the power figures that craftspeople in the Congo had been making for thousands of years, and encouraged her to do more research on the subject. "That's what started me really creating objects, sort of like a pharmacist, where I would pull together compounds of materials, and I would pull together within myself, mustering up whatever bravery of language that I could, to allow the work to attend almost pharmaceutically to a need, and to work with that purpose at the forefront of my being and allowing the materials to exact a kind of purpose," she says. "Then I would call in my friend who is a professor at Carnegie Mellon [Dr Edda L. Fields-Black] and I would ask her to look at my work to see if I was doing things intentionally and intuitively that had a broader esthetic language. She would look at my work and she'd be like, 'Well, you're doing this thing with vessels. I've seen this done before in this part of the Congo, I've seen it done in Sierra Leone, and I've seen it done this way.' So I would work intuitively, and then I would ask a specific human to do a little bit of decoding. That's sort of an origin place for me with the kinds of figures that I'm making."

Intuition remains a driving force for german. "I wasn't afraid to make through mystery, to say this is what felt right and to honor that. More and more I started to give permission to that open door of what felt right, to not always need to know the why and how of everything, but to really adventure into a place of queer, fierce shaking; to

Why I Make Art

have a place inside of myself, and then to have somebody give me language for that. It was very exciting."

In the years since, german's practice has expanded. Her figures have gotten larger, human-sized, the materials ever more unusual. During the three semesters she spent in college before dropping out, she invested a lot of her time participating in community theatre, and has brought a performance element to her work, as well as to her singularly entertaining talks at universities and museums around the country.

A reverence for and fascination with water has led to another recurring motif: the use of the color blue. german traces it back to an early traumatic experience. As a child, she remembers having to be rescued after her mother threw her into the deep end of a swimming pool. "I have always thought a lot about water and the baptism of water and how many days it would take you to die of thirst if you didn't have water. I've had obsessive thoughts about water from the time I was a kid, to the point where I had to write love poems to water so that I wouldn't be afraid to swim or put my head underneath the water. And so the blue is important because it's bringing in all of these ingredients of the power and presence of water, and all of our humaneness and all of our Earthliness."

But at some point she realized that she was still thinking too small. In the late 2010s, she began thinking more critically about what it meant to have "these really defined lines in my life around what is work, what is workspace, what is practice, what is process, but really allowing my entire being to inhabit those ideas as an undefined space and with as many living intersections as must come from it. So basically that meant I stopped working for programs and nonprofits, and I started saying, 'If this is really the mission, can you only do this mission when you clock into a job? Or is the mission alive? And how? And what does that mean, to live that way? And to create that way? What does it actually mean for me to believe in art in a way

Can I Love You Without Capitalism? How?, 2019
Mixed-media assemblage
59×67½×26 inches

Why I Make Art

that comes unraveled from any sloganeering? What does it mean to live and to be alive in that which you believe in?'"

In 2011, the year MSNBC described her community of Homewood, Pittsburgh, as "The Most Dangerous Neighborhood in America," german added a new dimension to her practice. She started working on her front porch and inviting passers-by to join her—an initiative later dubbed Love Front Porch. "I would make art on my front porch and just invite anybody to come and take up materials. And most of the time it was kids—adults were afraid oftentimes —and kids would bring other adults to my porch, and they'd be like, 'Mommy, let's make something together.'" It recalls the way her own mother lay materials before her children, inviting them to indulge their creativity.

Three years later, german opened the ARThouse, a designated studio space and community hub nearby. "Anytime the door's open, anybody can come in. We built a stage in the backyard with a set of bleachers; there's a big garden beyond there. *That* is the living scale. It's human scale, but at the sidewalk level. I didn't have to start a foundation, I could just do it at the scale of my own two hands and say, 'Ask for help when you need help and offer it forth as you can offer it forth.'"

The delineation between her personal and public art spaces has benefitted not only the community, which now has more room to flourish, but german herself. "A doctor had to tell me to have boundaries. She said, 'You've used the word "open" a lot. Everything can't be open all the time. You need boundaries. You'll feel better if you have internal boundaries, but you need physical boundaries. Like, you've got these properties. You need a fence around everything. You need a special fence around that, which is just yours.' And that's what I did. So there's my studio in my house, and the ARThouse is separate."

The demands of her own career have given german an appreciation for her mother's ruthless enforcement of the boundaries she set around her making-space at home.

Why I Make Art

"What I realize now, as a working artist who doesn't have children, is what it must have taken for my mother to define her space, and to define her space autonomously. Aside from being the mother of five young children, she was an artist and a maker, and if she didn't have that—that incarnation of her identity—to feel and to work her ideas and her being through, then she wouldn't have been OK. So, when I say that my mom closed the door, there were times where she was like, 'Get out. Don't touch my things. Things are where I want them and where I need them to be. Everything does not belong to you all. You have your own things.' I recognize that what my mother was doing was crafting an ecosystem where she could invest her being into creating, into making, and then she protected that."

Ultimately, however, german is confident that she'll be able to create wherever she is—something she's learned over the course of a career that sees her regularly traveling away from the comfort and conveniences of home. "I travel with a little studio. I have to check all the bags I ever take because I have so much paint and so many other materials with me. I know that they always think my hot glue gun, or my caulk gun, is a real gun, and I have to explain to people in customs that I'm an artist and I sit in hotel rooms and make stuff. That's what I do. A lot of those blue dresses from the last Blue Walk in Omaha, I made those in hotel rooms. I've made them across the country.

"My practice is never in pure balance, but it has to be fed. I have to feed making. I have to feed those parts of myself."

Allison
Janae
Hamilton

Fencing mask 7, 2018
Fencing mask, mixed media
12¼ × 7¼ × 11¾ inches

Why I Make Art

Allison Janae Hamilton's practice is steeped in the American South, its complex history and verdant landscapes permeating every inch of her work. The artist's multidisciplinary approach uses sculpture, installation, photography, and video as vehicles for exploring the social injustices and environmental vulnerabilities of this storied region of the US. From the materiality of her physical pieces to the bodies in her portraiture, her work fully immerses her audience into the very core of this place.

Hamilton was born in Kentucky in 1984 and raised in both south and north Florida. Her father's family stems from the Carolinas while her mother's family have owned a farm in West Tennessee since the 1930s. "I'd go to the farm as a kid to help out with every major harvest season. Spring is beans, August is corn, and fall is cotton," she recalls. She learnt black and white darkroom photography at middle school and enjoyed shooting her assignments on the farm. "I'd go around photographing the old barns, and I'm really happy I did because a lot of those structures aren't around anymore. None of my friends in Florida had family farms, so I realized that it was unique. It was a pivotal moment, where I married photography with a keen interest in landscape."

During high school she put her camera down and went on to study fashion merchandizing at Florida State University. "I had no concept that you could be a novelist or filmmaker or visual artist. I'd never been to a contemporary art museum. But I was trying to get closer to the creative field in any way I could." Landing in Harlem in 2007, she initially worked in sales for a luxury fashion brand then undertook her MA in African American studies at Columbia University while doing costumes for theater. Then, a friend asked her to participate in a charity art show in a coffee shop. She dusted off her old photographs. "That made the lightbulb click. I printed them and created an installation, but I still couldn't accept that I could do art full time."

It wasn't until her PhD at New York University that the penny finally dropped. "I was interviewing artists for my dissertation and was like, wait, if these people are doing it, why can't I? I had no more excuses." Post-PhD, she headed back to Columbia for her MFA in the Faculty of Arts. "I had so many years of art being this tangential thing on the side that I wanted that incubator of two years where I could feel like an artist every day."

Hamilton has swiftly established herself since her graduation in 2017. Her work has been acquired by galleries and museums in the US and abroad, and she has exhibited widely, including at the Museum of Modern Art in New York, MoMA PS1 in Long Island City, the Smithsonian National Portrait Gallery in Washington, DC, the Jewish Museum in New York, and the Istanbul Design Biennial in Turkey. Solo exhibitions include Pitch at the Massachusetts Museum of Contemporary Art (2018), Passage at Atlanta Contemporary (2018), and Wonder Room at Recess in New York (2017).

For Hamilton, everything she does starts with the landscape as the living witness to the stories that are being told. "I'm trying to think about landscape as central in our lives, rather than background. It was such a huge part of the development of our country so I'm looking at how we got to where we are now."

One way she does this is by sourcing particular types of materials for her work, ranging from plant matter and animal remains to field recordings and found objects. "While I'm trying to speak to the contemporary experience of the South, once you're there you can't get away from the history. It's in the ether, it's in the buildings, it's everywhere. So then I have to bring the materiality that I know. I drill down and get specific about those signifiers that can tell a story. It's that physical matter of this long saga of the American South. And all over. I look at it from a very personal perspective but when you boil it down through that specificity, you can see how these same patterns of

landscape and power and politics and social dynamics are coming into play all over the world."

Her 2021 solo show at Marianne Boesky in New York, A Romance of Paradise, addressed the myth-making used to rationalize the violent expansion of the US. To go west was an act of manifest destiny, while to head south was to discover an Earthly paradise. Early explorers called it the Garden of Eden, framing it as a fertile-yet-wild place that needed to be tamed. "There were many narratives used to justify American slavery wrapped up in pseudo-science and religion," says Hamilton, who can trace her family tree back to specific slave plantations. "There was this idea that if you brought people from sub-Saharan Africa and put them in the same type of sub-tropical climate, then it wasn't really kidnapping because they'd know how to work the land."

The immersive show featured fencing masks (a recurring motif in her work) adorned with feathers and hair, and three of her familiar sculpture creatures, an alligator, a deer, and a rattlesnake. Alongside these were photographs of her close family and friends, as well as herself, looking regal in white costume, becoming part of their landscape and in doing so conjuring up an epic allegory of their own making. Alongside explorations of how colonization has constructed contemporary realities, Hamilton's work looks at the communities that have nurtured their own rituals, art forms, and spiritual beliefs, turning a situation wrought with terror into a place that offers healing and sustenance—home.

As strong and nurturing as these landscapes may be, they are still prey to the climate crisis, which has greatly affected the rural Black South. And while nature is often seen as a great leveler, the environmental inequalities that result from climate change are not. "Nature is indifferent in that it doesn't matter who you are. However, the way we have structured our social world with nature in mind is not equal," the artist says. "When you have sea levels rising,

Floridawater II, 2019
Archival pigment print
24×36 inches

you have climate gentrification. So, when you have these major natural disasters, which are increasing in frequency and intensity all the time, it's those who live on the wrong side of the levy or have been pushed to the fringes of a city who are most vulnerable."

Hamilton's 2018 site-specific sculpture at Storm King Art Center, *The Peo-ple Cried Mer-cy In the Storm*, included a towering stack of tambourines (another of her regular motifs) in the middle of one of the museum's ponds. It was a meditation on "Florida Storm", a 1928 hymn about the Great Miami Hurricane of 1926, and the 1928 Okeechobee hurricane—which appears in Zora Neale Hurston's novel, *Their Eyes Were Watching God*—which killed thousands of Black migrant workers who were then buried in mass, un-marked graves. "Those two hurricanes are the crux of it but I'm also thinking about Katrina, and about Galveston and Hurricane Maria in Puerto Rico, and how these natural disas-ters illuminate society's views of marginalized folks."

Many of Hamilton's video works look away from land and toward the many meanings and real-life significations of water. While it would be easy to assume a preoccupation with the Middle Passage, the artist is in fact concerned with the rivers, canals, and swamps close to home. *Wacissa* (2019) submerges the viewer, upside down, in the Florida river of the same name, which is bisected by the Slave Canal (built using slave labor in an attempt to join the Wacissa with the Aucilla River) and was strewn with trees after Hurricane Michael. Originally a one-channel piece, *Wacissa* was transformed into a 73-screen experience in New York's Times Square in 2021. Another work, *A Pale Horse* (2021), is more serene, showing a smooth surface of water reflecting the blue sky above, only the odd bug disturbing the calm. In one of her photographic works, *Floridawater II* (2019), a woman is submerged in the depths; the water is a place of birth, baptism, and return.

Living in New York has allowed the artist to develop a different perspective on the South, and she enjoys the effect that frequent journeying between the two has on her mind. "New York is motivating because everyone is hustling so it's a culture shock when you land in the South. It's another atmosphere that lets you slow down. I go there to work with a skeleton of a plan but then I let it free flow," she says. "It's also hard to keep that New York feeling going when I'm humbled by my family. My grandmother will ask me what I'm doing. I'll say it's a sculpture at Storm King and she's like, 'That's nice dear. Storm what? Did you see the ball game?' It's all part of me."

Those intergenerational conversations and ancestral memories are inextricably linked to the musical pulse of the South. Whether collaborating with activist orchestra The Dream Unfinished or shaking those tambourines or composing photographic tableaus that nod to the esthetic worlds of Sun Ra and George Clinton, much of Hamilton's work stems from a childhood spent in Baptist choirs. "I grew up in the Black church so gospel music and that

whole type of sound was a key part of my upbringing. Everyone in my family sings, so music was ubiquitous for sure," she recalls.

"That's the part of church that I've kept. I didn't keep the religion but the cultural aspect is still there," she continues. "For me, Motown is secular gospel. That's where those chord progressions and rhythms come from. And with that you have the blues, rock 'n' roll, and modern offshoots like drum and bass and southern gothic. A lot of what I listen to in the studio has the same feeling and the same musical tenor, it's so familiar. If I'm working on a project, it has to feel home-based. It has to have roots."

Loie Hollowell

Though she's an abstractionist, Loie Hollowell tends to dwell on the more literal elements of her drawings and paintings. "I love talking about their formal, visual, and phenomenological aspects, and I feel like I never do because I just go straight to vagina, penis, vagina, penis."

Certainly, vaginas and penises—and bums, and nipples, and testicles—are something of a signature for the California-born painter, defamiliarized but still discernible in radiant color. In her conceptual self-portraits, which draw comparisons to the work of Judy Chicago and Georgia O'Keeffe, Hollowell has turned her sex life, pregnancies, births, and body into mesmerizing geometries that evoke at once the religious, the surreal, and the futuristic.

Hollowell has had a lifetime to develop her way of seeing and modes of making. Growing up on a one-acre plot of land outside Woodland, in Yolo County, California —about an hour and a half from San Francisco—she spent her childhood surrounded by fields and farms and the animals who call them home. She and her younger siblings were "feral children. There were crazy art kids running around," she recalls. "And animals running around. We had chickens. Roosters. We had a lamb at one point." But it wasn't a farm, she clarifies. "It was like an acre surrounded by farms. We didn't know what to do with animals. Like, the lamb lasted a month, two months. I don't know what happened to the lamb. We had bunnies I think at one point. All these animals disappeared."

Her father, a pointillist painter and art professor, drew her to art through his practice. "My dad would come home, and he'd be in the studio on the property, and everything's open. The doors were open."

When she was young she would spend time in this studio, and this is where she started to develop her own artistic ideas. "I would go in there and watch and help him mix paint, so I'm told, and sometimes he'd give me materials to play with on my own—not helping him, but doing my own thing. At one point, I asked for my own studio, so

my parents gave me a closet and a little setup of oil paint."

Once in her own space she remembers fashioning the likeness of one of the several dogs that the family kept at any given time. She was a lab mutt called Lucy. "I made a painting of Lucy sitting on a wooden floor," Hollowell says. "I can still see it in my head. It's a nice perspective painting with the wooden floor kind of coming out towards you, you know? Like a David Hockney setup with fat Lucy sitting dead center in the back. I would love to find that painting. I'm sure it's much worse than I imagine it."

Hollowell still keeps the company of animals to this day. Her cats keep her entertained in her studio, ensuring she is happily distracted while she works. "You're painting and then as you're mid-stroke, you kind of look around and you see them chasing each other across the room. It disrupts you in a good way."

Attending UC Santa Barbara—the only school that offered her a studio on campus—was more about broadening her horizons than building a foundation for her craft. "From square one, I had that basic formal painting training, with my dad, and learned what it means to be an artist. What I needed was to be free," she says. "I needed some female professors, I needed some multimedia professors, performance art professors. I didn't realize that at the time, but that's what that program had to offer."

A few decades and degrees later, Hollowell has a defined lexicon of compositional styles and graphic elements, including glowing, almond-shape mandorla (borrowed from Christian iconography) that form cosmic vaginas in the center of her canvases; while the phallic lingams she piles in winding stacks. She considers certain repeated images as sites of play, where she can experiment with color and tone.

"In some images, the body space, or the sexual nature of it, is more obvious, and I will repeatedly go into that image with a different color, or a different texture, trying to abstract the image more or to make it more obvious.

A Gentle Meeting of Tips, 2018
Oil paint, acrylic medium, sawdust, and high-density foam on linen mounted on panel
48×36×3½ inches

Why I Make Art

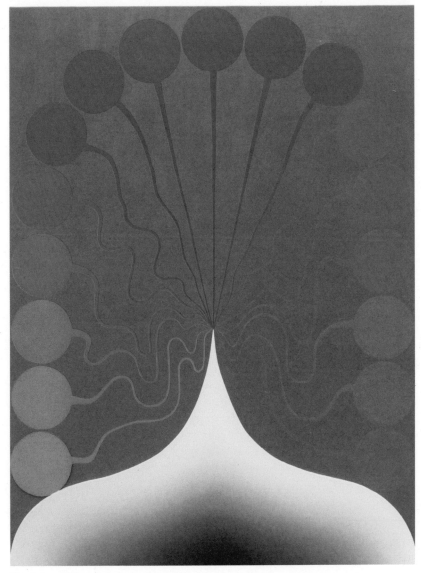

First Contact, 2018
Oil paint, acrylic medium, sawdust, and high-density foam on linen mounted on panel
48¼×36×3¼ inches

Loie Hollowell

I can't just leave it as one or the other when I know that there's another way possible," she says. "It's then going back to color theory. Like, how can I push this space back? Can I pull this space forward? It becomes this super formal question. The color and the shade are as much a character in the painting as the composition."

She'll also create variations of a composition by building up or downplaying certain spaces using mounds of foam: "I'll make one where a lump representing my ass is coming out of the canvas one or two inches, and then another version of it where it's actually receding—like it's actually moving back into the panel—or where the canvas is flat and I'm just painting it to create the illusion."

Hollowell's husband, sculptor Brian Caverly, is also an art handler at the Guggenheim, and it's here that he sourced the foam that she would come to use in her work. "He did the Peter Fischli and David Weiss show and they made these pedestals out of a hard-density carving foam. He took all of it from the Guggenheim," she recalls. "They were just gonna throw it away. We went up there in a van and took all the materials. We started carving all of these shapes, these half circles, and then we put a layer of a gel medium with sawdust on top, and then that gets another layer of the gel medium on top. So it's basically this pretty lightweight shape."

While Hollowell used to work alone, considering the use of assistants akin to "blasphemy," her stance has softened since she started working in three dimensions in 2016, carving the high-density foam into semi-circles to mount on her panels. It also pushed her to look elsewhere for studio support when her husband started to protest. "I had all this work going on sanding and carving, so I was spending most of my time in there sculpting, not really doing it right," she says. "Sculptors can do it better than me, and I want it to be perfect. So I had someone come in and help me aside from him because he's like, 'Fuck you, I'm not going to help you all the time. I'm not your slave.'"

For all of the work that goes into making these three-dimensional shapes, Hollowell is used to seeing them flattened. Some of that she takes credit for herself: in some works, 3D forms are painted "in a way that they flatten out and become one with the rest of it, so it confuses the eye."

She's also interested in pushing age-old assumptions about the synonymity of beauty and symmetry. "I'm trying to throw off the symmetry here and there," she says. "I think that's an aspect of beauty that we're so attuned to, when something is a little asymmetrical, it actually becomes more beautiful in that it pulls you in and you try to find where that difference is."

Not afraid to explore new working habits, Hollowell has embraced the possibilities that the digital world has to offer. "I'll take a drawing and put it into Photoshop—I might tweak the color, and then that might inspire me to make another drawing," she says of her dalliances with computer-generated imagery. "And actually, I just got an iPad—a big iPad and you can draw on it. That's amazing. I've been doing that a lot too.

"I'd started making the strongest paintings on 9×12-inch paper, these little drawings. And then it was like, I really like this proportion in relationship to my body, it's kind of perfect. Then I started realizing the phone becomes a proportion of the paper. And the paper, who knows? Perhaps a proportion of the body? I don't know," she ponders. "There's this kind of continuous connection to the perfect rectangular space. So this ratio has stayed the same whether the image is vertical or horizontal. It's still 9×12, which is very accessible for printing and for phones."

Thinking about her work in this way has allowed Hollowell to embrace social media—or at least have a pragmatic take on it. And at this point she's also more interested in how our ubiquitous smartphone screens squeeze her works of shadow and nuance once crammed into an Instagram post.

"That's the only way a ton of people are going to see an artwork. They're not even going to go to the artist's website, where they have a side view of it, or a video —who has time? I just go through Instagram and take a real quick look at the images," she says.

"I love that this becomes another place where people are flattening the image even more. It gives another kind of enjoyment when they see it in person."

Kahlil
Robert Irving

It comes as little surprise that Kahlil Robert Irving enjoys reading poetry, or that he often carries a notebook around with him. The San Diego-born artist, best known for ceramic abstractions that recreate the realities of the urban environment in concentrated form, has a lyrical way of expressing himself. "Gerry Mulligan will make you cry in one direction, but Pepper Adams will make you weep in another," he says of his beloved jazz saxophonists.

Irving's talents extend in many directions too, including musically. In middle and high school, he played tenor and baritone saxophone, and was taught by the American virtuoso Hamiet Bluiett. "He let me play one of his horns and it was a Jerry Mulligan baritone and it was amazing. He said, 'You really have to blow in this horn. You want to get some sound? You gotta blow. Control your air,'" he recalls.

Irving's life has been rich in such mentors, inspiring him and helping him develop his artistic sensibility. Perhaps his earliest champion was his paternal grandmother, with whom he lived in St. Louis after leaving San Diego as a child, and who consistently supported his interests—whether in music, ceramics, or even video gaming. "My grandmother was a really big influence on the video game showreel," he says. "She would buy me them." Later, when he attended the Kansas City Art Institute for undergraduate studies on a full scholarship, his grandmother maintained her steadfast encouragement. "She helped me make it through—phone calls, conversations, sending me money. College was really hard for me and people think that I have these White saviors in my life that came down and granted me millions of dollars to make it through college. No. I have a lot of mentors and a lot of people who help remind me that perseverance is a way to make it through."

Along with music, making ceramics was an early love, and remains the material cornerstone of his conceptual practice. It was through his involvement with different studios and programs in St. Louis that Irving forged some of the most important relationships of his life—not least with the wheel itself.

Why I Make Art

Downtown Norfolk, Nebraska (1998), 2017
Unglazed and glazed ceramic, enamel, luster, and image transfers
15×11×9 inches

"My father took me to a Saturday afternoon open studio program when I was 12. It was at a place called the Potter's Workshop, run by the South City Open Studio and Gallery," he remembers. "That's when I first learned about pottery—and I've been making pottery since." Seeing somebody throwing on the wheel, he immediately decided he wanted to take a turn. "They said, you have to come back next week if you'd like to do that. For wheel throwing, you've got to be a return member, you've got to earn your keep. So I came back every weekend from then on. I would go during the weekdays. I would go in the evenings after school, I would ride my bike from my high school there, I would do everything it took to get there. I was entranced. I didn't think about it necessarily as making art. It was an escape, it was fun, the glazing, the firing—true learning."

He also frequented the Craft Alliance Center of Art + Design, where he attended a program called Crafting-a-Future, and it was here he met Pam Caskanett who was at the Kansas City Art Institute. "She was such an important

person to tell me that I could do something well. People don't really understand how much of an effect mentorship and love can have on a person. She influenced me, and told me, 'You should apply to art school.' Before meeting Pam, I had no idea about going to college, I definitely didn't know what going to college for art was, let alone what it was like attending the Kansas City Art Institute."

Ceramics aside, art in high school held only limited appeal. "I took art classes, but it just never clicked, like making drawings and watching people paint just didn't click," he says. Even then, his interests lay in building things up and making 3D objects: "Growing up, making Lego, it just really worked.

"It's all so imaginative," he continues. "You build a model and in your mind you can make it look like whatever you want. But a painting, or a drawing, it yields itself, what it is, because it's presented itself to you, you can infer more on it. It's so one-to-one, in a way it's your mind on the paper or your mind on the canvas or panel. Whereas with ceramics or Lego... I mean, I would combine all my toys, Lego, superheroes, action figures, all the plush toys, they're out, everybody's out."

This instinct for assemblage is in many ways at the heart of his work, especially his pieces that reveal the substrata of city life. His sculptures, and the hand-pressed tiles that also form part of his oeuvre, are embedded with remnants of these tumultuous times. One of his sculptures might contain, for example, slip-casts of individual pieces of crockery, drinks cans, cigarette packets or pottery shards, variously pressed into breeze block-like forms printed with headlines and newspaper clippings, often highlighting contemporary Black experience and representation in the media.

Recalling the Antioch mosaics held at the Baltimore Museum of Art, Irving was struck by the narrative power of these third-century pictorials from modern-day Turkey, many of which document daily life. "If they're telling stories

about millennia ago, can I make a work that tells the story or kind of narrates or looks at today?" he wonders. "So, the work is this push and pull of the real, the found, the embedded, the entrenched, violence, despair, longing, memorialization, all packaged in one." Put simply, the work is, he says, "layered conceptions on life and love and loss.

"It's so heavy in the realm of what I want to talk about and it's also heavy in the realm of its material," he continues. Four pieces in the Black ICE show, for instance, deal with the 2017 killing of Anthony Lamar Smith in St. Louis by police officer Jason Stockley. Similarly, a work Irving showed at his 2017 exhibition, Streets:Chains:Cocktails, at Callicoon Fine Arts in New York (now closed), entitled *Compact Mass – News; Nation Holds Breath for Death (Pride and Protest) – NO CHARGES FOR WILSON* (2017), focused on the 2014 shooting of Michael Brown, also in St. Louis. "I remember the night that Darren Wilson [the police officer who shot and killed Brown] was acquitted and I just couldn't stop crying in my studio," he says. It's these experiences that shape his work. "My show was about aligning historical colonial violence to the evolution of violence against Black people today and it rendered itself in ceramic objects that were replications or phenomenon of the street."

Though Irving's work is often about life in present-day urban America, he speaks fondly of formative experiences as a student traveling and studying abroad, in Budapest and Jerusalem, as well as in Laos, Thailand, and Vietnam.

"It's amazing to be able to have these experiences, to keep traveling and keep expanding my engagement with the broader world outside of the States," he says. "Sometimes people are like, oh, I've got to get out of the States, I've got to run away. OK, but where are you going to live, where are you going to make money? Capitalism is built for the wealthy and it's not built for the faint-of-heart, either. I don't want to run away from the States, but it gives me so much life and breath to see the length at which

*White Matter, white text [Department of Justice *memorandum document*,{Darren Wilson, pgs 1 - 86}]*, 2019
Decal on glazed commercial tile
Dimensions variable

human existence is going, the fact that there is such
a broad swathe of life. It reinvigorates me."

 Ever since he was a child making and selling pottery
in St. Louis, Irving has been phenomenally productive;
his working process is intensive. "I watch a lot of TV when
I'm working," he says. When I was working on my show
for Wesleyan University [in 2018], I watched the whole six
seasons of *The Wire* in, like, a week and a half, two weeks."
His two shows at Callicoon Fine Arts drew much acclaim,
and he has since exhibited at the 2019 Singapore Biennial
and, most recently, at The Studio Museum in Harlem and
the Museum of Modern Art.

 The artist's focus, however, is on a wider concept
of success. "I recognize that I'm born to a mixed parentage

but I identify as being Black, and I deal with the experience of being Black in this country and Black in the world," he says. "Having ancestors that were enslaved and forced to create the infrastructure of this country, and whose labor gave White people wealth that we see and they're continuing to build life off of—my family doesn't have that.

"The one thing my family does have is family, but when I think about going forward in my future and my desire for building a world and continuing to build a life for myself, it involves building, actually building. I want to build, I don't want to play," he says. His ambitions are big and he encourages younger artists to dream at the same scale, steadily working on each step, with view to bigger things. "That's really the only way it's going to change."

Clinton King

For artist Clinton King, experimentation is the greatest source of motivation—or an effective substitute for it, at least.

"I'm constantly pulling the rug out from under myself or changing things up to make it harder. I don't have will-power pushing me from behind," he says. "I don't have an excellent work ethic. I'm not that guy. So I switched from a pushing, behind-the-wheel determination, to more of a pulling from the front—being pulled by this desire to go into the unknown, learn new things, try something I've never done before—and constantly experimenting. I think of it as falling into this void I put in front of myself, just to see what happens."

This approach has seen the artist span various media over the course of his career, from abstract paintings to large-scale installations and graphic videos. And while he's best known for fragmented, incandescent works on canvas, he trained in sculpture and continues to produce three-dimensional art. King traces his fascination with sculpting to his childhood.

"I found a spike in my dad's garage, a headlamp and a hammer, and I went into the woods. I had this really weird compulsion to strike it into stone. I went out there at night, and I just tapped a hole in this boulder behind my house. I remember this feeling came over me. It felt like *Close Encounters of the Third Kind* and that guy with the mashed potatoes," he says (referring to a scene in the Steven Spielberg movie where Richard Dreyfuss' character shapes his mashed potatoes into a mountain). "It felt like it meant something.

"The next time I had that sensation was not too long after that. I took two chunks of sandstone and was rubbing them together and making a pile of sand below. It felt like something clicked."

If King's first brushes with artmaking were uncon-ventional, then so too was his path to New York's rarefied art world from humble beginnings in Coshocton, Ohio, more than 60 miles east of the state capital, Columbus.

Emotional Superstructures, 2021
Oil on linen
84×71 inches

Adopted by factory worker parents around the age of four, he spent some of his childhood living in a trailer "off this dirt road and in the middle of the woods." Many members of his family, including his grandfather, had been coal miners, and King jokes that his background is more "black collar" than blue.

"I could look down into the cave mines," he recalls of a visit to nearby Murray City, the Ohio village from which his family hailed. "This was in the early 1980s, and they still cooked with coal, heated the house with it. Everything smelled like coal. Everything was coal. They had a giant stack of it in the backyard. It's all they ever knew."

King's upbringing was one of dirt bikes, fishing, and shooting. Taking up skateboarding as a teen became his "first attempt at delineating yourself from your surroundings." It was, he adds, the first time he felt "connected to something much bigger than my small town in Ohio."

A career in the creative arts still seemed an unlikely prospect. King was, by his own admission, a "pretty bad student." But while an art teacher recognized his talents and recommended summer programs, it was, ultimately, a bad acid trip that led him to apply to the Columbus College of Art & Design ("I had a realization that I had to go to college, that I had to get out of my town," he says).

Despite his early impulse to sculpt, painting and drawing seemed like the obvious—or only—choices for his undergraduate studies. "I went [to college] thinking art is just what pictures you draw. So, I went in for illustration. That did *not* last. I hated it. 'I've got to draw what you *tell* me to draw?'" he remembers thinking at the time. "I didn't understand that aspect of it."

King found his calling through a work-study college job in 3D illustration that saw him "making this weird stuff" with silicone and rubber. Then, after graduating, he experimented with installation art, even though the discipline was, in his view, "sort of on the wane" at the turn of the millennium. He took a job with Columbus-based artist

Ann Hamilton, known for large-scale multimedia works, and followed her example by turning an entire boarded-up house "into a sculpture." Using the project to apply for graduate schools, he then began exploring "real far-out" conceptual art ("I was making Post-it Notes look like Post-it Notes, but they weren't Post-it Notes"). By the time he completed his MFA in sculpture at the School of the Art Institute of Chicago—and after encountering the work of performance artist and sculptor Matthew Barney, which King describes as a "revelation"—he was seemingly finished with painting altogether.

"The last painting I made drove me so crazy," he recalls, saying that he "rammed" a garden tool right through it. "I kept only one painting from my entire grad school. At the end, I just took it and I threw it up into a tree. I was done with this painting stuff. All I did was sculpture and performance."

King's curiosity led him not only to new methods and media but to new surroundings entirely: Japan. Still living and working in Chicago after his master's degree, he dived into the unknown once more.

"The art scene in Chicago kind of sucks; it's all over the place," he says. "And everyone kept saying, 'You got to get out of here.' I was working at a factory sanding Bondo [polyester putty] for cars, and I was working for a scenic studio for a while. Then, I remember one day, I looked up and I could see all the sanding I had to do, laid out in front of me in sections. And this voice in my head said, 'That's two months—I know exactly what I'm going to be doing for the rest of summer, and I'm doing it right now.' It just clicked: 'I'm going to go to Japan. That's it.'"

With little money and no income, King took a job teaching English before securing an art residency outside Tokyo. "I couldn't believe it," he recalls. "It was a dream come true. They gave me really nice rent. And I had a really nice place: tatami mats and sliding doors." Yet, there were creative challenges in Japan—not least the difficulty of

Inner Weave, 2021
Oil on linen
64×50 inches

making sculptures from found objects. "There's no trash anywhere," he says. "In Chicago, I was just grabbing things left and right.

"I didn't know what to do," he continues. "I wanted to be there. I wanted to get away. But I knew I had to make art. So I started with collage. I started doing photography back then. Just working with everything. And, slowly, a kind of 'way' was coming out."

While his two years in Japan were "a transformative time," the move distanced King from his contemporaries and the New York-centered US art scene. "That really, really messed my career arc," he admits. "It killed me. I just vanished off the face of the Earth to everybody."

Eventually, he engineered a move back to America when the Massachusetts Museum of Contemporary Art hired him as a draftsman for a retrospective of the then-recently deceased Sol LeWitt, a conceptual artist known for his geometric sculptures. But when it came to King's own practice, being "open to everything" had its downsides back in America. "It was hard for me, when everything and anything could be art. I liked that idea. But I found it harder and harder to do that. How was I to go to New York and get a show with a stick leaning against a wall?"

In this regard, LeWitt proved an important influence. Working on canvas again, King created self-imposed boundaries—as the late artist had done—to focus his practice. "What if I limited myself like LeWitt did, and all the possibilities that are inside that limit?" King recalls asking himself. "I remember thinking, 'Well, I'll just buy 25 little canvases, all the same size. Then I'll only buy primary colors and see what I can do.' That limitation was interesting for me: to focus my energy in one thing. That's kind of what got me back into painting."

It was a fortuitous transition—one that eventually led to solo shows at galleries like Dorsky Foundation and Stellan Holm Gallery. And King has further refined his distinctive style of making "maximalist" paintings "with

minimalist means," as he puts it. Full of colorful fractured shards and psychedelic arrangements, his art is as much the accumulation of "thousands and thousands of single brush marks" as it is a carefully considered whole.

"I don't think about meaning as much when I'm making an abstract painting, or when I look at one. It's more of an emotional, intuitive effect to me. It's something to do with the act of accumulating," he says.

This outlook is intrinsically tied to his studio practice, which, like his art, is constantly evolving. "If there's leftover paint on my brush, or the palette, it's going to go some-where. I would work on maybe 20 works on paper [at once], plus a couple paintings on the wall and a larger painting, and they are just accumulations of various marks over time.

"When you're making a wet-on-wet painting, you're catching one moment in time," he continues. "But when you make these accumulative paintings, it's like you're com-ing at it with different moods. Every time you come at it with a different perspective, a different mindset. So, they become a compression of who you are, like an average of all your moods."

King's impulsive, incremental approach can make it hard to know when to stop. "I hate the end. Right before anything is finished, I pull away from it. It's been that way with everything in my life. I love nothing more than a blank canvas.

"The end of a work says a lot about an artist's un-derstanding of esthetics, of formal issues," he adds. "Also, as an end-result, as product, it says a lot about where you are. You can have a tremendously creative, spontaneous practice until you get to the end and really ruin a painting because the final moves are too obvious or too on purpose. It's the last moments I always dread."

Yet, the artist also recognizes a new maturity in his methods. Creating art is increasingly a matter of "con-necting" previous experiences and the lessons learned along the way. If his paintings are the sum of thousands

of individual brushstrokes, they are also the culmination of years of experimentation, of discovering what does—and doesn't—work.

"All the things I studied, my time in Japan, all the things I've been interested in—they were always blocks of unfinished, unconnected pockets of experience and knowledge and information, a lot of it wrong. As I'm getting older, I'm starting to make deliberate attempts to connect things. I'm finding that 'Oh God, I was wasting so much energy; it's all right here.' I feel like I don't need to look at the paintings in a particular way anymore. I just do what comes naturally."

Chris Martin

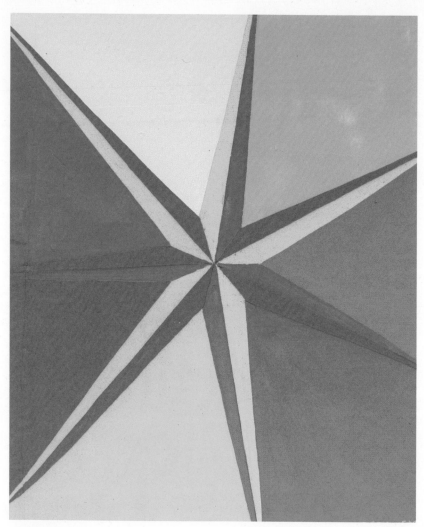

7 Pointed Star #1, 2013
Oil on canvas
54×45 inches

Why I Make Art

Chris Martin hates the label "outsider art," a term used to describe work by people without formal art education or gallery connections. But this might be because he has helped produce more of it than almost anyone else in contemporary art.

After dropping out of Yale in the 1970s, Martin instead trained in art therapy at the School of Visual Arts in New York. He then spent more than 15 years working full time as a painting therapist for people with "so many problems," from men and women with HIV/AIDS to those experiencing mental illness or drug addiction.

"These people were just extraordinarily interesting, and we had a lot of fun," he recalls. "I used to make lots of art in day-treatment settings and residential settings, hospitals. I have all these books; I've been studying art for all this time. So, what does it mean when someone just comes in and makes a great painting without the 'education'? They haven't been to the museums; they don't know who all these artists are. But they're able to express themselves in a fresh and profound way.

"Initially, I would say, 'This is terrific,' and they were puzzled because this was the first painting they'd made since they got out of prison," he adds as an example. "So they knew they weren't any good, and initially they're thinking, 'Why is Chris hustling me? Why is he saying this?' So I learned that this wasn't a good thing. I might be privately thinking, 'This is fantastic,' but I would say, 'This is really interesting—maybe you want to make another one.' I learned that I couldn't lay that kind of praise on people. It would not be understood."

Martin went on to become one of New York's most respected living abstract painters, both a so-called "artist's artist" and, in a sense, something of an outsider himself. That the diverse people he worked with during his therapy career were somehow "inadequate," regardless of their talent or ability, speaks to a sense of exclusiveness that the painter challenges—it's one that afflicts the visual arts more than any other creative discipline, he says.

"If there's a party, and they put on James Brown, everybody gets up to dance," he offers as a parallel. "No one's saying, 'I didn't study dance'... But if you say, 'Can you paint?' most people say, 'No, I don't know—I never was *taught* how to paint.' So painting is one art form where there's this curious, huge, heavy burden. That society somehow takes away everyone's freedom. Everyone should be making their own paintings, and people don't, because they feel that they don't know how, or that they have no talent.

"I remember a teacher telling me that she would ask her third-grade class, 'How many people here are artists?' And everyone in the class would raise their hand. By eighth grade it's just the two weird guys in the back row that still raise their hands."

Martin poses a question of his own to students he meets: "Isn't it a miracle that there are no graduate schools for rock 'n' roll or rap, and yet the music doesn't die? Whereas in painting, somehow society has really fucked with everyone's head, and everyone believes 'I don't know how to paint; I don't have the *right* to paint.'"

While Martin refuses to see education as a prerequisite to being a good painter, he nonetheless threw himself into art history. His colorful work—now found in public collections ranging from the Museum of Contemporary Art Chicago to the Museum Boijmans Van Beuningen in Rotterdam, the Netherlands—is steeped in the American abstract tradition. Citing the likes of Al Held, Jasper Johns, and Elizabeth Murray as influences, Martin says when he arrived in New York in the mid-1970s, all the "serious painters" he knew were "doing some kind of minimal abstraction.

"I was very much obsessed with art history. By the time I showed up in New York, I was deep into Abstract Expressionism. I had piles of books. I was obsessed with De Kooning and Clyfford Still. I was reading everything that I could," he says, adding: "I guess I discovered Abstract Expressionism and psychedelics about the same time.

Homage James Brown Godfather of Soul..., 2001–2007
Oil and collage on canvas
15×18 inches

It formed the way I looked at De Kooning and Pollock and all kinds of painting."

The young artist's interest in the contemporary canon led him to the Guggenheim, where he worked briefly as a guard. ("I thought it would be a great gig because you could look at paintings all day," he recalls, describing an encounter with Jasper Johns at the museum as a rare highlight, "but it was very, very boring.") In those days, however, there were other ways to make ends meet in New York's art world.

"It was super cheap," recounts Martin, who was born and raised in Washington, DC. "Rent was $125 a month. I had a job unloading trucks at the wholesale cut-flower market and made $45 a truck. So, in three nights, I made

my rent ... It was great for artists. Everyone had space. You didn't have to work—you worked part time and you could buy whatever you needed to live. At the same time, it was scary. I was one of the few people I knew who didn't get shot, stabbed, or hit or something. You know, most people were mugged at some point."

Although he "tagged along" with the downtown scene, Martin set up in Williamsburg, Brooklyn, where he still has a studio. Developing a signature style through the 1980s, his unique take on abstraction incorporated a sense of geometry and graphical sensibilities, his canvases an experimental confluence of influences from Motown to psychedelia, Pablo Picasso's collages to Buddhist mandalas. Martin has even described himself as a landscape painter of sorts, identifying with what he calls the "Albert Pinkham Ryder, Marsden Hartley, Pollock strain of American landscape painting."

Then, there was the other major force brewing in New York at that time: street art.

"These guys—the first ones spray-painting whole subway cars—were a huge influence on me and all the artists who would admit it," he says. "There were these fantastic paintings going up on the streets of New York, all over the place. Those guys had to do something in three or four hours, and then maybe the police were going to chase you. They were risking their lives, balancing on the edges of buildings to make paintings."

For Martin, graffiti resembled the other "outsider" art forms he was so drawn to. "It's its own world. It doesn't really coincide with the gallery world. And they do this stuff, basically, for free. They put it out there. There's tremendous respect and a real hierarchy within that community. But they're not asking for rich people to validate them. That's very healthy."

One of the most important artists to bridge the gap between street art and the rarified art world was fellow New Yorker, Jean-Michel Basquiat. Martin, also an impulsive

doodler, found that the Neo-Expressionist's distinct style made an immediate impact on his own creative process.

"I couldn't believe that this kid could be so great, and it was my first experience of seeing people younger than me that were way ahead," he recalls. "I have a drawing habit—I make drawings constantly—and I can look back at my notebooks and show you exactly the moment when I started seeing all these Basquiat drawings. One of my notebooks, for about 30 pages, looks like Basquiat. I just did Basquiat. And in the process of copying what he was doing—and I wasn't looking at his drawing, I was just sort of doing his style—I looked at my notebook and went, 'Oh my god, he really is something great.'"

Keith Haring was another key figure on the 1980s New York scene. And while he now admits to being "very envious" of him and Basquiat, Martin was not, at first, convinced. "I remember having arguments with the writer Glenn O'Brien," he says. "He was saying, 'It's like Haring's got a Zen thing, he can do it, he's got this instantaneous energy, he's great.' And I was arguing with Glenn, saying, 'I don't know if he's that great.' It didn't seem quite serious enough to me.

"I had been raised up with De Kooning, Giacometti, and this modernist tradition," he offers as an explanation for his initial indifference. "In that tradition, one is revising. So the painters that I'm talking about—people like Elizabeth Murray, Al Held, and Bill Jensen—got to their best paintings by painting, and repainting, and repainting. I didn't take Haring so seriously, because he wasn't suffering and repainting his paintings."

Martin was ultimately won over, however. "There was a big slab of concrete right outside the building that we were living in on Mott and Houston [in Manhattan]. Keith Haring did this mural on it. I saw him work with a bunch of guys and he did it in about two days. And it was great. I was working on 20-foot paintings and killing myself. I would work for months and years on these paintings. This

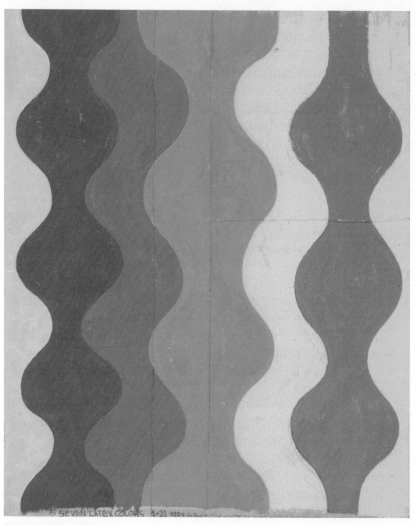

Seven Latex Colors, 1989
Latex on canvas
127 × 108 × 3 ⅜ inches

Why I Make Art

kid shows up and, *boom*, they make a really exciting painting. I had to admit, it was pretty damn good."

What Martin learned from his street art-inspired peers was a sense of speed and immediacy—which he used to transform his own practice. "It took me a while to realize that I was editing much too much, and it was better for me to make a lot of drawings, make a lot of paintings," he says. "So that was a great lesson." (The ability to work quickly is a quality he recognized in another set of art-world outsiders, too: "My own children influenced me very much," he says. "There was a period when we made paintings together. We would sit down, I would put out paint, and before I was done setting myself up, they had each made a painting. They would just start, finish painting, done.")

Having staged a string of solo exhibitions in the 1990s, Martin gained wider recognition in the new millennium and was awarded the prestigious John Simon Guggenheim Memorial Foundation Fellowship in 2002. Six years later, he held what he calls his "first real breakout show" at Mitchell-Innes & Nash in New York. Described by the Chelsea gallery as "investigations in color, form and texture," the paintings he exhibited there incorporated elements of collage and materials as diverse as papier mâché and vinyl-record fragments. The work, though abstract in form, was still grounded in Martin's experiences and the world around him. It also signaled an evolution in how he approached his art.

"I'd been in this camp of the serious abstractionists, and I gradually started to let things go inside my practice," he says. "At that point, I started deliberately doing things... The paintings were stretched badly, or I was cutting holes in the paintings, or I was collaging all kinds of things into the paintings. I started working with bits of food and I started sticking on banana peels. Everything in my life and my studio practice just started coming into the paintings."

One standout piece from the Mitchell-Innes & Nash show was Martin's *Homage James Brown Godfather of*

Soul (2007), which took him several years to complete. Full of energy and complexity, the work epitomized Martin's newly liberated approach to artmaking. "Around that time, James Brown died, and I was surprisingly moved by that," he says. "I felt really sad about it. I had all these James Brown records and I started gluing them into the paintings. I just started bringing my life into my work."

That 2008 exhibition, which largely comprised artworks made the year before, also heralded a shift in how Martin positioned himself in the abstract genre. "The other thing was that I started bringing a lot of humor into the paintings," he explains. "I started to realize that the paintings that I loved made me laugh. I would see a great De Kooning and I would laugh, or a really goofy late Guston and I would laugh. It's not like you'd laugh at a Jimmy Kimmel monologue. It's a different kind of laugh, but it's laughter. It's something kind of absurd and crazy. I realized that I would recognize that in the paintings I was most excited by. And I started letting more of that energy into my own work."

Martin would go on to present shows at Mitchell-Innes & Nash in both 2009 and 2010. It's this period of his career he credits with another pivotal change to his practice, beyond the introduction of everyday materials and an element of slapstick: growing productivity. Whether or not thanks to the influence of Haring and Basquiat, or the uninhibited "outsiders" he worked with, Martin reached what he called "an opening" in his work that allowed him to produce art in a far more prolific manner. (He admits to previously being "into this romance, of 'I can't finish anything—the struggle—I'm really suffering—I'm so serious that I can't finish anything.'")

Many of his works continued to take years to complete. But by increasing the volume of paintings he was developing at any given time, Martin sidestepped the bottlenecks presented by the unfinished, difficult ones.

Circle of Regeneration,, 2017–2018
Acrylic, oil, collage, and glitter on canvas
58×49×2 inches

"I started a lot of paintings," he explains. "So I learned that what I needed to do was to have a lot of work in progress simultaneously. I was able to stock up lots of materials and lots of canvases, and that felt really great. If you're just working on three or four paintings, and one of them starts looking weird, you put all this energy into it like, 'What should I do with this one? This is an odd one.' But when you're working on 50 paintings, and you have something really odd, you go, 'Well, I don't know what that is,' but you can just leave it in the corner for a while.

"So it enables you to give birth to a lot of odd possibilities. You're not narrowing down; you're letting things go. And then, over the course of time, you see which paintings are finished and which come along. I've always made paintings over long periods of time. I've always gone back on my own work," he says, adding: "I opened my practice up so that I could paint different kinds of imagery, use different mediums. I was doing a lot of things simultaneously. And that to me, finally, was a natural state."

There are still, of course, tricky paintings. But this is something Martin has learned to deal with. "I have to hide them. I used to take paintings that were bugging me down to the cellar or into the boiler room. And then I could forget about them. Otherwise, you keep looking at them thinking, 'What am I going to do with this?' There's a discipline. You learn not to ruin things. If I want to work on a painting, I usually have to turn every other painting away."

One key to expanding his output was widening the notion of what constituted a reason to paint—and accepting that not everything had to be his best work. It's a revelation that Martin recounts through a conversation with his friend, fellow Williamsburg painter Peter Acheson.

"I remember us talking about the idea of making not just the 'good' paintings, or trying to make good paintings, but we would try to make 'all' the paintings. So if there was a part of me that wanted to make a really sappy something, I would make those paintings. If there was a part of me that

felt very serious, I'd make those. But I would make all the other ones, too. I started recognizing parts of my work without judging it so harshly and letting more of it all live."

The approach has seemingly paid dividends. Growing international acclaim for Martin's work has resulted in solo shows as far afield as Germany, Belgium, France, Israel, and Ireland. A monograph of his career to date, *Paintings*, was published in 2017. He also continues to exhibit extensively in the US.

"It's very exciting to work for a show," he says. "It focuses the mind, and you really work hard because you're going to be on stage and you don't want to embarrass yourself in front of all of New York. It gets you a lot of energy. On the other hand, it's great to have this break where I can work in a less focused way. Just play around."

Martin now divides his time between New York City and the Catskill Mountains a couple of hours north, where he also keeps a studio. As well as a change of pace and space, the upstate retreat sees him taking paintings outside to view them in a new light, both literally and figuratively. But his studio practice remains a fundamentally lonely endeavor, he says.

"I wish that it would be like, three guys come over here and we do the work together," he says, comparing solo painting to the more often collaborative process of making music. "That would be an amazing thing. And then it may be everyone gets on each other's nerves after a while, but that idea of collaborating? I envy that. It's tough to go into a room by yourself for hours."

On the Job

I did things that many artists do: I went from one job to the next for many years. I met the artist Alan McCollum when I was at Pratt, and anytime we were walking around New York he'd say, "I used to work here..."

—Lisa Corinne Davis

I was the super of a building. I would fix things. And I seem to have this funny aptitude for electricity.

—Dan Walsh

I always worked in restaurants, and I couldn't conceive of any life besides doing my art and then washing dishes at night.

—Steve Keene

I worked for Jeff Koons for a year, and what I learned was to be methodical. Before that, my palette was more chaotic. I'd be holding like five brushes and sweating.

—Jenna Gribbon

You know that feeling where, if you don't change something, it's going to become your life? I would have probably become a really good teacher. But the painting part would have died.

—Hiba Schahbaz

I was a seamstress; I had always made my own clothing from when I was in eighth grade. I ended up making clothing for people that I designed, and that's how I ended up supporting myself.

—Ellen Berkenblit

Tony
Matelli

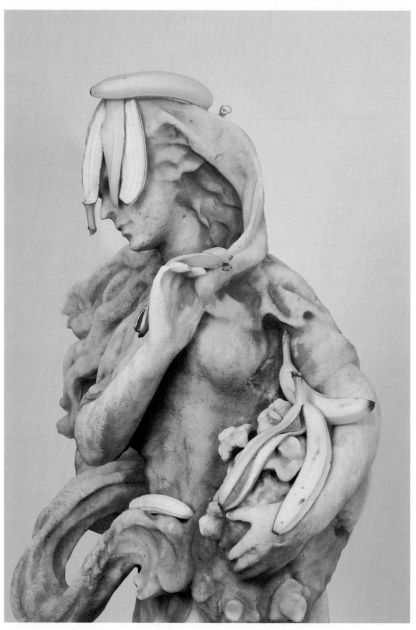

Woman in the Wind, 2017
Marble and painted bronze
68×31×18 inches

Why I Make Art

That Tony Matelli makes art, over any of the other creative disciplines that interested him as a teen, may owe to the fateful advice he was offered by his mother during high school.

"I knew I wanted to do music, architecture or art," he recalls. "I looked at my options, and thought I was better at music than art. [Then] I had a conversation with my mom that kind of changed my life. She said, 'Well, you don't necessarily have to do what you're *best* at, you just have to do what you like.' It blew my mind that she would say that to me."

Thankfully, Matelli's passion and talent coalesced in sculpture. His creations, whether grotesque human figures, upturned bronze plants, or disorienting stacks of everyday objects, are simultaneously unreal and hyperreal, familiar but unsettling. High-profile solo shows across the US and beyond, from Russia's State Hermitage Museum to the Aarhus Kunstmuseum in Denmark, are, perhaps, testament to his mother's wisdom.

But as Matelli discovered, success requires more than a passion and gift for art: it requires the discipline needed to run a studio. This was a skill he began crafting at Cranbrook Academy of Art in Bloomfield Hills, Michigan, where the graduate school's famously unstructured environment encouraged the kind of productivity he would later rely on (Matelli earned his bachelor's degree from the Milwaukee Institute of Art & Design—an education he describes as "super provincial").

"You learn right away who's serious and who isn't," he says. "You learn about a studio practice, and that, to me, is the most critical thing. How do you generate your own ideas for no good reason? How do you continue working when there's no assignment? That was all really valuable."

These lessons proved crucial as he secured his first gig in the commercial art world. Just weeks after relocating to New York City in the mid-1990s (among what he calls "the last wave of artists" moving to Williamsburg), Matelli

landed a job with Jeff Koons, creator of some of history's most expensive works of sculpture. He joined as an assistant during preparations for *Celebration*, a series that included Koons' now-iconic *Balloon Dog* works.

The young Matelli, then a self-professed Koons fan, found himself at a studio in "chaos" and "going bankrupt constantly." (It is, he clarifies, "run very differently now.") But the pressured atmosphere was both fun and, as he affectionately describes it, "bonkers."

"There was some real talent there," he says. "You learn how to work fast in that environment, too. It's like, 'OK, we need to get this done, and the clock is ticking.' In your own studio, you can hem and haw, but when you're in an environment like that, where it's really about money and deadlines, you learn real quick to cut through the bullshit and get stuff done. And I've internalized that pretty well."

Spending around two years in Koons' studio, Matelli was meanwhile hard at work in his own. "When I had my first show, my dealer at the time said, 'You know, Tony, you are never going to have this much time to work on a show again in your life.' And that was obviously true... I was terrified and nervous, so it didn't feel like a luxury at the time, but you realize it is."

The resulting works and solo shows at the likes of New York's Basilico Fine Arts hinted at what was to come. "I was making a kind of quasi-figurative art that was stylized in a kind of dignified way, but usually [it] would focus on figures in crisis," Matelli says, using one of his early works as an example: "I made a sculpture of two seals—a mother seal and a baby seal—in a pool of oil with a 'theme parky' kind of rendering. And I liked the contrast of those two things. [The seals] were kind of nuzzling one another, so it was a kind of loving gesture that the mother was giving to the dying child."

Such hints at the absurd may explain why the word "humorous" is so often applied to Matelli's work. But while it is a description he recognizes, it is not one he will indulge.

Why I Make Art

"I know that [humor] is in the work, but I don't think about it much," he says. "And I honestly don't really think any of it is very funny. I think the work is dead serious."

Perhaps, then, viewers' amusement is an instinctive response to the disquieting nature of Matelli's creations. His wide-ranging body of work features deconstructed faux-meat faces crawling with tiny flies; fruits and vegetables resting precariously on Greco-Roman-style statues; and naked silicone figures standing on their heads, their hair and genitals appearing to defy gravity. The artist's best-known creation, *Sleepwalker*, which depicts an alarmingly realistic male figure lurching forward wearing only under-wear, sparked significant controversy when it was installed in the grounds of Massachusetts' Wellesley College in 2014, with students suggesting it could prove triggering for victims of sexual assault.

"The language of the grotesque is the collision... of humor, and maybe something abject or something violent, or the playful rendering of something really horrendous or more serious," Matelli says. "And those things, when they collide, form a kind of friction that is 'the grotesque.' It's that moment where you don't know if it should be pretty or you don't know if it should be funny. It's confusion. I have always been attracted to that moment in art."

Matelli likens this to dreaming or watching David Lynch films, whereby things are "just slightly off." Indeed, the sculptor's habit of putting familiar objects in unex-pected configurations can give them a new, uncanny character.

"You can make sense of what the objects are," he says of his work. "You can see what they are; they are clear in what they represent. But they don't always make sense together. They don't always add up in a way that is coherent. And that's important. It's like a magical real-ism kind of attitude. It's not a Surrealist thing, where things are shape-shifting and moving around. It's more just two strange things put together that make another thing.

"I was never really that interested in creating a new visual language," he later elaborates. "What I like to do is use existing vernaculars to communicate quickly, and to use them almost as ready-mades."

The act of breaking down and reconstructing objects' meaning also relates to the experience of taking psychedelic drugs, Matelli says. "This is a cup," he offers as an example. "I know this is a cup, and there are all kinds of meaning in this object right now. Its contents are known to me, so I see this as a cup. But when you're on psychedelics, it's a way of breaking down the content of objects... you see [the cup as] a cylinder that is made of paper."

The meaning of objects also changes with the context they are presented in. An invitation to show work at the residence of late Bay Area sculptor David Ireland in 2018 offered Matelli an opportunity to consider how his art would translate outside a conventional studio or institutional setting. After all, he reflects, his creations will invariably wind up in homes—those of the people who collect them, specifically—meaning that his art is created in an environment "that is so completely foreign to its final destination.

"Artists don't ever get to show their work in houses the way they want to," he says. "They always see their work in houses, and, speaking for myself, it is never how you want it. It's always a compromised kind of situation because you conceive of the work outside of the domestic environment. Most of us think about a white wall in an empty space, so you can see the piece, and that's it.

"[But houses are] where it goes; that's where it lives, so actually it really should be made in that environment," he adds, joking: "I should put some couches in here—and some drapery."

He is referring, of course, to his studio in New York, where he has lived and worked since his Koons days. Born in Chicago but raised in Delavan, Wisconsin, Matelli grounds his practice in his adopted community. The days of cheap Williamsburg studios may be long gone

Figure 1, 2015
Silicone, steel, urethane, and hair
67 × 18 × 8 inches

("You could grind metal on the sidewalk," Matelli recalls of the 1990s, "you could do anything you wanted, and it felt so much freer than the Lower East Side, where the hipness was"), but living in Brooklyn still has its benefits. Regularly bumping into fellow artists like Joe Bradley and Haim Steinbach, for instance, offers Matelli an ongoing source of inspiration, even if their work does not strictly overlap. "Meeting people is really useful. I run into people on the street all the time," he says. "Making those connections is so valuable, and makes you feel like you're 'in it.' It isn't just valuable in a mercenary sort of way, it's valuable in a wholesome kind of way... You can say we're walking the same streets. We're in the same game."

Tomokazu Matsuyama

Tomokazu Matsuyama was born in Takayama, Gifu Prefecture, a large but sparsely populated city in the midst of the Japanese Alps with a rich history of kimono-dyeing, ceramics, and lacquerware. But the artist's earliest creative memories are set further afield, in Orange County, California. After moving there with his parents and older brother when he was eight years old, Matsuyama was enchanted by the city's emerging skate scene and graffiti, as well as the DIY esthetic that surrounded them both.

"Those skaters-slash-artists influenced me a lot," he recalls. "Coming from the middle of nowhere in Japan, being exposed to that culture was quite a shock, which wasn't bad at all, actually. One of my mom's friends was dating John Grigley, one of those early pro skaters who did their own skateboard deck design. I would go visit them with my mom, and they would give me random sketches.

"I was always trying to copy those skate decks and those influences that I had—not that I think that was any type of artwork or anything. It just very naturally grew, and I kept drawing and drawing."

Matsuyama only lived in California for three and a half years before returning to Japan, but when he did, he had "pretty much become an American kid," bringing with him a stash of Bones Brigade T-shirts, heavy metal cassettes, and an interest in drawing and skateboarding. But transitioning back to life in Japan wasn't always easy.

"Japan is so isolated. There are really no neighboring cultures, it's surrounded by the sea," Matsuyama says. "It was hard going back and readjusting myself after being in LA and becoming a different kid, because we were living in a very conservative part of Japan. They don't have this rule at schools anymore, but at the time you had to have one of those buzz cuts, and all the uniforms looked like military uniforms. You needed to wear a helmet to get on a bicycle. It was full of restrictions. On top of that, there was no one else who had returned from another country. So I did get picked on pretty hard for just being a little different."

Beautiful Stranger Beyond The Sunshine / Nothing's Burning Underground, 2018
Acrylic and mixed media on canvas
67×105×1½ inches / 68×105×1½ inches

Making the most of Japan's mountain ranges, Matsuyama shifted his interest in skateboarding to snowboarding while in high school. But academics became a primary focus. His parents enrolled him in a Tokyo boarding school where he had a "classic 'study-for-ten-hours-a-day' Asian education," he explains.

After graduating, Matsuyama enrolled as a business management major at Sophia University in Tokyo, which his older brother, who also attended, told him was the easiest course of action. The program was flexible enough that he was able to take a year off to pursue a career as a snowboarder between his junior and senior years, after finding a brand sponsor. ("When it comes to college in Japan, you just have to study until you get in. Once you get in, you have four full years of freedom," he explains.)

"I wanted to see how much further I could take snowboarding, and I came to the US to attend snowboarding

We Met Thru Match.com, 2016
Acrylic and mixed media on canvas
100×240 inches

camps and do some shoots. By then, I was becoming some-
what of a semi-professional snowboarder," he explains.

When he was 21, Matsuyama broke his ankle while
training. The injury required surgery and stopped him from
walking—let alone snowboarding—for 11 months, at which
point he decided to recalibrate again.

"I realized I would probably be able to do this for
several more years, if I was lucky, but not longer than that.
I was still going through this business management de-
gree, but I thought that creating something visually, which
I've always enjoyed doing, was something I could do my

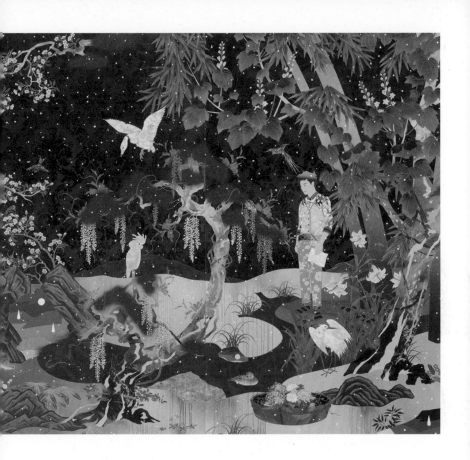

entire life. So then, still being a little bit realistic, I decided to pursue graphic design. While I was in my last year of college, I didn't do any corporate job interviews. I decided to go to this night school program to see how graphic design is, and I got really attached to it."

After finishing his business management degree in Japan, inspired by the artist-skaters he encountered in LA as a child, he reached out to his contacts for work. "I took all of the artworks I created to the sponsor that I used to ride for and all these magazines that I used to be featured in. They would give me these projects... A year or two later, I

actually became a creative director for one snowboard company, and was in charge of doing all the decks, ads, apparel lines, and stickers. Everything. So that really became an outlet."

In the early 2000s, Matsuyama relocated to Brooklyn, where he's still based today, to pursue an MFA in communications design at the Pratt Institute, living off his income from the snowboarding industry.

"I still remember meeting some fellow artist friends of my generation, maybe a little older, who were quite active, like KAWS and José Parlá. This group of artists really influenced me. I was like, 'Wow, becoming an artist is an option in life.' So I finished my studies at the Pratt Institute in two years. I remember that by the time I had finished my first semester, I kind of knew that I wanted to become more of a fine artist," he says.

"That was when a lot of galleries were starting to pop up in Chelsea," he continues. "I really wanted to see how the contemporary art world functions, and I was very lucky to become an assistant for this one painter who then I think showed at Paula Cooper. His name's John Tremblay. He was a minimalist—well a lot of artists at Paula Cooper are minimalists—which is kind of rich because it's pretty much the opposite to what I do now. But he had a couple of assistants and I saw the work and that was a big influence. I was there for maybe four months—I helped him for a big show that he was prepping. That made me want to step into where I am now."

Today, Matsuyama is known for colorful, often collage-like paintings that respond to his experiences navigating between Japanese and American culture. He has drawn inspiration from both sides—from Jackson Pollock, Pop Art, and graffiti to manga, the Meiji era, and woodblock printing—often merging Japan's historic focus on decorative art with Western conceptualism.

Rather than playing up the geographic and esthetic differences between his two homes, Matsuyama

emphasizes cultural hybridity in the age of globalization: "I don't like the term 'East meets West.' It's more 'East is West.' I mean, come on: If you circulate through, they go the same direction'" he explains. "It's so naturally, kind of organically, blended together that the boundaries are really not there.

"It comes down to patchworking different esthetics," says the artist, who has referenced works from the likes of Picasso and Hokusai, as well as abstractionists Sarah Morris and Sam Francis. "If I incorporate several different masters within one work, it looks like it's none of them, you know?"

Music has inspired his sense of hybridity as much as his own bicultural upbringing: "I got the idea from sound producers sampling a lot of different notes. I could use the term 'readymade' or 'appropriation', but it simply came from the type of music that I listened to," he says.

If Beastie Boys and early hip hop sparked his appreciation for sampling, living in New York accelerated it. "Being in New York, you just meet everybody really. You meet DJs, musicians, rappers, composers. That's when it really came down to mish-mashing everything. Everything has its own beauty, and it just naturally led to this kind of a mess."

Like skate culture, with its emphasis on DIY, music has provided Matsuyama with a model for what can be achieved when an artist looks at boundaries as fluid rather than fixed. "Musicians are so translucent in the way that they shift from one genre to another. It's just so free. When I first stepped into the contemporary art world, there was a lot of 'You can't do,' 'You shouldn't do.' There were so many rules," he says. "But I think those rules are becoming looser and looser. People are getting bored of being told what you can and can't do."

This is especially exciting for an artist like Matsuyama, who has not only blurred the limits of genre but also the definition of what constitutes art—something he first observed from the skaters who could turn stickers, T-shirts, and pins into bold artistic statements, but also in his own

Japanese culture, where folding panels and teacups could be considered masterpieces. Though fine art remains his focus, Matsuyama has also done collaborations making artwork for snowboards, skateboards, clothing, and toys.

"When I see art in the West, it's really about authorization, right? It can only be 'art.' Whereas in Japan, the most valuable, the most highly thought of art was always utilitarian art," he said.

"I can still create a T-shirt, but I can also make these massive paintings that go on to a museum. And I think that is what makes our generation interesting and unique: pretty much anything could be artistic these days."

Geoff McFetridge

2020, 2020
Acrylic on canvas
60 × 44 1/10 inches

Why I Make Art

Born in Calgary, Alberta, in 1971, Geoff McFetridge grew up on a potent mix of local garage bands and skateboard magazines, notably the scene-defining *Thrasher*. These formative interests helped propel the young Canadian into his multidisciplinary career, including his first job, as art director for the Beastie Boys' *Grand Royal* magazine. **"I** was always the kid who drew, then I became the guy in our group of friends who like, if you wanted to make a zine, I'd do the cover and the layouts. If you had a band, I'd do your T-shirt," says McFetridge. "That doesn't come from being the best drawer in the class," he adds. "I didn't get the highest grades in art class or anything, but I liked it the most."

Now based in Los Angeles, McFetridge has come to be known for his work featuring anthropomorphic forms rendered as simple geometric shapes. He breaks down figurative imagery to its key components with a graphic-art clarity that somehow leaves nothing and everything to the imagination. He continues to take on design commissions for sport, street, and skatewear brands including Stüssy and Nike through his design firm, Champion Studio. He's also left an indelible mark on the world of snowboarding.

Around the age of 16, McFetridge started creating artwork for The Snowboard Shop, a local haunt that catered for Calgary's snowboarders and skaters. There was little delineation between the two sports, so the same teenagers who were hitting the slopes in winter were also riding handrails in summer. In 1993, one of McFetridge's friends, Jon Boyer, turned pro and won a sponsorship deal with Barfoot Snowboards. "It went from drawing on his skate-board with felt tip pens to 'Would you do my graphic?'" He says. "Then his company called me and said, 'Would you do all our graphics?' So, the next year I did all their graphics for them and they didn't even know who I was." By McFetridge's recollection, this early commission was the first time a snowboard graphic had been made on a computer.

The eighties and early nineties were the Wild West for snowboarding, which had been around since the 1960s and was then, decades later, gaining fast popularity. Snowboarders pioneered new ways to promote their sport, which was largely banned from US ski resorts and ignored by the Olympic Committee until 1994. Meanwhile, the snowboarding industry was keen to develop a visual identity that represented its irreverence and breakaway attitude towards traditional sports. Luckily, eager artists like undergraduate student McFetridge were on hand to lend their radical design sensibilities to the cause.

"My standard for pen and ink drawings was Pushead," says McFetridge of the American graphic artist known for creating hardcore artwork for bands like Metallica and the Misfits. "My standard for graphic design was the stuff David Carson was doing or what Jim Phillips was doing in the world of skate graphics. So I had this gnarly but great visual culture, and that definitely had an effect on me. I didn't know any artists, but I knew what I liked and I knew it all came from California."

Swapping the inclement weather of Alberta for the West Coast was an easy move to make when McFetridge decided to do his MFA at the California Institute of the Arts. Despite being offered a scholarship to study illustration at the School of Visual Arts in New York, he figured he already had experience in that field and was on the hunt for a new challenge.

"People were using design as self-expression," he says of that period in the mid-nineties. "I wanted to explore the unknown, so I went to CalArts and just immersed myself in typography and design. What I learned there was how to critically use the conceptual process to make work that is still applicable to what I do today."

While under the guiding hand of American graphic artist and tutor Edward Fella, McFetridge forbade himself from doing any drawings for two years. He reinvented his practice and chose to work with rubber stamps, printmaking,

graphics—anything that marked a departure from the illustrations that had come to define the ostentatious skateboarding esthetic.

But, as is often the case, the best laid plans went awry. "Immediately when I graduated, I went straight back to working with skateboards," says McFetridge. "I just sort of got spit out the other side, got on my feet and I needed to make money to buy a computer. I returned to where I left off, but everything had changed. My thinking had changed, so I started applying that thinking."

Bringing his newfound learning and conceptual understanding to the process of pairing text with images ended up paying off for the young graduate. After participating in a poster show in 1999, a design of his caught on big when it found its way onto a T-shirt produced by Japanese/American label 2K by Gingham... The stencil-like image depicts a teddy bear sitting at a bar with a drink and a cigarette above the words "I'm rocking on your dime." For those in the know, the original T-shirts are now collectors' items.

"I did a number of things like that which were operating in the commercial realm," says McFetridge. "In that I was getting asked to do projects but I was just pulling directly from my personal work."

Another breakthrough moment came when he was included in the influential 2004 traveling exhibition Beautiful Losers, named after a novel by Leonard Cohen and curated by film director Aaron Rose. The show featured the works of many practitioners working at the edges of the art world and crossing boundaries between disciplines. Other artists on the roster included Thomas Campbell, Cheryl Dunn, Shepard Fairey, Harmony Korine, Clare Rojas, Barry McGee, Margaret Kilgallen, Tobin Yelland, Mike Mills, Ed Templeton, and KAWS—the majority of whom, a decade earlier, had been bona fide misfits exhibiting work in Rose's Lower East Side gallery in New York, Alleged. Beautiful Losers was designed to spotlight the DIY visual cultures of

skateboarding, graffiti, surf, punk, and hip hop, and to give these breakaway artforms a voice on the world stage. The group involved would prove sympatico company for McFetridge, with Fairey going on to found Obey streetwear and finding fame with his own graphic designs, while Templeton founded skateboard company Toy Machine.

A winner of the Cooper Hewitt, Smithsonian Design Museum's prestigious National Design Award in 2016, McFetridge has made light work of bridging divides between art and commerce, and extending to the world of film. He created graphics for Sofia Coppola's *The Virgin Suicides* (1999) and Spike Jonze's *Where the Wild Things Are* (2009) and *Her* (2013).

These accolades and big-budget ventures might appear like a misstep for an artist who cut his teeth in a cultural milieu that was staunchly anti-establishment, but McFetridge swiftly addresses this matter in the *Beautiful Losers* documentary created for the titular exhibition. "This is the game. Are you gonna decide you're playing the game or not playing the game?" he posits. By looking at the long list of international collaborations and accolades bestowed on McFetridge and his peers, it seems they all rolled the dice and won.

In 2001, for his solo show titled The Rock Machine, McFetridge made a series of engraved, handmade throwing stars that he launched into a wall at the Colette concept store in Paris. No repeats and no takebacks appeared to be the motto of the decade. However, in the years that have followed, he has built an art and design practice that accepts nothing less than repeated perfection—albeit with a healthy disregard for preciousness.

"My assistant gets frustrated because I'll stack paintings on each other or put a coffee cup on them and he's like, 'Look, you gotta treat these with more respect,'" says McFetridge. "But I'm used to it because so much of the meticulous process is about courting disaster. What I'm doing is sketchy. I'm cutting on the canvases, I'm doing

Image Based Gamelan 8 Right to Left to Right, 2020
Acrylic on canvas
41×72 inches

stuff where I have one take and I'll have one take ten times in a row and any one of those could fail."

He employs a punctilious process that is similar to how a designer might make various renditions of a graphic for a client. Typically, McFetridge does a series of small sketches on a pad, then chooses one to develop on a larger sheet of paper where he plays with scale, reflection, and levels of abstraction. For other projects he will scan, trace, redraw, retrace, and continue going until the final image bears little to no resemblance to the original.

"I'm becoming like Adobe Illustrator. When I look at my line I'm like, 'Oh, that's a perfect curve,'" says the artist. "I can see where the toggles are and I often draw rectangles around my drawings. I don't let them float on the page."

From animation and ceramics to textiles and wallpaper, McFetridge's creativity seems to have no bounds. And across the board his work has a visual vernacular that is akin to a well-rendered company logo—it's transparent and emotive. Nevertheless, he approaches each project by

asking the same question: "Instead of being in service to commerce, can design be used in the service of expression?"

In 2020, McFetridge went back to where his career began—with the Beastie Boys. Apple TV commissioned the artist to create five illustrated posters to promote the Spike Jonze-directed documentary on the influential hip hop group, *Beastie Boys Story*. In the same way McFetridge returned to designing skateboards after graduating from university, and how his practice relies on multiple passes of the same sketch, the artist's work and career can be said to follow the path of a Möbius strip. It moves along a single continuum that folds back onto itself, seeing the world from a slightly different but congruous perspective, forging ahead with renewed purpose.

Maysha Mohamedi

Curious at Any Cost, 2021
Oil on canvas
73×83 inches

Why I Make Art

American abstract painter Maysha Mohamedi remembers reading a book she got from the University of California library about the personality traits of scientists.

"The author came up with categories of behavior, and one specifically was about idiosyncratic actions that lead to discoveries," she says. "These scientists are following actions that are so idiosyncratic to themselves and their laboratory procedure that they get led to that novel discovery. That's exactly what every artist is doing. Every day they're getting more in touch with that thing that is so specific to them and trying to carry that out in some sort of visual form."

At the time of her library trip, Mohamedi had just completed a degree in cognitive science and was embarking on a PhD in neuroscience. "I really loved science—all the tinkering and the beakers, the measuring and the math behind it," she says. "It sounds gross, and I don't think they would allow it now, but in school we dissected a cat and I was so fascinated by that

"Having been through a phase where I was a scientist and worked in a lab, I feel like art studios are very much like a laboratory space where you're keeping records of data," she continues. "If you're a ceramicist, you're going to keep a record of glazes—if they've worked, how they've worked, or color mixing. There's a lot of similarities, but you wouldn't know that until you're in the practice on a daily basis."

To create her large-scale abstract work, Mohamedi treats her studio like a lab where she can experiment with unorthodox painting tools. Often these are found objects imbued with special energies—tar balls found on a beach trip, her son's toy car, a pebble from her driveway—that she dips in paint to create marks on a canvas. The result is an alchemical approach to painting that produces protean shapes and magnetic fields of color.

"That sensation of getting a sheet of stickers and covering the car, or drawing on your bedroom wall with a pencil in your toe, or something weird like that, those kinds

of sensations are very important to me," says Mohamedi. "That's the sort of release I want to have when I'm expressing something onto the surface. That something could be an emotion or a more general idea that doesn't have anything to do with me personally. It could be a variety of things. I know how to get in the flow of painting quickly because I'm so in touch with what I'm doing. I have specific pencils and discarded objects, and things I know that drag on the canvas in a certain way. It's all about that sensation for me." Despite her scientific background and analytical mind—she knows, for example, that green artwork is statistically less likely to sell at auction—Mohamedi is uninterested in demystifying the unconscious energy that drives her art. In fact, she shields herself from anything that might influence her work.

"I don't look at that much art because when I look at something, my hand knows how to do it... I love old masters and all that stuff but I have to be careful about what I look at because I want to make something that feels pure and from me alone. Maybe that's impossible but I'll do my best to try."

As a result, the individuals that stoke her imagination are more likely to be found on a list of Nobel Prize winners than they are in the index of an art history book. "I think computer scientists are some of the most creative people because that kind of thinking is so abstract," she says. "Your brain has to move in a lot of different directions to be able to solve coding problems."

Mohamedi recalls the reassuring aspects of studying science. "In my science classes, how to excel was so straightforward. If I studied, I could get a 90 out of 100 on an anatomy test—It was just so figure-out-able," she says.

By comparison, the unfathomable subjectivity of art led her to question herself. "In my art classes, I was in drawing and ceramics, I was so confused about how to get a good grade. That was such a roadblock," she says. "I distinctly remember a class where there was a painting assignment

for a still life. I was really happy with mine and I think I got a B but there was no explanation. I didn't understand why I got the B."

Mohamedi pursued a career in science, and traveled to Tokyo in 2004 to take up a National Science Foundation Fellowship. It was 5,000 miles away from home, and when faced with the prospect of spending six years researching "a very specific neural pathway"—a fate that seemed so limiting to her creativity—she realized she wanted to become an artist. "I made paintings in my little apartment. I went to the Japanese art store and I bought stuff and I made terrible paintings. My colleagues knew I wanted to be an artist, so they took me to the museums. They were so generous, and gracious, and wanted to treat a visitor with the utmost respect."

When she returned home, Mohamedi audited art classes at San Francisco State University for two years, carried out independent drawing and sculpture projects, and used that work to apply for an MFA in painting at the California College of the Arts. She explains how her lack of belief in art as a viable career delayed the start of her own professional commitment. "I feel like I spent many years teaching myself that it was OK to be an artist. In a way, I think I lost some time there. Also, I didn't respect the idea of art. I thought that if I went into art, I'd be in this class of people who are more likely to get pregnant out of wedlock. I had this puritanical vibe about it and I don't know where I got those ideas. In high school, I just had this vague idea that it meant you were promiscuous."

Faced with what she describes as the "first-generation pressure" of choosing a successful career (her father and mother moved to the US from Iran in the sixties and seventies, respectively, and met in Los Angeles), she felt her options were restricted. "I could only look at the professions around me—doctor, scientist, nurse, teacher, really general things—and pick one. But I had the fantasy of being an artist. It was always with me. I remember in my second year

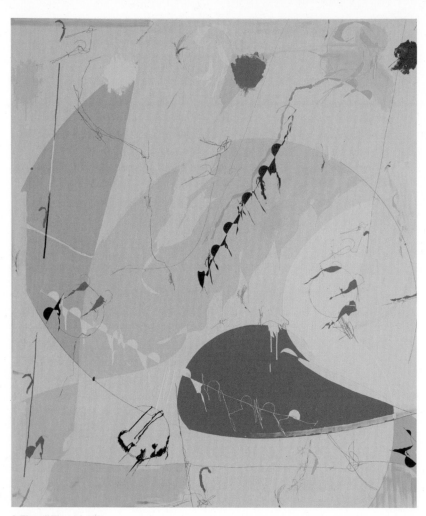

Is That All There is?, 2021
Oil on canvas
88×77 inches

Why I Make Art

Candy Shell Inc, 2021
Oil on canvas
88×77 inches

Maysha Mohamedi

of college I went to the career center and learned about being a scientific illustrator. This was a pivotal moment in my life. I looked into it pretty deeply and determined that I'd have to tack on an extra year. I went and did a tour of the MFA studios. I kind of walked around and I saw one person slumped over on a couch, and I concluded that artists are lazy and I don't want to be one. Nobody was working. So, again, I was judging and it's taken me a long time to grow out of that. I didn't have the bravery to do it at that time."

Born in 1980 in LA, the artist's family then moved away when her father opened a fried-chicken fast-food restaurant in the farming community of San Luis Obispo, a city near California's central coast famous for Bubblegum Alley, a 70-foot long alley lined with chewed gum. Mohamedi's "crazy dark country upbringing where you just see weird things," came with a level of freedom that gave her time to get creative with her friends, draw incessantly, and watch her interior designer mother paint.

"She paints symbolic landscapes that represent the US and Iran," says Mohamedi. "There are bodies of water, horses, and architectural forms that are very Middle Eastern. Now, I'm looking back at them with greater appreciation. The thing I got most from seeing her work was witnessing the calligraphic line that's present in Persian miniatures and Farsi script."

Mohamedi has said that engaging in creativity as a person of color can feel like a privilege, especially in the case of abstract art, which provides an opportunity for expression free from the archaic systems that interweave identity with artistic intent. In a research project that she submitted to the Institute of Contemporary Art in Los Angeles (ICA LA) in 2020, Mohamedi posed a simple question: who are the BIPOC abstractionists? To investigate this query further, she joined with fellow abstract artists Laura Owens and Lisa Diane Wedgeworth to help set up and facilitate a research discussion group. Mohamedi's successful ICA LA bid resulted in a presentation, live discussion, and a

crowd-sourced database of almost 400 abstract artists, past and present, that is regularly updated.

This project celebrates Black, indigenous, and multiracial artists while also addressing the fact that, historically, art created by these groups has often only been seen as valid insofar as their racialized background informed their work.

The source material Mohamedi draws from is decidedly idiosyncratic. A 1972 edition of Family Circle's *Illustrated Library of Cooking* has become the unwitting companion to much of her recent grand paintings, for instance. She takes her color palette directly from the pastel-toned pages of the bygone women's magazine and creates work redolent of apple-pie America and femininized domesticity.

Birdie on the Back of a Sleeping Tiger (2020) borrows the same shades of yellow and orange used in a recipe illustration for rhubarb and custard, while *Aloe Cuts* (2021) splashes shocks of faded blueberry and pistachio over a washed putty canvas that brings to mind Formica lunch trays and sun-bleached pages.

When Mohamedi presented the latter painting in 2021 under the show title Sacred Witness Sacred Menace at Parrasch Heijnen Gallery in LA, the world was still dealing with a different crisis of domesticity. "The pandemic is not that different from having a baby. You're kind of trapped and the walls are closing in," says the artist. "When you have a new baby and you have to pump every couple of hours, it changes how you operate, your energy levels, toxins... To embrace whatever space and time restrictions you are facing can really open up doors in your work."

The artist says she prefers the more analog, slower pace her family life has taken since the pandemic. "I see it so strongly in my kids because they have started playing differently. The way their daily life is structured is much like how my childhood was in the 1980s. They find an old vitamin bottle and entertain themselves with that for two hours making up games, or they'll play with just random things they find in the garage. They never used to do that stuff

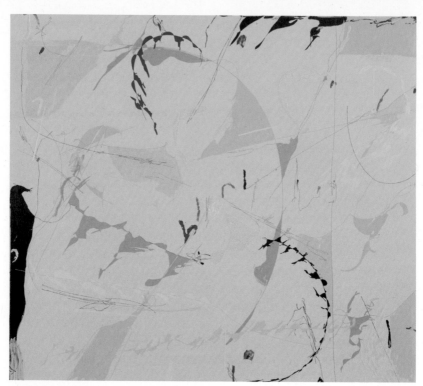

Laura Dern's Voice, 2021
Oil on canvas
73×83 inches

Why I Make Art

before. To see them act that way and evolve and adapt so quickly to the changing terms was really uplifting."

The artist displayed the same fortitudinous spirit at the start of the pandemic when an earlier exhibition had to launch as an online-only event. She explains how it felt by offering this analogy. "If you're someone who really likes chocolate, you'll be happy with a Hershey's Kiss, even though some high-quality chocolate is better. Right? So maybe my online work is just satisfying the Hershey's Kiss level."

Growing up in an environment that is constantly challenged by earthquakes and drought, Mohamedi has learned to work with uncertainty. Another life-disrupting experience she and her family faced took place in November 2018. The artist recalls getting caught up in the deadly Woolsey Fire which burned across 97,000 acres of the Los Angeles and Ventura Counties. "We had just bought our house and a month after that we had to evacuate. For several weeks we were thinking our house could burn down," says Mohamedi. "So, I feel like the natural disaster vibe has been ever-present in the last couple of years for me."

But no matter the external turmoil, Mohamedi manages to home in on that well-practiced Californian art of finding inner peace. "Everyone is kind of going through the garage, which is where I work. My husband does CrossFit, so there's all this gnarly weight equipment. There are points when I'm painting and the kids are screaming—you know, with joy, I'm not talking about fighting. The *Frozen II* soundtrack is blasting and I'm in this cone of light. I feel like my mind control is so strong because I can make a painting in the midst of that much chaos... Also with the hellscape of the pandemic in the background."

Chaos and adversity, it turns out, can be seen as a boon. "From the very first week of the pandemic this word came into my head—'rupture.' I feel like that word can be positive or negative or just neutral," says Mohamedi. "So much good can come from rupture. Like a rupture of old systems, a rupture of everything we've understood about how society

operates, class systems, and all these things are obliterated and destroyed on a certain level."

Traditional art institutions had to stomach a lot of change in order to survive the pandemic. Museums digitized more of their collections, artists' talks were made available for everyone to watch via Zoom, online sales of artwork increased and NFTs entered common parlance—and the demand for these were testament to the long-awaited digital evolution of the art world.

"Most people experience shows online. So the pandemic is just improving the interface in a way that really democratizes the experience," says Mohamedi. "You can even see the prices of art, and of course I feel a little weird about that, being the artist, but it would be really exciting if I weren't the artist. Usually, you have to sheepishly ask for that information."

True to the spirit of democratization, Mohamedi was one of the original co-founders of the Los Angeles-based art collective the Binder of Women, which today continues to engage audiences and galleries with art made by women. The name of the group references a political gaffe US state senator Mitt Romney made during a 2012 presidential debate with incumbent president Barack Obama. When questioned by a member of the audience on how he would tackle the pay disparity between men and women, Romney responded that he had been handed "whole binders full of women" to help him find eligible candidates to serve in his cabinet. The phrase quickly became a meme and was used to mock patriarchal structures and business leaders who were seemingly incapable of finding ways to recruit women.

As with politics, the art world is not immune to gender-based discrimination. The Binder of Women takes steps to redress this fact by creating a platform that will bring attention to the work of women and artists from under-represented communities, joining a movement to diversify the art collections in galleries around the world. Initiatives like this have the potential to change the future for young

girls, as well as individuals from marginalized backgrounds, who may one day choose the artist's path. Mohamedi, who used to think of herself as a scientist moonlighting as an artist, has come a long way. "I didn't call myself an artist until maybe a couple of years ago," she says. "Now I shout it from the rooftops. It feels normal to me."

On Making

Periodically I have to convince myself I'm starting over again. I don't know why. I need to fool myself into thinking this is a whole new thing, like, I'm starting from ground zero.

—Byron Kim

My rule for myself has always been: It doesn't matter what the output is, save the judgment for somebody else. Make sure that you're giving yourself the space to let things out.

—Austyn Weiner

I don't ever want there to be a painted mark that doesn't refer to a stitch in fabric, or the marling of a sweater, or a strand of hair.

—Michael Stamm

The melancholy of being an artist is that there are some things our sub-conscious won't let us do. I can't live in a symmetrical world, so I have to break it.

—Stephen Westfall

I love the idea that people are constantly trying to make sense of things, and always trying to make things extraordinary. And it always collapses. That's the human condition.

—Ellen Harvey

I have this idea of what I want my studio practice to be and it's very clear, which is good, but it's getting there which is difficult.

—Justin Liam O'Brien

Liz
Nielsen

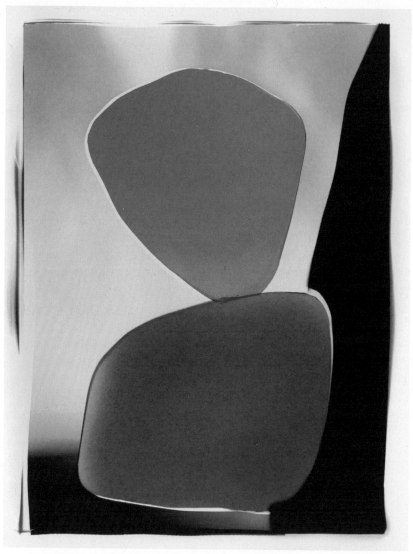

Kissing Stones, 2021
Analog chromogenic photogram on Fujiflex
43×34 inches

Why I Make Art

Before she knew anything about electromagnetic frequencies or wavelengths, photographic artist Liz Nielsen had been enthralled by the properties of light. "I had a strong interest in color when I was a kid," she says. "I would go and spend all my allowance on food coloring and then mix it into different amounts of water. Then I got into putting it into little sandwich bags. I would mix colors into them and hold them over my eyes so I could see the world through one shade."

One only has to substitute Nielsen's childhood invention for a light source and a darkroom to see that not much has changed over the years. From her studio in Brooklyn, Nielsen makes camera-less images by working directly on light-sensitive paper. She creates handmade negatives, and projects different types of light onto collages of shapes, gels, and transparencies. The result is a luminescent study of the topography of light.

"I'm probably one of the most technical photographers that I know, and that means inside the camera and outside the camera," says Nielsen. This is due in part not only to her longstanding curiosity about color and light but also her comprehensive résumé that extends beyond the bounds of art photography. Before the artist earned her BFA in photography from the School of the Art Institute of Chicago in 2002 and her MFA from the University of Illinois at Chicago in 2004, she worked as a studio assistant for sportswear brand Eddie Bauer and retailer Nordstrom.

"I just went in and got this job where I basically set up lights and loaded film and did all the grunt work," says Nielsen. "It wasn't actually where I wanted to go, but I had my hands on new cameras. I had my hands on 4 × 5s, I learned how to load sheet film and work with Hasselblads and things like that." This formative experience, at the heart of the commercial photography industry, helped the young artist get familiar with the entire photographic process.

"I'm very focused on the math within the work, even though it has a really intuitive quality," she says. "Every

color requires light wavelengths to hit the paper in certain ways. So, if you look at the photograph you can tell that there's a sense of control in the colors that I'm getting."

The show-stopping results of Nielsen's vibrant photograms—the term originally coined by early photographer László Moholy-Nagy to describe prints created without a camera—may be the result of math and rigorous testing, but there is much more room for surprise than the images let on.

"Some of the work is a lot more planned, where I'm mixing colors very specifically through different transparencies," she says. "Sometimes when I'm using the cardboard elements and I'm just literally throwing different flashlights, handheld lights, toy lights, all that stuff, that's when I get a lot of surprises, but I'm learning how to tame it."

The allure of Nielsen's work lies in how variegated materials, accidental light spills, uneven surfaces, and a whole host of other imperceptible factors can change the outcome of an image. "I make negatives out of anything, and they're not slick," she says. "I'll just dig through the garbage and use a random piece of paper. I'm holding things up to the light all the time because they have these different pulps, textures, and ways of letting light through at the edges. Sometimes if you print cardboard in the negative carrier, that corrugation shows up. It's beautiful." This means that no two photographs can ever be exactly the same. And any chances of creating a duplication is hindered by the fact that Nielsen practices her alchemical art in pitch-black darkness.

"It's super performative. I actually practice my movements," she says. A well-choreographed dance in the darkroom is essential to creating the results seen in her photographs. Before her spectator-less performances, she asks herself the following questions: "How far do I need to stand back to make the color I want? How close do I need to get? Am I grabbing two lights or am I grabbing three lights? In what order am I doing things?

"One thing that I love about being in the dark is that it renders you bodiless. If any other entities or ghosts existed that you couldn't see based on the wavelength of light, I would be the same as them at that moment. We're both bodiless. I love thinking that I'm channeling and manifesting beings, entities, or things from outer space."

The spiritual component of Nielsen's work is not just a contextual aside. The titles of her prints, such as *Winter Portal* (2019), *Cosmic Clam* (2019), and *Fortune Teller II* (2018), hint at the subject matter hidden between oblique forms and complex color pairings; a crash of hues and shapes speak of interstellar travel, seances, and subconscious space.

"Totem shapes are something I've been working with a lot," she says. "I've been thinking about them as something transient and also as something that has an identity. They told stories and held history and warnings for their communities. I like to think that they have hidden messages in them from the future."

A fascination with all that lies beyond human perception—or at least the part of the electromagnetic spectrum that is invisible to the naked eye—has also fostered the artist's latest interest in mantis shrimp. These marine crustaceans have the most complex visual receptors in the animal kingdom. Where dogs have two photoreceptors (they only see blue and yellow), and humans have three, a mantis shrimp has up to 16 light-detecting cells.

"One of my favorite things is colors within colors, within colors, within colors, which I'm sure is what the mantis shrimp sees," Nielsen says. "I think they have the ability to see a color and then also see everything around that color in a way that we can't necessarily understand. I'm always thinking about the edges of the spectrum, that's why a lot of the blacks in my work fall into red at the edge. I'm trying to get the most range of colors. Also with the whites. A lot of the time I'm aiming at something that is close to white but not quite white. I think if there was an ability to see beyond that, it would be amazing."

Whether inspired by the cosmic realm of ghosts or the visual range of mantis shrimp, Nielsen continues to search for new ways to bring an interdimensional quality to her work. The Fujiflex paper she chooses has an incredibly glossy surface, which makes colors appear like pools of water rippling on the surface of an image. Likewise, the collage effect she employs creates new layers of reality, conjuring landscapes from imagined space. In the age of digital media, Nielsen's work celebrates the materiality of the photographic process and presents the image as an art object.

"I know there's a lot of people working in analog photography and they have their own thing that they're doing," she says, "but I do feel like I'm doing something unique." What is singular about Nielsen's approach is her contemporary take on a rudimentary art form. As someone who draws with light, she is a photographer in the truest sense of the word's etymology. Her translucent exposures unveil the painterly potential of photography and have inspired gallerists to position her photography as an evolution of expressionist painting in group shows.

"Painting is the medium I'm most drawn to, especially for research. It's my favorite thing to look at," says Nielsen. "I'm interested in classical beauty, but it has something to do with math for me and I suppose that's also a part of modernism. I'm interested in classic, ancient shapes. So, circles, triangles, squares. Simple things. Those will be brought out within my work, whether they are in conversation with skateboard art or floating like mandalas."

Nielsen's disparate interests are what give her work its playful edge and appear more like an invocation of nature than the product of mathematical endeavor. The photographer still marvels at color with the same wide-eyed fascination as the little girl who held sandwich bags of food dye to her eyes. "I sneezed the other day and a little particle of spit hit my phone and then I saw this little rainbow inside the spit," she says. "I loved the red, green, and

Staring at the Moon, 2021
Analog chromogenic photogram on Fujiflex
50×73 inches

blue popping up on my screen through the light. I used
to stare at the TV in the same way when it had static on
it. So, I do think about mixing light a lot."

Helen O'Leary

"I can remember getting an indoor toilet. Everybody came down to look at it and say it was unhygienic and that it wouldn't last," says Helen O'Leary. "It was the sixties, but not the sixties that you had in America. It was the Irish sixties, which was like the 1860s."

The coastal village in County Wexford where the experimental painter grew up housed a rural community trapped in time. "It was one of those kind of pre-industrial places," she continues. "We always had a couple of tourists around who were anthropologists documenting the disappearing culture of Ireland—my father's time. His way of life was archaic, I suppose."

Richard O'Leary was a farmer and minor inventor. The way his artist daughter tells it, her father could make a potato sorter from scrap metal as easily as he could make an electric turbine from miscellanea that had washed ashore. O'Leary credits her father's ingenuity and the time she spent growing up on the farm for her unconventional approach to painting.

"Art and pragmatism became a huge part of my childhood. I'm face blind, so pattern recognition is hard for me," says O'Leary. "To identify the cows on the farm I chalked them in blue and eventually they all became the same color. To amuse myself, I'd paint their portraits. I can remember the cows looking blue in the fields and they were just this hazy horizon. That was the first art. It had a function. It was about demarcation. It was about being very pragmatic, but it was very beautiful."

Standing at almost ten feet tall, the cow portraits that O'Leary painted as a child forecasted the monumental Abstract Expressionist pieces she would go on to show at the MAC Belfast, the Gallery of Modern Art in Glasgow, SNO Contemporary Art Projects in Sydney, the Zolla/Lieberman Gallery in Chicago, and many others years later. In the late 1980s she moved to the US to complete a BFA and MFA in painting at the School of the Art Institute of Chicago. It was here that she learned to subvert history

Cost #2, 2021
Pigment, polymer chalk, wool, silver leaf, and portrait linen on wood
18×13×10 inches

Helen O'Leary

paintings by creating didactic works encoded in an idiomatic language. Once deciphered, her abstract bricolages of joinery, armatures, shelves, and broken wooden frames come together to tell the story of an Irish family that fell on hard times in an era of rapid modernization.

"We were definitely odd at school. Our poverty was evident, and we were slightly feral because of it," the artist says of herself and her siblings. "We didn't know the boundaries or the constraints of the culture because we were free of them." O'Leary recalls that she did not own her first book until the age of 13 or 14. The budding artist had won a paperback on the work of sixteenth-century Flemish painter Pieter Bruegel the Elder in the annual Texaco Children's Art Competition. "It had a huge effect on me as it was all about peasants," she says. "And I went, 'Jesus, somebody painted peasants. They painted us. That's us! I've dragged that book around the world with me and I still have it.'"

O'Leary and her family's rapid descent into poverty was set in motion by a chain of unfortunate events. And like many things in Irish symbolic culture—from the Celtic knot to the shamrock—the bad news came in threes. "The place was just blown away and the full surrounding farm was put into the sea," O'Leary says of a freak tornado that hit her home. "The news reporters came down because it was so rare. I can remember seeing ourselves, small, in black and white on somebody else's television, because we didn't have one, and there was something about that image of us all clustered together and holding each other in this dark wind. It was the first time I saw us as poor. We were farmed out to relatives, and that place was rebuilt with modern asbestos and tiles, and plastics. The old was really swept away." A few years later, the new family home was struck by lightning and burned down. Then the sudden death of O'Leary's father left the family destitute.

"We were totally bankrupt. So, my sisters and I had to farm the place," she recalls. "We'd never really worked like that before. There was a real sense of survival. There was

a real sense of us at odds with the people who wanted us to leave and sell the land to people who could farm it. It was a reasonable thing for them to say that my mother couldn't manage. And, to her, selling was unreasonable because the land was so important."

Catapulted into adulthood by the family's misfortunes, O'Leary had to draw on her utilitarian sense of creativity to help keep the farm afloat. "I painted on stones or painted little souvenirs," she says. "The idea of the souvenir was something that you could make money out of. My mother knitted socks for money and I painted stones."

From a young age, O'Leary learned to keep the land at any cost. "You could sell all your things but you'd still have the view" was her mother's line. The artist remembers another defining moment from her childhood that captured this sentiment. "My mother shared that the banks were closing in on us, so we had an auction to sell everything off and all my father's inventions. Everything was named and labeled like auctions do. Everything was numbered, like the china from their wedding, and the harnesses for the horses and the cattle. Everybody came down as it was a public bankruptcy auction. And what was left afterward were the pieces of paper on the cement in the yard. I must've been 11 or 12 just looking at how everything we owned had become abstraction. It was a very potent image."

This early experience of her family's belongings being sold piecemeal to strangers fed into O'Leary's work in the late nineties. "When I started making little fragment pieces —when I started taking everything apart—there was this idea that the work would be sold as a fragment but I'd own the big piece," says the artist. "The big piece was the land for me, you know, the big piece was the idea."

Her mother ran the family home as a guesthouse and rented out the children's beds whenever the demand was there. The artist recalls that many of the visitors during the late sixties and seventies were "hippies who came over with their guitars, and their music, and their bell-bottoms." The

The Shelf Life of Facts, The MAC Belfast, NI, 2016
Egg tempera, chalk, clay, wood, gold, metal, and linen
Variable dimensions

Why I Make Art

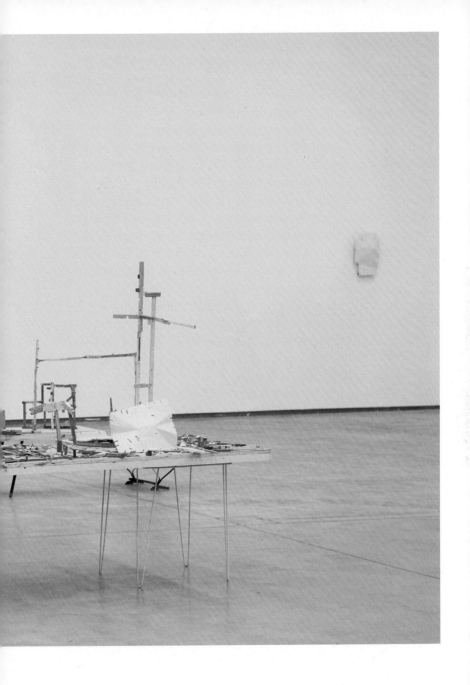

Helen O'Leary

flower power movement had finally reached rural Ireland and marked O'Leary's first exposure to the world beyond the farm.

"In retrospect, it was like a party," she says. "A nuclear power plant was proposed on our shore very close to our farm. We didn't even know what it was, so we didn't have many opinions about it but other people did. A lot of young German and American people would protest. They put up tents on the strand and I remember going down, looking at the tents and seeing that people were having sex. People were naked and people were topless. It was wild. I remember coming home and my mother was there going 'don't go down to that strand' and the priest was going on about it. To me, the world had opened and it could never be closed again."

The guesthouse was an invaluable source of inspiration for O'Leary, whose home buzzed with the sights and sounds of American youth culture. "Music was introduced by the hippies," says O'Leary. "I remember hearing Leonard Cohen and Janis Joplin at about 15 or 16 and I just wanted more."

O'Leary still has a great affinity for music to this day. The artist recalls that during her time in New Orleans as the inaugural recipient of the Joan Mitchell Center Artist-in-Residence program, she discovered one of the city's quintessential traditions: jazz funerals. Rather than solemnly mourning the passing of a loved one, the "second line" in a funeral parade stages a vivacious fanfare of brass instruments and traffic-stopping theatrics. Like O'Leary's work, jazz funerals may be born of sorrow and loss, but they are not defined by it.

"When I was in New Orleans I really put my work together with jazz for the first time," says the artist. "I thought of big bands, I thought of parades, and the idea of the way you just improvise and make it really big for a minute and then take it down again." Similar to the spirit of free jazz, O'Leary's work is also improvisational. With virtuosic variations on a theme, she breaks down conventions in

painting to find harmony in dissonance and restores order through abstraction.

When asked about her first encounters with abstraction, O'Leary's memories return to Wexford. "Farm work was something that really influenced me, and the abstraction that surrounded me, like the troughs that were dug out of granite, or the line in the road that my father dug," she says. "We had 60 cows and I remember sweeping the yard with a hose and a brush and putting fluid on it. When you throw disinfectant on the yard it becomes kind of petrol-colored and I remember just loving it and I'd make designs with the brush while sweeping the yard. I remember the contentment of looking at the yard after I brushed it and the patterns in it. It'd have these zigzags and my mother would growl at us for being idle or not doing it fast enough."

Home is where the art is for the painter and Guggenheim Fellow, as she continues to mine her childhood for experiences of esthetic appreciation. "One of my early memories is going up to the corn loft and seeing my father sewing sails because he loved building boats. There were swallows up there, so there was always bird dirt everywhere. I remember all the birds shitting the corn, the beauty of the white on the canvas, and my father's annoyance at it. Later, I thought of Pollock when I thought of that kind of scatological language. I think that was an influence I didn't even know could be art."

The epic canvas works from O'Leary's early art career could be said to bear resemblance to Jackson Pollock's vivid, gestural paintings, but by the 2000s, her practice had adapted her childhood interest in making art with the materials that lay at her feet. Invoking her father's spirit of material conservatism, O'Leary collected off-cuts and remnants of previous projects to create skeletal, three-dimensional paintings.

"I think of my studio as a tornado. There's a lot going on. It's all chaos," O'Leary says of her studio practice. "I will have a piece cannibalize itself four or five times before I'm

happy with it. I continue breaking them down, and this idea of something just being ploughed back into itself is important to me. I love it when I don't know what I'm doing. When I make something and I think I know what I'm doing, I'll inevitably break it up again."

Much like the tornado that tore through her childhood home, O'Leary has come to appreciate the creative potential of destruction. When her installation for an exhibition in Belfast was damaged in transit, instead of tragedy she immediately saw an opportunity. "It was an unbelievable thing to open a crate and find everything broken," she says. "But then I realized that I actually loved that. It was my tornado. The thing was in smithereens. I just asked for a bandsaw and some glue and some dowels and I went at it. And it was better."

Having learned from a young age that one's lot in life can change in an instant, O'Leary is rarely perturbed by tricky situations. "I often wonder how I thrive on being uncomfortable," she says. "I thrive on sleeping on a couch, or being displaced, or just working myself into a corner of a room. I think it's just replicating how I grew up. I remember reading Joyce when I was a young student and I loved the uncomfortableness of it. I loved the way everything moved."

Regardless of how content O'Leary is with feeling at sea, as the daughter of farmers, she has never relaxed her grip on the land. Around the same time that she accepted a permanent teaching position at Penn State University, she also bought a house in County Leitrim, Ireland. "I keep a house and I know it's there," she says. "It's an image on my computer that I pull up every now and again. I barely go to it because I'm always running around but I know it's there."

Romantically referred to as the land of saints and scholars, the Ireland of old lives on in O'Leary's imagination and continues to inspire her with its cultural abundance. "I love storytelling. I love it when a poem tells me a great story," she says. "Seamus Heaney was my first love, which I'm almost ashamed to say as an Irish person. Seamus

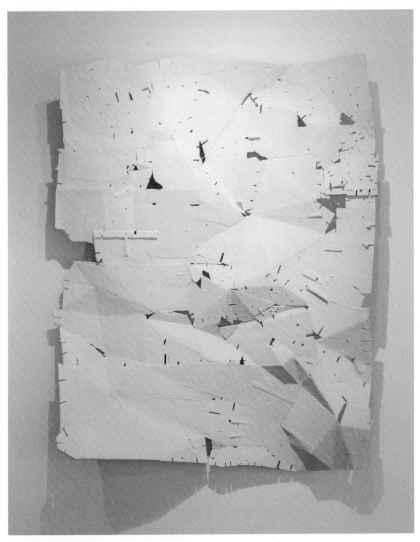

Efficiency of Love, 2015
Egg tempera and oil emulsion on constructed wood
56×43×5 inches

Helen O'Leary

Cost #19, 2021
Pigments, polymer chalk, and linen on wood
28×32×7 inches

Heaney, Samuel Beckett, James Joyce, that's our Trinity.
"The language, the literature, I love it. I read it out loud
sometimes just to hear the pace of it. The pitch is different.
Irish poetry is very important to me. The sense of trauma
that's in the culture is very important. I think it's handed
down, from hurt to hurt, for generations, which manifests
itself in the literature and the arts."

Another Irish hero of O'Leary's is Shane McGowan,
the notoriously shambolic lead singer and songwriter
of folk-punk band The Pogues. She recalls a memorable
encounter with him at a bar in Chicago where she was

working as a bartender during her college years. "The bouncer tried to throw him out because he thought he was a ne'er-do-well. I jumped over the bar and I was so excited when I saw him that I fed him buckets of margaritas.

"He gave me Ireland back, which is a funny thing to say. It was through him that I relooked at Ireland and re-looked at the lyricism of what had been lost or what was possible. It was part of the eighties. It was part of relooking at more marginalized cultures, or things that might've been overlooked, or rethinking what you grew up with. So, he was a big hero, and to see him getting drunk on my margaritas was fantastic."

The artist's 2018 show, Home is a Foreign Country, looked at the idea of a lost Ireland and drew on the Irish musical tradition of *sean-nós*, a type of lament usually sung by a single, aging vocalist. Much like the tourists who used to visit the farm and document the artist's way of life, this show was akin to an anthropological study of Ireland. The materials and techniques that she used, such as knitting, alluded to the lost traditions of basket weaving and thatching that were once prevalent in Ireland.

Home is a Foreign Country spoke of the temporal nature of culture and looked at identity as something that is undergoing a constant process of editing and revision. O'Leary's work as a whole considers taking fragments of the past to construct new foundations for the future.

Though she has lived away from Ireland for so many years, it remains her home, at least in her imagination. "I never felt I lived anywhere, and it's funny, because I've lived in the United States for 24 years. It's this immigrant mentality where home is always home. When I talk to another Irish person and we talk about going home we'll laugh at ourselves. I always felt like I was a world citizen, as I've lived everywhere. So, I feel as American as much as I do Irish. But Irish literature is something I go back to. That's the rock that I like to sit on."

Carl
Ostendarp

241

In the late 1980s, artist, curator, and educator Carl Ostendarp set about producing his first exhibition works with a self-imposed challenge—a predicament to resolve.

"When I started out, there was this idea that abstract painting was a genre that had run its course and was compromised in all kinds of ways: that it couldn't carry that utopian ethos because it's so specifically Western and so specifically a 'macho tradition,'" he says. "And the ways they talked about Abstract Expressionism were so daffy. I got into it thinking, 'I have to find a way around this problem; I want to be involved in this thing.'"

His first response came by way of bulging foam urethane, which gave his early paintings a soft, sculptural quality. But for all their obvious appeal, the works belied something far more confrontational. Rather than salvaging what was loved from the past, Ostendarp found himself more concerned with what was despised.

"The most disgusting, hated part of that genre were those late, fat color-field paintings, where the flex gel comes out," he explains. "And so the first works I showed, these foam paintings, were my versions of those. I thought, 'Go to the belly of the beast, and find the thing that's most reviled,' then work from there."

From something seemingly so loathed, Ostendarp built a practice admired by many—not least the Art Institute of Chicago, the Whitney Museum of American Art, and the San Francisco Museum of Modern Art, just three of the many public institutions that hold his work in their collections. Playing with both images and text, biomorphic shapes and onomatopoeic words, his paintings and installations often ooze with saturated color. Fusing minimalist and color-field influences with Pop Art sensibilities, Ostendarp offered the abstract tradition something he felt it lacked: humor.

"One problem with abstraction is this reputation for hyper-seriousness," he says. "It's a means and ends problem—to the degree that you're a plumber and people

Untitled (Couple Painting – Yellow), 1999
Acrylic on linen
68×77 inches

keep admiring the plumbing, rather than washing their hands or taking a shower. So, humor seemed to me to be a really valuable thing in the beginning, at a moment when it seemed like abstraction was not viable. This was at a time when almost anything that was referenced as humor would automatically be called irony. It seemed really important to make a distinction between humor as a means and irony as a kind of environment."

It's an approach that has seen him dubbed a "master of comic minimalism" by the *New York Times.* But for Ostendarp, humor is a serious business. He lists cartoons and early silent movies among his source materials, as well as "reading about jokes and the theory of comedy." He also cites the likes of John Wesley, Paul Feeley, and Ralph Humphrey, postwar painters who, like him, forged a path between genres.

"There's a bunch of these painters that I always think are not really pure 'Pop' painters, and not pure abstract painters. They're something in between. The work dates from around the same time that there's this explosion in media installation and time-based stuff.

"I always think about that period as the moment when reviewers and critics, instead of saying 'This is a great show of paintings and this painter is a good painter,' started saying, 'This artist is *using* painting.' That moment has been really interesting in an ongoing way for me. I go back to that as a way of thinking about what painting can do."

Staging dozens of solo shows over the past three decades, Ostendarp has experimented in both materiality and method ("The world wants to think of painting as a noun, but really it's a verb," he reflects), and as both an artist and curator, he has sought to dissolve the distinction between the two. His curatorial productions often see him making two-toned wall murals, which then serve as backdrops for other artists' work. His shows often feature music, too, reflecting a refreshingly accessible approach to the gallery experience.

"The idea is always to make this stuff available—to lift the veil of 'Oh, this is about these issues, or this comes from its time in this way,' and to find a way to make the work experientially immediate to the viewer."

Ostendarp's commitment to communicating the value of art comes as little surprise given his day job at Cornell University, where he has taught for over two decades. Having previously worked at New York University, Tyler School of Art and Architecture, Rutgers University, New York's School of Visual Arts and The Cooper Union, his artmaking has long been balanced against academic responsibilities. But while his practice is, as a result, less studio-based than some of his contemporaries, he has found other ways to recreate the studio mindset—including on his daily commute in Ithaca, New York.

"It's about a 25-minute walk, and I got really good at thinking the same thing over and over and over again, so when I do carve out time for a deadline or exhibition coming up, it's like I've thought it through already. I feel like I took orders or something. It makes it feel like I'm in my studio on my walk. I don't carry a cell phone, which I know is insane. My kids think it's insane. But there's so much distraction."

It was, in fact, having kids, not teaching commitments, that brought about the most radical change in pace. "There was a big shift when my kids were first born," Ostendarp recalls. "It was like, 'Oh, wait, I'm not doing this navel-gazing thing when I have time in the studio.' But I was lucky: I had a nice six- or seven-year stretch of being able to wake up and go to the studio."

The son of a college football coach, Ostendarp always felt at home in academic environments. He grew up "pretty much on the campus" of Amherst College, and his father's predilection for sports did not come at the expense of the arts, which played a significant role in his upbringing.

"My dad was supportive of it and he valued it. He was into ballet and opera. I remember a stretch where we

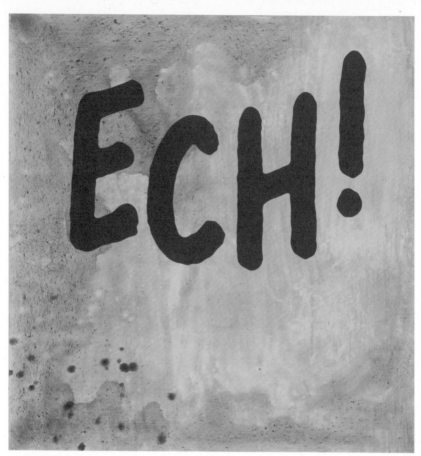

ECH!, 2016
Acrylic on canvas
52½×51 inches

Why I Make Art

had to sit on the couch and listen to the Texaco opera radio broadcast on Sundays," Ostendarp says. "He was interested in art. He actually kept a catalog of a Clyfford Still show, which was at Albright–Knox when Still was alive, and he had gone up for the opening. He'd seen his paintings somewhere and wanted to meet him, and I thought that was pretty interesting."

When it came to attending college himself, Ostendarp studied at Boston University and, later, Yale Graduate School. The latter was a formative experience, he says. "It was huge—without it, God knows what would have happened." He would go on to become one of a prodigious generation of artists to emerge from Yale into the New York scene in the late 1980s and 1990s.

"I think the intensity of the experience at Yale had a lot to do with wanting to do this," he says of his career, adding that a school's prestige is as much about the students as the faculty: "As much as people talk about CalArts and Baldessari, or Michael Craig-Martin and Goldsmiths, or Yale and Albers, it's almost always the group of students that gain the reputation for the place. It's the chemistry between them and how much they're willing to get involved with one another."

A life in art was, at the time, something of a default option. "It wasn't like, 'I'm going to have a career as an artist,'" he says. "But it meant 'I'm going to opt out of having careers.' It was less of a proactive decision."

Of course, the New York he graduated into was starkly different from the city it is today. Ostendarp may have traded the urban landscape for quieter, academic surrounds, but as a college arts professor, he is all too aware of the challenges now facing young creative workers. Amid a dearth of affordable studio space, newcomers may not be able to make art for art's sake, a luxury often afforded to previous generations. The rise of graduate residencies is one of the notable ways in which the landscape has changed, Ostendarp says.

"I keep thinking about this profound change between the affordability of living in the city and getting a sense of community, and the explosion of these residencies—how bureaucratic that process is, and how much it reinforces the idea of making this project like, 'Oh, I'm going to do this, please accept me into your residency, and I'm going to make this while I'm there.' I totally get it, that's how you find a community, but that's a big change."

There are new opportunities, too. Where there was once what Ostendarp calls a "rigid hierarchy" by which one navigated the art world ("It was like: these are the galleries you could expect to show at if you're starting out, and then you go to this level, and then this level"), globalization has, he says, helped diversify the paths to success.

"I think the fact that it's gone so global has changed it fundamentally. Outside of the market thing, there are so many exhibition opportunities—it's so much bigger."

Hilary
Pecis

Hilary Pecis' first art instructor was a spaceman named Commander Mark. Growing up in Northern California in the 1980s, the Los Angeles-based artist recalls spending hours in front of the television watching *The Secret City Adventures*, a sci-fi-themed PBS show where American artist Mark Kistler taught kids the basics of three-dimensional drawing.

"You could have your parents send in your drawings that you made from his instruction, and they would post it on PBS, and my brother and sister and I all did it," she says. "My mom isn't an artist but she's creative, and she always had materials out for us. At Christmas she'd give us a big container full of supplies. She encouraged us a lot."

In high school, Pecis pursued art with increasing seriousness, enrolling in Advanced Placement (AP) art classes. "I never thought I wasn't an artist," she says. "Even when whatever I was making totally sucked, I just didn't feel like I had to justify it until I was an adult.

"I was a really bratty kid," she adds, before reconsidering. "I shouldn't say that. I was polite. But I just didn't want to try, and I got myself in some trouble as a teenager. I had to go to juvenile hall and my AP art teacher, who was really lovely, wrote letters to encourage me to keep up my art practice. They were written on tie-dyed paper."

Pecis grew up on teenage rebellion and punk music —influences that were close to home. "My brother is only a year and a half younger than me and he was in punk and ska bands," she says, calling her hometown of Redding "a weird city" that facilitated her musical interests. "It's on the I-5 freeway going up into Oregon. So a lot of bands would stop there on their way to Portland or Eugene. We got a lot of shitty punk bands coming through in the 1990s. My mom would oftentimes go and take tickets, or sell tickets at the door, so it was very much a family affair."

Despite the anti-establishment bent of her teenage years, figuring out what kind of artist she would be proved complicated, as for a long time Pecis' views about what

Why I Make Art

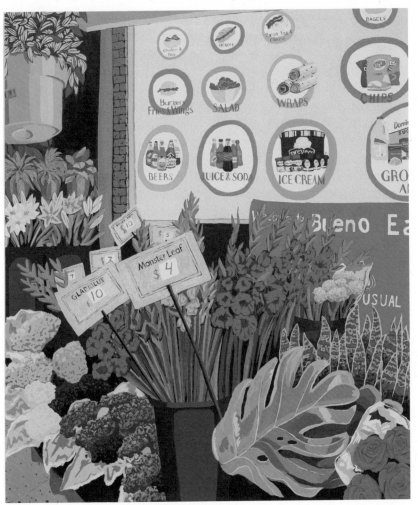

Bueno East Mart, 2021
Acrylic on linen
74×64 inches

it meant to be a serious artist were narrow and rigid, shaped by clichés and perceived industry prejudices.

"The late 1990s is when I really started to understand that contemporary art was more than just painting and sculpture. I remember at the time thinking that I'd make representational work and abstract work, and just sell them to different people. It was this idea that abstract work was the one high art, and representation was this other thing that had to be low brow," she explains.

Today, Pecis is best known for expressionistic, Fauvist-hued interior scenes that celebrate the quotidian —overstuffed bookcases and cluttered kitchen tables, joyful bouquets, and detailed paintings within paintings. "There's often a wonkiness to the perspective, or something in there appears to be more or less like plopped onto a surface, not actually part of it," she explains. "It's because I'm usually working on one little thing at a time within the painting."

Pecis' source material is taken from people's houses, including her own, or from her travels. "I make two genres of paintings. It's either still life/interiors or landscapes. I work from photographs off my phone, which seems so wrong on so many levels. I remember in school hearing, 'Don't work from a photo!' and then working from your phone seems like an extension of wrong."

Her landscape paintings follow a somewhat different kind of logic, although the results share a similar intentional flatness with her interiors. "With landscapes, I take a different approach because anytime there's something that's abstract to me, and I don't know how to make sense of it, I tend to make a sketch or a drawing to simplify the situation," she explains. "Then I'll work off the sketch. You know, like trees and things, I make a quick drawing and figure out an abstract way to depict that. So landscapes end up being the most fun for me to paint."

This may be why Pecis has a tendency to sneak landscapes into her other work. "Sometimes I'll put a landscape

Why I Make Art

painting that I made inside of a still-life painting. I love the freedom to get really loose and try out different marks. I love to paint other people's paintings inside my paintings for that same reason. I can be a tourist and try out new things, but also stay within my own mark-making vocabulary."

Before landing on interiors and landscapes, as a student at the California College of the Arts (CCA) in San Francisco, where she completed both her BFA and MFA in the 2000s, Pecis primarily created maximalist, abstract collage works—not so much because they excited her, but because it was the medium *du jour*.

"I was using paper and ink and magazine scraps and dyed paper. There was spray paint on them and sometimes glitter," she says. "I was also making digital collages. In the early 2000s there was all this new photography happening, which was really cool. As far as making collage, it was just an extension, so I made digital collages as well. Then sometimes I would cut those up to use as paper collage."

This type of artmaking seems like a lifetime ago to Pecis. "It was very busy work with heavy patterns and stuff," she says of her early collages. "If you saw it I don't think you would recognize it as mine, although a quick Google search would show you what it looked like. Unfortunately it just won't disappear."

Armed with a romantic idea of the Big Apple, Pecis moved to New York for nearly a year between degrees. She had the notion that once there, she would "start making this really profound work," she says. "I was happy with the work I was making when I graduated with my BFA, but for some reason I thought that I would move to New York and everything would just click and shift and I was going to be very successful somehow as soon as I got there.

"The reality was that I was bartending at a crummy restaurant as a day bartender—so I only really got the hard alcoholics, which is such a bummer—and I wasn't making very much work because I was so tired by the time I got home at night. Nothing profound had really clicked, so when I

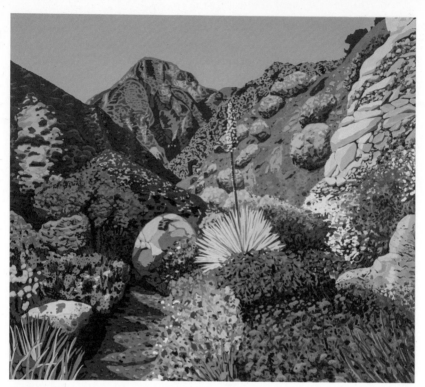

Gabrielino, 2021
Acrylic on linen
64×74 inches

got back into CCA I was happy to get the hell out of there and go back to California."

Pecis believes she truly came into her own after moving to Los Angeles with her husband, the painter Andrew Schoultz, in 2014, two years after giving birth to their son. "I was moving to LA, and I was making these paintings—just to keep something in my back pocket in case I didn't want to make collages anymore. Everything was turning upside down, I was exhausted. I had just had a baby. So I halted for a moment and thought, 'Well, I'm going to work on some paintings until I figure out what my next move is.'"

For the next five years she spent her days working as a registrar at David Kordansky Gallery while, in her free time,

Why I Make Art

she pursued art as a hobby, unencumbered by expectations. What she did know is that she didn't want to cease making art full stop. "I didn't want to be that statistic that they talked about in grad school, like, you know, only 5 percent of you will go on making work," she explains. "So I was like, I'll just keep making these silly paintings."

But it was the paintings that she made during this period that would come to define her style today. And though she had intended to move back to New York at some point, she's stayed put on the West Coast. "In the new landscape I felt so liberated," she says of LA. "I could paint anything I wanted to. I was getting farther and farther out of grad school. I didn't feel the need to prove myself anymore. I also felt like, if I'm only going to ever be a Sunday painter, I'm really OK with that, because I'm liking what I'm doing. And if nobody likes it, nobody else likes it."

Pecis returned to representational painting with zeal, depicting her new surroundings in works that not only left her feeling fulfilled but also resonated with viewers.

In 2019 Pecis left her gallery job and transitioned to artmaking full time. Since then she's enjoyed solo exhibitions in Los Angeles, New York, London, Beijing, and beyond. In a full-circle moment, she joined David Kordansky's roster in September 2021.

"I really enjoyed collage when I was making that work, but I felt like I was always fighting to add this really conceptual edge to it, so it felt really contrived," she says, recognizing that this approach was a losing battle for her—and for her audience. "It's that adage that if your heart's really in what you're doing then the viewer will read that and feel that. The moment you start trying to make things for other reasons, something insincere or forced, it just might not connect with people—or it does in a different way, I guess," she says, adding, "When I was letting go of any ego or ideas of who I had to be was when the work actually started to be more authentic."

Erin
M. Riley

Erin M. Riley's tapestries take the relentless stream of unsettling images we regularly consume online and make them very real. Mixing intimate selfies and personal memorabilia with screenshots from social media, newspapers, and pornography, the New York-based artist reveals the everyday realities of women navigating personal traumas, sexual desires, and the toxic male gaze at the intersection of IRL and virtual experiences. While it only takes a second to scroll past a headline reporting a rape case, or an ad for a cam girl, Riley's large-scale works, which can take up to a month to weave, confront you with their presence, reminding you of the raw realities behind the screen.

Riley was born in 1985 in Cape Cod, Massachusetts, which she describes as "nice as a tourist," but "a boring, old small town all of the other months of the year." She discovered her interest in the arts during middle school. "I was one of those after-school kids whose parents are at work so you're alone in the house and have to figure it out. We'd paint, sew, build forts in the woods, make weird stuff, whatever," she recalls. "Then in high school I took art the whole time. I loved painting and there was ceramics and graphic design. I was pretty lucky."

Her other passion was for music, and she was drawn to the local punk and straight-edge scenes, but ultimately the culture that surrounded it turned her off. "I dated guys in bands and went on tour with them. You'd see the same people at shows every week and hang out in the grocery-store car park afterward. So there was bonding, but it was very harsh on women and it got to a point where I was over the misogyny of it. Then I started transitioning into this new friendship group: the art guys."

Riley relocated to Boston for her BFA at Massachusetts College of Art, where she discovered weaving in her first year and was instantly hooked. "I'd always spent a lot of time by myself sewing and knitting. I made my own clothes and wanted to be a fashion designer. So, once I started weaving, I just never stopped. I learnt about ordering yarn

and how to do all the calculations, which is an amazing math formula that I love. Once I understood what was possible on the loom—weaving fabric, tapestry, and other sculptural things—and realized I could make something that was meticulous and hard and also incorporated imagery and text, I felt connected to that."

She puts part of the appeal of weaving down to having the right temperament. "Weavers are OCD and process obsessed. I've asked older weavers if they have unending patience in life in general and they say no, just for weaving. And it's the same with me. I hate waiting in line, but I will sit on the loom and weave for ten hours a day."

Riley spent her undergrad mastering centuries-old tools and methods, all the while spying on the other art departments enviously. "Fibers was a small department and there wasn't a lot of varied work being made because the learning curve is so steep. I'd walk through the sculpture and painting halls, and there was all this amazing work happening. I always like to create things that hang on the wall but when you're young, you just think, 'I'm making sad girl art while these people are doing insane performances with lights and sounds. Oh God!'"

Graduating in 2007, Riley went on to do her MFA at the Tyler School of Art and Architecture in Philadelphia, where she began to conceptualize her practice. While she was interested in feminist ideas about reclaiming crafts that had been historically dismissed as domestic, and therefore lesser, she preferred to find her own path. "We were forced to look at those things about women's work and labor. I am interested in that but in the end it's just something I enjoy and I like color, and it can be that simple," she says. "We had critiques from other departments. They thought I was giving fibers this old-fashioned interpretation and wanted it to be more installation-based. But it was good for me. I was young and I worked like crazy."

After graduating she developed her career in Philadelphia for a few years before the opportunity arose

to take a studio in Bushwick, Brooklyn, precipitating a logical move she'd been putting off for some time. "I never thought I could afford to live in New York but once I got here it wasn't this struggle. In Philly there were rats in our building and I was on the Wawa [convenience store] diet. In New York it was hard, mentally, but it was more adult and I felt less stressed." The city welcomed her warmly, and it felt like the right place to be at the right time for her practice. "Since grad school I'd always shown in San Francisco, so I moved here thinking I wouldn't get any shows. I'm a pessimist, basically. Then I sent out the email blast saying, 'I live in Brooklyn now' and all of these people came out of the woodwork."

Her resumé has since been filled with group and solo exhibitions, including at Jonathan Hopson Gallery in Houston, Galerie Julien Cadet in Paris, Kohn Gallery in Los Angeles, Gana Art in Seoul, Timothy Taylor in London, and Kristin Hjellegjerde Gallery in Berlin. Riley has also been the recipient of a United States Artists Fellowship grant and an American Academy of Arts and Letters Art Purchase prize.

Her honed, meditative process involves sourcing production excess wool scraps, which often come from closed-down textile mills across the US, then washing, stripping, and hand dyeing it her desired colors (some calm and fleshy, others neon bright). Once she's gathered her source imagery, Riley does a to-scale sketch of it, which she pins beneath her Macomber floor loom to use as a guide. Then it's a case of stringing cotton lengthways to form the warp, followed by the weft of yarns using a bobbin, shutters, and beaters.

"They are beautiful and they're super old," she says of her treasured collection of vintage looms. "One starts to creak when I use it so it's like it's talking to me. It's funny. Come on girl!" Once a piece is done, the gloriously laborious work she's put in is there for all to see. "Knowing that a human being spent time with an object forces you to investigate further. With weaving, the process reveals itself."

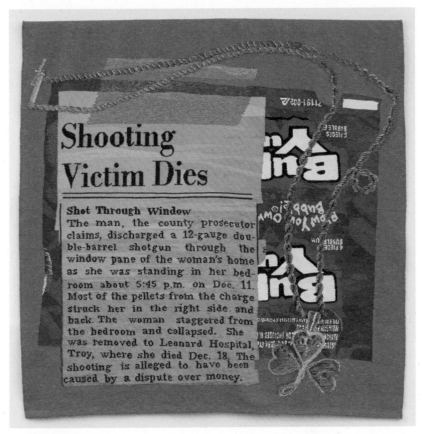

Believe Me, 2020
Wool and cotton
94×100 inches

While the artist's intricate methods are admirable in and of themselves, it's the subject matter that makes her work truly captivating. Still lifes reveal the parts of women's realities that are usually kept hidden— bloody tampons, birth control pills, vaginal creams, and dildos. Other pieces lay bare what could be the aftermath of a debauched party—used syringes, cigarette packets, and condom wrappers. Meanwhile, Riley is often naked in her self-portraits, assuming sexualized poses or showing the act and results of self-harm.

Erin M. Riley

Affair, The, 2020
Wool and cotton
72×100 inches

Her body is also covered in tattoos, which have be-
come a recognizable motif in her work. One reads 'Treasure',
another 'Weaver' alongside a plethora of birds, flowers,
and hearts that change in color and definition, piece to piece.
"It's important to use myself in the work but it's getting to
the point where maybe I should stop getting tattoos—it'll
make it easier to weave my body." By implicating herself
—her body, her trauma, her coping methods—the art of tap-
estry becomes a process of perpetual healing and personal
activism against patriarchy for Riley, while it also makes her
experiences relatable to others.

For Used Tape, her 2018 debut solo at P·P·O·W
Gallery in New York, autobiographical references to failed
relationships come together with ephemera from crime
scenes. *Evidence* (2017) shows the contents of a rape testing
kit; while the tapestry for *911 Call* (2018) simply reads "Inaudi-

ble screaming," a reference to a snippet from an emergency call to the police. These works are the result of the artist's head-long research into reports of domestic and intimate partner violence. "I prepare myself for when I'm not going to see people, and spend days reading police reports and going through horrible pictures. It's important to see the monotony of trauma. People say you have to report it, but can you deal with the paperwork and all the things you have to endure? I'm also reminding myself of other people's experiences, not in a torturous way but in a realistic way. They're not alone and I'm not alone."

The fact that Riley is able to readily find this material in the news also speaks volumes. "As somebody who has experienced that kind of stuff, and has friends who have experienced it, it's interesting to see the way it's presented. They're selling pain that, oftentimes, was made public yesterday but has probably gone on for months or years. Then people are discussing it online. You get to see how gross people are, responding to something within seconds with their instinctual judgements. It's obvious why people don't come forward for fear of the stream of comments that come out."

Some of Riley's more recent works examine her childhood, showing domestic violence pamphlets from the 1970s and her own adolescent journals scrawled with affirmations such as "There is a way out... There is!" These were included in her 2021 solo at P·P·O·W Gallery, entitled The Consensual Reality of Healing Fantasies, alongside tapestries reflecting her solo sexual exploits during the COVID-19 lockdown.

All realized in lovingly woven wool, the materiality of Riley's pieces speaks more to comfort than destruction. "Fabric invites you in," she says. "It's this weird, flawed thing that is handmade. There's this connection to fabric. There's an energy." The artist's lengthy pursuit of crafting beauty from the mire tells us it's OK to reflect, to fight, to appreciate the self, and to allow tenderness in.

On Education

We'd go and cut up a car and bring it into art school and people were like, "What the fuck are you doing?" And we didn't know. We were just simulating a very recent sonic echo.

—Matthew Ritchie

The local school was essentially a prison. It had no windows, but there were all these amazing walls and that's where my creativity really started.

—Barnaby Furnas

Any teaching that I benefited from wasn't very technical. So that means I don't know how to do anything. I just have to make it up.

—Byron Kim

By the time I was a junior, I had my own office and I had gotten married to my James Joyce teacher. I sort of blundered my way into that. It was the early seventies. Things happened.

—Stephen Westfall

There was basically no theory at college. The theory was, "Make work," which was great.

—Jenna Gribbon

In art school they were telling us that the worst thing you could make was escapist art. But to me, it seemed like the culture of escapism was responsible for the shape we were in.

—Fred Tomaselli

At school I had a little studio for the first time, and I learned how to be alone there. You start doing that muscle memory thing of going somewhere every day and picking up your brushes and paint, and working.

—Ellen Berkenblit

Devan Shimoyama

Devan Shimoyama's mixed-media work is an explosion of glamor, fantasy, and all things sparkly. From life-sized paintings awash with sequins and rhinestones to installations and sculptures filled with silk flowers and glitter, each piece accosts the viewer with bright colors and a total sense of extra-ness. In doing so he makes the Black queer body a site of beauty and desirability, while addressing the contemporary politics of both LGBTQ+ communities and Black America.

Shimoyama was born in 1989 in Philadelphia and grew up with a love of drawing. He initially chose to study life sciences at Penn State University but after two and a half years he swapped his major to art and began exploring multi-dimensional painting. "I was pouring a bunch of different paints and seeing what was happening. I was playing with materials and figuring out how to prime surfaces for different types of marks. All of that was how I learnt how to technically make what I'm making now," Shimoyama recalls.

He went on to complete an MFA in painting and printmaking at the Yale School of Art, where he was awarded the Al Held Fellowship and felt ready to dive into the conceptual side of his work. The artist has always been attracted to studious environments because this is how he feels he can propel his work forward. "I have always chosen places with an academic component because it helps me think in a more informed way," he explains.

"A lot of my work is fueled by reading—fiction, fantasy, prose, poetry. I wouldn't have known about that stuff unless I had a good education," he adds. "I remember a class in queer cinema that spanned from the 1920s to the 1990s, which was incredible. It meant reading Marlon Riggs and looking at how queerness can be buzzing underneath the narrative structure that's on display. And then conversations with my peers, professors, and critics shed light on how these ideas would bleed into my mind and manifest themselves in my work."

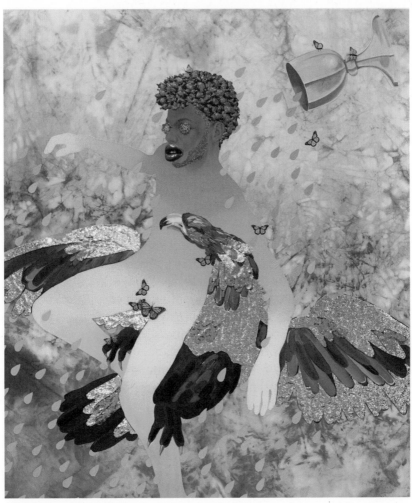

The Abduction of Ganymede, 2019
Oil, colored pencil, dye, sequins, collage, glitter, and jewelry on canvas
84×72 inches

Devan Shimoyama

This scholarly interest continued: straight out of graduate school in 2014, Shimoyama took a one-year visiting professor position at Carnegie Mellon University in Pittsburgh, where he's since become Assistant Professor of Art. This position has afforded him the opportunity to develop his experimental practice in tandem with teaching. "Moving to Pittsburgh meant I could make all the work I needed to make with ample space and time. I can clear my head and don't have to feel panicked or rushed. People might think you have to be in New York or Los Angeles, but many of my show opportunities have been through the generosity of the community here. When it comes to making connections, a lot of it has to do with being kind and receptive to people. Being genuine goes a long way."

Shimoyama has exhibited extensively across the US including De Buck Gallery, Lesley Heller Workspace and Kravets Wehby Gallery in New York, Kavi Gupta in Chicago, Samuel Freeman Gallery and Zevitas Marcus Gallery in Los Angeles, Alter Space in San Francisco, and Emmanuel Gallery in Denver. Internationally he's shown at Kunstpalais Erlangen in Germany, Frieze London, and the Fondation des États-Unis in Paris, among others.

The artist has become renowned for his portraiture, whether of himself, his friends and acquaintances or what comes out of his imagination. He cites the rigorous conventions of old masters such as Goya and Caravaggio as influences, as well as Wangechi Mutu's fantastical collages and Kehinde Wiley's bright paintings. On his canvasses, smooth expanses of color are formed from oils, acrylic, and pencil, while photographs may be used for eyes or mouths, accentuating these facial features. Then come the textural materials such as Swarovski crystals, fur, glitter, fabrics, and gemstones—demonstrating a magpie eye that was originally fostered by his grandmother's taste in costume jewelery, ritzy tablecloths, and best china.

Drawing from astrology, folklore, and traditional belief systems, orisha spirits and Apollo's Daphne come

into view too, as do serpents—which for Shimoyama are not the cause of the fall but guardians of sacred realms. These figures often hang out in the background of his works, as in *Dizzy Spell* (2021), or coil around heads and shoulders, as in *Sedusa* (2021). "I'm creating my own queer Black male origin mythology," he explains. "A lot of the materials I use are being imbued with meaning and specificity when they appear in the paintings. For example, black glitter represents the night sky, which for me is ripe for storytelling. The night is a time when there's a higher possibility for true magic moments to occur."

Another favorite motif is the teardrop, variously appearing as both physical tears and emoted rain. "I started the teardrops because growing up I never really saw Black men cry in a public way, or being allowed to feel in pop culture," he says. "A lot is being said creatively right now, but at the same time we're being oppressed from the top so there's this friction. Its intense. People are not very open to saying how they feel."

An early series of paintings was inspired by those of Shimoyama's musical heroes who use the language and cultural codes of queerness without explicitly presenting as gay. "Johnny Mathis came out and was then threatened back into the closet to continue his career. Frank Ocean made an open statement about having an intimate relationship with another man but doesn't identify as gay. Prince was super glam and benefited from all of that. I'm interested in those who are othered in that way but don't fully engage with it in order to have success. And I'm waiting for that moment when it can be from the beginning, when we don't have to hide."

For the artist, the 2017 film *Moonlight* was a watershed moment. It was the first time he'd seen a Hollywood movie that represented his lived experience in so many ways. "It's an all-Black cast. It's not about slavery or servitude. It's a LGBTQ film that's not about AIDS. And it's not just scary dudes standing on corners with guns. They're

Akasha, 2021
Oil, colored pencil, glitter, acrylic, costume jewelry,
rhinestones, and collage on canvas stretched over panel
72×72 inches

telling a modern coming-of-age story about love and
self-acceptance. It's important to see those types of bodies
in those positions. And that's why it's important that I'm
making work from a specific point of view so communities
that don't get exposure can keep getting pushed out into
the ether. People will see it and will think about it for a second
and it might sit with them later."

 In 2018 Shimoyama enjoyed his debut solo institu-
tional exhibition at Pittsburgh's The Andy Warhol Museum.

Entitled Cry, Baby, it put his work in conversation with Warhol's *Ladies and Gentlemen* (1974–75), a series of portraits of trans women and drag queens in New York. Over 40 years later, here comes *Miss Toto* (2018), a portrait Shimoyama painted while shadowing said Miami drag queen and body builder for a month.

Another major focus of this show, and many subsequent works, has been the Black barbershop. The self-portrait *Sit Still* (2018) depicts the artist's first experience of sitting in the barber's chair, jewel tears falling into his iridescent beard as the razor approaches. It is a reflection of how uncomfortable he and others have felt in this traditionally heteronormative, hypermasculine atmosphere. In 2019, Shimoyama was part of The Barbershop Project, an initiative by non-profit arts group CulturalDC, for which he created *Mighty Mighty*, a barbershop-cum-art installation in a Washington, DC, parking lot. Inside, transgender barber Brixton Millner gave free cuts surrounded by Shimoyama's riotous paraphernalia and paintings.

Also in 2019, his solo show at Kavi Gupta Gallery in Chicago, We Named Her Gladys, examined Black ownership of properties and businesses as a way of securing agency and guarding against displacement and gentrification. Inspired by the purchase of his first home in Pittsburgh, paintings in the show depict Shimoyama weeding the grass and watering plants in his own safe space. But it's back out in the public realm where he has found his now most recognizable symbolism—the hoodie. Since 2017, Shimoyama has produced a number of large-scale hoodie sculptures, responding to a garment that has become emblematic of young Black men who are "up to no good." The artist's versions are adorned with ephemera that reference the spontaneous memorials that crop up on the sidewalks where boys and men have been killed. *Untitled (For Trayvon)* (2021) celebrates the life of Trayvon Martin, who was gunned down by police in Shimoyama's old neighborhood of Philadelphia in 2012.

Taking this thinking further, his site-specific installation for FUTURES, the 2021 exhibition at the Smithsonian Institution in Washington, DC, imagined a monument to the tumult brought about by racial violence and the COVID-19 pandemic in 2020. *The Grove*, with its crystal-covered pillars surrounded by glistening sneakers and flowers, offered up an exuberant forest within which visitors could pause, forgive, and heal. As with all of his work, Shimoyama is bringing his audience to the intersection of Blackness and queerness to bear witness and to see the light. It's not difficult to see how the rage, alienation, and grief could be all consuming, but for this tender artist the end goal is always joy and always love: "I've no interest in making a bunch of sob story paintings. Or showing Black men in pain or grief as a singular emotion. It's not all they are. My paintings are super glamorous and celebratory—they're directly confronting the viewer and engaging with them, posing and gesturing to them, inviting them. It's important to make it an open story."

James
Siena

Shaehft, 2020
Watercolor and graphite on paper
19×25 inches

Why I Make Art

James Siena may now be among America's most celebrated living artists, but his success was not instantaneous. As he developed his signature abstract style in 1980s New York, he was also finding creative ways to support his craft, from printing T-shirts to making custom picture frames (a job that entailed "holding an electric sander all day long, eight hours a day").

"In 1985, I was cutting mats for a living," he says. "I was doing it in my apartment on 5th Street. I had this table that I could set up in one of the rooms of this two-bedroom apartment. I'd make mats and sell them to people and then break it all down."

These side gigs were about more than making ends meet. Siena's understanding of physical production processes has had a huge impact on his artistic practice, which uses a strict, rules-based approach to create hypnotic paintings in an almost industrialized manner. And the California-born artist always found time for his own work.

"I lied to my clients all the time," he says. "They'd want to come in on a Thursday. I'd say, 'Sorry, I'm booked with another client.' But *I* was the client. I guess I still feel a little bit like that. I don't want to shoot myself in the foot, but I have to say, I kind of miss that lack of pressure."

Siena's advice for aspiring artists is, therefore, born out of experience: keep creating and, sooner or later, you'll find your audience. "Or your audience will find you," he reflects. "It's a war of attrition, in a way."

In those early years, being proactive was similarly important. "I went to the Wolff Gallery, in the East Village, and got their attention. I got home and the phone rang ten minutes later. Then another ten minutes went by and they came over.

"It didn't really lead to much. I showed a number of times with them and I think I sold two pieces. But when I talk to students about this stuff, I say, 'If you're interested in showing, why don't you show the gallery that you're interested in *them*?' Find a gallery you'd like to show at,

Dyscopia, 2021
Acrylic and colored pencil on linen
60×48 inches

Why I Make Art

Tycloictradn, 2019
Acrylic and charcoal on linen
75×60 inches

go there and say interesting things about the work you're looking at. Pay attention to them—they're people too."

These were all lessons the artist learned on the competitive New York scene of the late 1980s and 1990s. "I guess I could say I was invited into galleries and disinvited," he recalls of his "half-hearted attempts to show," and "a few aborted successes."

"I remember talking to Iris [Rose, Siena's ex-wife] about it at the time, and she said: 'You are not going to get recognized for what you're doing for a while, because people aren't ready for it. And one of these days some people will really fall in love with your work, and you'll be alright.' I say that to people now, and it's true of so many people. Every artist gets rejected and reacts to it with frustration sometimes. But persistence pays off."

Siena's persistence has yielded critical acclaim and solo shows across the US and Europe. His intricate creations, often formed from concentrated and vibrant freehand patterns, are held in numerous public and private collections, including the Museum of Fine Arts, Boston, the Metropolitan Museum of Art, the San Francisco Museum of Modern Art, and the Whitney Museum of American Art.

"I was 39 when I really started showing more," says Siena, who's now in his sixties. "And it happened in a very correct, organic way, at least to me. Joe Amrhein started a little gallery called Pierogi—it was called Pierogi 2000 back then, because it was 1995. He had a little space, and had originally wanted to do modest shows and have a flat-file program [collecting artworks on paper that could be held in plan chests and were available to view]. No drawing would cost more than 50 bucks, and then he moved it up to $900. But it was it was basically an artist-run space and it galvanized the community."

Siena's Pierogi show was well received, with artist and critic Elisabeth Kley concluding that his works were both "refreshing" and "acerbic." His paintings were, she

wrote, "too precise to be organic, too illogical to be geometric, and too dry to be decorative." His solo exhibition was soon followed by another—this time at New York's Cristinerose Gallery. The show, along with Siena's growing profile, heralded a new kind of pressure: to keep creating work.

"What frightened me was that I looked around the room and thought, 'I don't think I can ever do this again,'" he says of the 1997 exhibition. "Nobody's ever going to give me five more years to make another show. I had a very strong feeling that these artworks would be liked by somebody, just like Iris had predicted. But I didn't have a timetable, and I didn't want to push it. I wanted to make the work as good as it could possibly be."

He need not have worried. Siena, now a prolific printmaker, painter, and sculptor, went on to stage solo shows —sometimes as many as four a year—across much of the next two decades. In 2016 he took over MoMA's lobby with James Siena, *Pockets of Wheat,* a series of large-scale black and white compositions that responded to various self-imposed constraints, including one in which his lines were forbidden from touching one another.

The works were emblematic of Siena's highly systematic approach, which often sees base components repeated indefinitely across any given medium. Part-programmer and part-artist, he abides by parameters he has described as "visual algorithms." Siena's adherence to these rules is so strict that he would sooner abandon or remove part of an artwork than allow an error to be shown. "If I get a mistake—an oil stain, an ink stain—or I make an 'illegal' move when I'm drawing, I cut it out," he says. "If there's a foul, I make it over again."

This mathematic mindset belies a practice that is, for all its rationality, imbued with human character and biomorphic allusions. The randomness of what Siena leaves to chance generates art that is, somehow, consistently surprising. His methods—ever more relevant in the age of advanced coding and AI—are still rooted in the artist's

Infolded Ridgeling, 2020
Acrylic and charcoal on linen
36 × 48 inches

own handiwork. Imperfections arise from the fallibility of
his own hand, but doing things manually is, he says, "some-
thing I've been concerned about forever."

In exploring this relationship between artist and
system, Siena has employed a vast array of methods, media,
and materials. Starting out in performance art, he became
known for works of enamel on aluminum, and has since pro-
duced everything from woodcuttings and ink drawings
to lithographs and bamboo sculptures. He has even used
toothpicks to produce a series of geometric objects
—sculptures that he destroyed in the 1980s and has since
remade. ("I wasn't really sure whether they were 'me' or
not; now I'm sure they *were* me," he explains.)

Among his more recent experiments are an on-
going series of mesmerizing prints made using manual

typewriters. An avid collector of the machines, Siena does sometimes use them for their intended purpose ("I used to have a very regular correspondence with an artist friend, Dan Schmidt," he says, "and we always wrote on typewriters"). But it was, perhaps, only a matter of time before he began making art with them. A typewriter's combination of mechanization and manual input seems perfectly suited to Siena, who forms patterns from repeated sequences of numbers and letters. "Bicycles, typewriters, musical instruments—they are non-electric," he says of his three collecting habits. "They don't really come to life until the muscles of the human body engage with them, and in some cases the mind. There's something terribly moving about that.

"Collecting typewriters was just a pastime," he adds. "And another way to slow things down—I'm always looking for new ways to slow it all down. But then, when I was in Rome in 2013, I started thinking about typing drawings. And, of course, I hadn't brought a typewriter with me, so I had to go find one, which I did. I made about 25 drawings there, and have continued to do that."

Though this method of artmaking can accommodate works of almost infinite length, if not width, he is content with the 8.5 × 11-inch dimensions of standard typewriter paper. It seems that Siena has always been more comfortable with smaller canvases (his aforementioned MoMA works were the exception, not the rule, and had initially been envisaged as enlarged versions of microscopic drawings). "I could type a drawing that's 27 inches wide by n inches long," he explains, "but it doesn't feel right to me. I make a lot of drawings of that same size, but I like that intimate scale. There's a kind of pedestrian modesty to them, too, because I started drawing in 8½ × 11 for money reasons."

Siena is no stranger to shoestring budgets. After obtaining his BFA from Cornell University in Ithaca, New York, the artist painted his father's house in return for a plane ticket and made what he believed, at the time, to be an "indefinite move" to Spain with just $9,800 to his name. In

the early 1980s, one could "stretch it out for a while," he says. The trip, to the island of Majorca, only lasted six months, but it was a formative period in which he connected with the Cuban-born American artist John Ulbricht and the now-acclaimed Spanish painter Miquel Barceló.

"There was some art going on and we also had access to a stone house in the mountains with no running water," he recalls. "It was a wonderful time. I got a lot of work done, mostly works on paper, and I developed a nice friendship with Miquel.

"We were both making our own paint, which was something I didn't know that many people were doing. And it was very process-oriented work. He was coming out of Tàpies," Seina adds, referring to the influential Spanish artist and theorist, Antoni Tàpies. "I was coming out of minimalism and postminimalism."

After running out of cash, Siena ended up back with his father in Washington, DC, where he had spent much of his childhood. But he continued to develop the process-driven techniques he had experimented with in Spain. After earning some money, he went back up to Ithaca, New York, where he lived in "an old rundown house, again without running water. It was very pared down and isolated."

Siena would later move to New York City, renting "a pretty good-sized studio for about $300 a month" in Brooklyn. A far cry from his days in rural Majorca, he even began experimenting with computer-aided design (CAD) software on an early personal computer made by 1980s technology firm Leading Edge.

"I had a painting studio space, which was freezing in the winter. And then I built a little room within another part of the loft. I put the computer in there and put a door on it, put a storage unit up top, so I could pack everything away and have a nice empty studio to work in," he says. His early digital experiments led to very little, however. "I was trying to make drawings on a computer and completely failing—I wasted like a year of my life."

Moving from Brooklyn to Lower Manhattan's Canal Street, where his studio has remained since the late 1980s, meant paying "$100 more for about a third of the space," he says. The artist also moved his mat-cutting practice out of his apartment and into the studio, leaving even less room to maneuver. But for an artist who is constantly playing with scale and proportion, adapting his practice to a small space felt somehow related to his art, says Siena, who called the process a kind of "literalized compression."

"I was more of a process artist and more into the phenomenology of seeing and making—that kind of total postminimal thing—and re-presenting things that aren't supposed to be art but become art, shifts in scale, materiality. Then I really got involved in a notion of crafting. When it takes a week to make a minute, you can map that onto taking a week to make an 8 × 5 drawing. The idea of slowing things down, compressing. And what I did in the first studio that I rented at 83 Canal Street was build a cabinet the size of one of the walls, about 4 feet deep, and I put everything in there. So now the room is smaller, but there's nothing in it."

Siena also relished the chance to not share his studio space with others—not least "the guy who rents an entire floor and then takes half the floor for himself and rents the other half to 400 people who get 100 square feet each and it fucks them over," he says, describing an all-too-common practice he believes to be "evil." A self-professed "packrat," his studio is filled with his own artworks, including ones he doesn't recall making. "I used to say I'll leave that place horizontally," he jokes. "But maybe I want to be in control of that. I'm not sure. There's work up there that I don't remember making, that's for sure. From the early 1980s, from the farmhouse and Ithaca days."

But if Siena is a hoarder, that doesn't mean he's an artist caught up in past glories. "I think I'm making better work now," he says. "We always think we're making better art. What's your favorite piece? The one I did yesterday."

Siena may not be alone in thinking his latest work is his best. His more recent art has also, he says, elicited an emotional response from viewers that he had not expected: happiness. "It's funny, the reaction and some of the comments I'm getting from people. There are a lot of people saying that these new drawings make people happy, which is nice, and they make them laugh. And it was never my intention to be whimsical, but I kind of love that."

Which artworks make us happy is, of course, entirely subjective. It's a point Siena illustrates through his recent encounter with an absurd, sexually explicit work by an Iranian art student.

"He adorned a staircase in the Yale galleries with this kind of kitschy Arab restaurant-wall paintings of apples with faces on, vases, birds eating cherries, and all these patterns around them," he recounts. "Then it gets to the landing of the staircase, and there's this painting, on canvas, of this Saddam Hussein-like, hybrid tyrant face where the windows of an airplane would be. But the cockpit has an ass, the face is just this fascist cocksucker, and coming out of his face is this uncircumcised dick. Then he's holding out his arms as the wings, and there are these dicks under his arms. There are all these headless people pouring down, and there are these other people that look like they're doing the can-can cowering below him.

"And I said something like, 'It's so uplifting to look at this painting; this painting makes me so happy.' Of course, somebody else said, 'This painting makes me really, really upset.' I said, 'Well, similar emotions.' I was energized by the kind of defiant thrill of a guy who has lived under Ahmadinejad, Khomeini, and the Shah, and under a kind of blood-soaked barbarism."

Siena, who lectures at numerous institutions and is part of the MFA Fine Arts faculty at New York's School of Visual Arts, believes that activism is crucial for both emerging and established artists. "It's important to be an activist and there are various ways you can do it," he says. "You

can do it in your art, you can add a new angle to your work, or you can send a branch off into politics. And you can write letters. You can write them on a manual typewriter, even. I plan to do that."

Nonetheless, he admits to being "not so much of a planner," explaining: "I'm a reactor. I react to the thing that came before and the next thing." It's a mindset that may explain the huge variety of endeavors that Siena has embarked on alongside—or in tandem with—his art career. He runs a small gallery space from Canal Street and has written dozens of articles and publications. He has even produced lyrics for a contemporary opera and designed the prestigious Yaddo Artist Medal, as well as being a keen musician, with his guitar playing something that is "keeping me from going nuts," he says.

"I play every day. I don't play *a lot* every day—sometimes I play just two songs. Katia [Santibañez, Siena's artist wife] and I will play. We'll sing a song or two while we're making dinner or on the weekend. Or if I have a little more time, some nights I'll just play for an hour. It's therapeutic. It's completely amateur for me. I have no real ambition for it to have meaning."

Artmaking, on the other hand, comes with certain expectations. Despite the great success he has enjoyed since sanding picture frames in the 1980s, Siena admits to feeling "a little pressure" when it comes to new shows.

"It's weird. It's not an awful feeling. It's just like the little knee problem I have right now—just because I'm aging and I keep running, even though I probably shouldn't as much as I do. It doesn't hurt, it just feels weird. And we have to get used to feeling weird."

Cauleen Smith

In another life, Cauleen Smith—the prolific creator of experimental films, conceptual installations, and art objects—is a professional cellist. In that story, the instrument is foisted on her during the fourth grade at her public elementary school in Sacramento. A love of music is fostered by a too-cool drummer brother who plays records from jazz greats like Miles Davis, Stanley Clarke, Wayne Shorter, and Jaco Pastorius in his bedroom. When she gets older, she joins the high-school orchestra and an extracurricular youth ensemble; she forms a string quartet with friends and plays weddings for cash. She plays her way to a music scholarship at Chapman College (now Chapman University). It all feels natural; she knows this is her calling and she dreams of the big time.

In this life, though, things didn't quite turn out that way. Smith did grow up playing the cello, and listening to her brother's albums, and playing in orchestras and wedding bands. But rather than pushing her toward a career in music, her experience at Chapman was disillusioning.

"I had to play cello every day for hours, and that's when I realized that I wasn't a musician," she says. "It came easy to me. I could read the music and I could play it, and then if I practiced long enough I could make it sound OK. But a musician is another thing: it's this ability to think through music and produce thoughts through music. I don't have that, and I started to realize it when I was with those who did."

If Chapman is where one dream died, it's also where another was born. In an elective course with the film department, Smith discovered the passion for film that would drive her career: "I made one project there and I loved the process. I loved using the camera, writing the story, designing the set, getting the actors. I didn't even mind that it was a failure because it had been so amazing to go through it. I felt so enriched by actually making it that I just wanted to do it again, and maybe do it a little better."

Eventually, Smith dropped out of Chapman, and with new focus completed a BA in creative arts at San

Pigeons Are Black Doves, 2017
Satin, poly-satin, indigo-dyed silk-rayon velvet, indigo-dyed silk satin, embroidery floss, acrylic fabric paint, satin cord, polyester fringe, poly-silk tassels, and sequins
70×49½ inches

Francisco State University, where she studied under Trinh T. Minh-ha and Lynn Hershman Leeson.

"They challenged me. They took seriously the work I was doing, which was so clueless, and insisted that I make it better," she recalls of her instructors. "And I paid attention to them. I'm still paying attention. Minh-ha was bringing in like, fresh English translations of Barthes and Foucault, when you couldn't really get them. She was bringing in these mimeographs and Xeroxes that had been copied ten times and forcing us to read them. No one was pleased about that. We didn't know what the heck it was. We didn't know how to read it. So she started reading it to us in class. That's how serious she was. I'm eternally grateful to her for that. Eternally."

Smith went on to do an MFA at the University of California, Los Angeles School of Theater, Film and Television, where she hoped to learn the secrets of American filmmaking. "I wanted the classical Hollywood narrative

trick. I wanted to understand how it worked," she says. "I went there because of the history. Charles Burns, Larry Clark, and Julie Dash in particular. And I wasn't disappointed."

Though she didn't train under those particular alumni, Smith did receive a rigorous education, courtesy of a group of instructors she refers to as the "Eastern Bloc." They were "highly skilled Russians, Hungarians, Polish, and Croatians training us. And that's what it was—training. We had this class with this Polish dude, and he would play any random Hollywood film and scream out the lenses at every shot. Like '25, 145, 250.' It was crazy."

Though she benefitted from what the teaching staff had to offer, Smith remembers being a "problem student" while at UCLA. Specifically, she made a feature film despite the fact that it was prohibited for students to do so. "I wasn't able to show that film to my teachers, because it was against the rules to make it," she says. "So I was making it in a vacuum, which was both terrible—It would have been a better film if I'd had help—but also great, because I thought, like, nobody cares. So I just finished it to get it done.

"When I look at it now, all I see are the mistakes and blunders and poor judgment," she adds. "Things I didn't know I should fight for then because they would haunt me 30 years later."

After graduating, Smith says she tried to forge a career in film, but that "It just didn't go well. I just couldn't make it happen." In retrospect, she thinks she never really wanted to go down that path. "I wanted to make films," she says. "But I didn't want to be in the film business. So I started teaching."

Now a professor at the CalArts School of Art, Smith speaks highly of the institution, and the students that fill its corridors. "I love the way CalArts figured out how to make a place that is so creative," she says. "You walk down the halls and there are these little art sprites running around everywhere. My undergrad students blow my mind. It's

wonderful to deal with people that young and open, or desirous of a creative practice."

Aside from teaching, Smith is known for video pieces and works in other mediums that reflect upon the everyday possibilities of the imagination, often through a feminist, Afro-futurist lens, and has staged solo shows for her films and installations at the Whitney Museum of American Art, the Los Angeles County Museum of Art, the Crystal Bridges Museum of American Art, and MASS MoCA. Since her time at San Francisco State, where she says students were trained to be resistant to narrative altogether, she's been more fascinated with the esthetics of film—the principles that shape how on-screen images are perceived—than its documentary potential.

"I think I have a problem with didactics in film because it's not what's interesting to me. Because I know how a film is made, I frequently lose interest; I see the craft and I distrust," she says. "My whole attraction to movies was that I wanted to like them. I loved the world-building, but I hated that movies always made me feel so bad [about myself]. And then once I realized what was happening in the movies, I understood why they were making me feel bad: It was a language and a syntax. It's the way the camera is, the way people are presented, the lighting—all these things. And I was like, 'Oh, those are just things you can control, so anyone can control them. They don't have to do this.'"

Though Smith no longer plays the cello, music has remained an important part of her life, "The model for almost everything I make," she says. Her Solar Flare Arkestral Marching Band project and short film *Space Is the Place (A March for Sun Ra)* (2011) engage with the legacy of the visionary Black jazz composer Sun Ra; while the life and music of jazz harpist, pianist, and spiritual leader Alice Coltrane seeped into her films *Pilgrim* and *Sojourner* (2018). She's found herself drawn again and again to Chicago and New Orleans—cities where African American music is baked into the history, the culture, and the people.

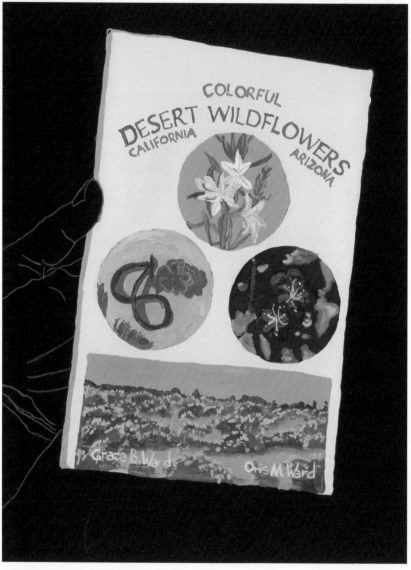

Colorful Desert Wildflowers: California and Arizona, 2019
Gouache on paper
12×9 inches

Why I Make Art

"I have an addiction to paralleling the sort of path of visual art and music. I think there are so many similarities," she says. "Film and music were made for each other and feed off of each other. And, for me, whenever I'm looking for a structure for a film, I look to music. I don't even think about narratives or novels or anything. I think about music right away."

She likens developing and structuring her films to the creation of a musical composition. "There's a snippet that I found of Sun Ra rehearsing with his band, and he interrupts them to lecture about the shape of sound," she says. "He talks about diamond-shaped notes and heart-shaped notes, how they sound different; you've got to play them. He was just hammering them—'you're not playing the right shape.'

"Music and film both affect you in non-narrative ways, in ways you're not aware of while you're experiencing them," she continues. "The structure and the form of music, it actually has a shape, and I want the film to have that same rhythm and shape and form."

Salman Toor

Pakistani painter Salman Toor exudes a geniality that seeps into his paintings. In brushy, layered strokes of color, his figures—often young, brown, South Asian men like himself —dance and mingle and cuddle and kiss, inhabiting inviting bars and intimate domestic spaces, often tinted a hazy green. Even when alone, texting or snapping nudes, there's a tenderness of technique. These are people the artist cares about, and you start to care about them too.

"It comes from a place of warmth, for sure. I definitely feel like I'm summoning friends and happiness," Toor says. "That's why initially I thought that the work was sort of silly. I thought a lot of contemporary art came from a very cutting, cold place... So why would anyone want to look at this?"

In recent years, Toor's instinct has been proven wrong again and again: It seems that in galleries and auction houses, there's an insatiable appetite for his flavor of warmth. A recipient of a 2019 Joan Mitchell Foundation Fellowship, Toor has been exhibited widely in New York (where he's lived since 2006), in his native Pakistan, and beyond. In 2020, he opened his first institutional show at the Whitney Museum of American Art to critical acclaim, and the following year, one of his paintings, *Music Room* (2021), was blown up and displayed on a billboard outside the Hayward Gallery in London.

But while Toor's work has international appeal, its subject matter remains highly specific. The fictitious scenes and imagined characters are primarily inspired by his own life experience and friendships with other brown bohemians.

Toor was born and raised in Lahore, Pakistan, "a really sensitive, effeminate boy" in a community that rewarded macho masculinity. As a kid, he had few friends and his share of bullies. Art became a source of entertainment and escape: "Everything came out of drawing for me... It was like a constant kind of conversation and a companion."

Music Room, 2021
Oil on canvas
102×81 inches

Beauty and femininity were recurring themes. "I was obsessed with drawing beautiful women with long hair all the time. My parents would say, 'Why don't you make fighter jets, or try sports cars or buses, or, like, guns?'" he recalls, laughing. "I remember that I drew a bus—I think that my mother has that drawing somewhere still. There's a bus with this lady's head sticking out of the window, she had long hair that was trailing in the wake of the bus's speed."

His parents had originally hoped he would channel his interest in beauty into a career as a plastic surgeon or an architect ("architecture has always been seen as a manly job—or at least used to be"). "But by the time I went to college, they were OK with me choosing to take a path solely in picture making and art history. I had a lot of bohemian cousins growing up, and they were sort of like my allies," Toor says. "A lot of them are teachers in art schools in Karachi and Lahore in Pakistan, and they're also printmakers and painters and so forth. They sort of understood what was going on with me early on," he explains. "They were very supportive. They would talk to my parents and say, 'Let him do what he wants to' and 'Don't get in his way. Just support him.'"

In the early 2000s, Toor moved overseas to Delaware to attend Ohio Wesleyan University, a Methodist liberal arts school that would act as a backdrop to his crash course in American culture. Arriving after 9/11 on a full scholarship, he was comforted by the "warm sense of Midwestern family values."

"I think I was just too ignorant to really understand at the time if I experienced any negative things from the culture. But my overall experience was actually very, very good," he explains. "I grew up watching Disney and maybe *Back to the Future*, *Labyrinth*—you know, the classics—and I had a very narrow idea of the varied values in a country... with all kinds of places and people. Across the world, there is a pervasive and singular image of consumerist culture in America, and so my experience was different."

Off campus, he lived in a hippie commune where there was "a lot of chakra music and that sort of thing. A lot of tambourines and nudity. That was also a good entrance for me into American culture because it was gentle. It could be silly at times, but open and welcoming, and with its own threadbare sense of beauty, which I was familiar with."

In an Art History 101 class, he was introduced to a more classical type of beauty that would make an indelible mark on his practice. "That was when my brain opened up to Western art history... I was just electrified. I wanted to take it in like a sponge. There was just so much to learn," he says.

While completing his BFA, he "went through different periods of obsession with different parts of European history of painting and sculpture. It began, I think with just the classic Renaissance—like Michelangelo sort of stuff —and moved on to the Baroque, and then the 18th century. At those times I wanted to teach myself to paint like those artists. And so I began doing that in the studio," he says. "I taught myself how to do underpainting and how to prepare surfaces and also have them finished in that old-master-painting sort of way in which everything is under this lake of gleaming varnish."

His professors at Ohio Wesleyan were encouraging, indulging his desire to learn sumptuous (if labor-intensive) historical techniques. "I think because it wasn't in a big city on the coast, people were just laid back. I think a lot of people wanted to paint beautiful pictures."

At the Pratt Institute in Brooklyn, where he completed his MFA in 2009, the staff were less impressed by his European pastiche. "I just wanted to have 17th-century costumes and candlelight all around me, that full Baroque gravitas. It's completely insane," Toor says. "I had to fight for it. I was pretty stubborn but I was good enough, so they didn't really discourage me from doing what I was doing. At the same time, I think I would have learned a lot more at Pratt if I went now rather than then because I was so closed up. The best thing that I got from that was my friends."

The Garden, 2020
Oil on panel
30×24 inches

Why I Make Art

Those friends, and other artists with whom he shared a Brooklyn studio space, would buoy him through the uncertainty of his early career. "I remember the extreme anxiety of thinking 'What is going on with my life? What am I gonna do?'... Because I had a community I could feel OK. Like, OK, fine. I'm happy. This is enough, right? I could talk about it with my friends, and we were painting together. And a lot of the time the problems that you're going through are so similar. That really helps."

New York itself has provided a limitless source of inspiration. "What I like about the city is that it's so active, it's never at rest, and so you just have to be 'on' all the time. That can get on my nerves after like six months. But it's great. It keeps my mind alive. I live in the East Village, so there are a lot of different kinds of communities there. And in New York, the drama of like a Sikh taxi driver who's driving this queer fashionista home—I just love that combination. It still really fascinates me, and I don't really get tired of it."

After graduating, Toor held onto his ambition to be "a very loser-ish painter" emulating the work of old masters like Rubens and Van Dyck. But eventually, the work became exhausting and the pay-off, diminishing. "I got tired of it at some point because there was a lot of intermediary stuff between me and the painting. I felt like I needed a fluffer to get me in the place where I could finally lay down a mark because I needed images, I needed models, I needed mood, I needed music," he says.

"One time after I had a show, I was like, I just want to paint some rubbish, some cute pictures from my apartment, and I want them to be completely imaginary and to maybe look like a picture out of a graphic novel. And so I did a bunch of those, and they were really satisfying to me. They were very silly and not 'deep', but I was very happy with them. They were embarrassing—I didn't show them to anyone, I didn't put them up in my house. But I kept making more and I kept getting better at them. I started collecting them in my studio, and in a year I had about 30."

Bedroom Boy, 2019
Oil on plywood
12×16 inches

From then on, Toor says, "I wanted to just kick out as hard as possible from my previous practice. I experimented with text a bit, and that worked for a little while, but I felt like I was still ignoring the true issues that were closer to my way of thinking. I think once I started making completely autobiographical work—well, actually, I shouldn't say completely, but somewhat autobiographical—I was comfortable with the painting being about my own experience, rather than taking on concepts or themes that I thought were bigger, like language or cultural differences. Choosing what I thought was a simpler or dumber way of doing things was actually better for me because it came more naturally. It began without much thought, but it always ended up in a place where it was more meaningful to me."

Weaving fantasy from memory alone, rather than research and constructed scenes—a directness that at first

Why I Make Art

felt "almost like cheating or sacrilege," Toor's work became more immediate, and his output more prolific. The transgression became part of the fun.

"There was no need to edit those images as much because there was nothing I didn't know in the image. It was already completely filtered. Everything in the painting —objects, people, whatever—was just very essential," he explains. "The way that I was painting before—like 2012, 2013—I could maybe do 20 paintings a year at the most, and I felt like so many ideas were just putrefying in my brain. I didn't have enough time. In this way, I felt like I was able to create a world by making numbers and numbers of paintings and inhabiting that world more easily. There was also the element of chance—the things that I would do on a canvas that would surprise me, that I didn't know I could do, or something completely new. That was great."

Toor did not, however, abandon everything from his earlier practice. His paintings contain a sort of timeless loucheness. "I'm concerned with fashion, you know. I paint different kinds of clothes. It's almost like fashion illustration. So I'll do different textures and what I think of as different cuts and different layers and articles of clothing. That's kind of related to the way I admired European paintings that have fashion as a huge part of them, like different plumes and different kinds of satins and velvets. There's a kind of yumminess and, weirdly, a feeling of safety and domesticity in the paintings that I like to work with," Toor says.

"I like that combination of flouncy, frilly, feminine domesticity coupled with hairy brown bodies, and the idea of the glamour of effeminate men together and happy in groups or circles of friendships. I think that's one of the things that really drives me: apart from the idea of ecstasy in the paintings is queer friendship and communities of support. Growing up, my friendships were possibly the most valuable thing to me. In high school I found friends who I understood and I felt understood completely by them, and we were all artists, all queer.

That's a really important thing that I like to think about often when I'm painting."

For Toor, his paintings represent a respite from the harshness of the outside world. "I also think of the paintings, because they have so many little domestic spaces in them—like the ones that my friends and I have in the East Village—as safe spaces, even though it's a safe city. I grew up in a culture that was pretty conservative, so I'm still attached to the idea of safe spaces and I think maybe other people are as well—even people who grew up in the States and in spaces where it's completely safe to express everything."

Safety, however, does not equal tedium—neither in life, nor on the canvas: "I need every part of the surface to be interesting to me, and so I have to reinvent everything until it becomes interesting. That's a lot of rubbing away and then reworking or working on top of something until it's interesting. One of the things that I really guard against in my own painting is vast, dead surfaces, because the paint, as a material, is so alive. I just want it to be animated, and to have at least three points of maximum animation."

Toor views his practice as part of a wider generational mission to appropriate the tropes of the past in the name of inclusivity. "It's a kind of revision of figurative painting in which a lot of queer people are attacking their heroes—well, not attacking, but maybe talking to them in a way, and expanding on their vision. For instance, we were so used to this heterosexual way of looking at things that said it's OK for Picasso to have tons and tons and tons of pictures of women in all kinds of splayed positions, and also women in vulnerable situations where they're crying or they're hurt. That's still encapsulated within this bracket of 'woman', while the artist is looking on indifferently," he suggests. "I love Picasso. I'm not trying to be more clever than him. But we live in an age that requires it to be expanded, to be more inclusive. There are so many more interesting ways of looking at

Why I Make Art

Fag Puddle with Pearls and Sock and Shrubs, 2020
Oil on panel
Diameter: 24 inches

Salman Toor 309

people now that we have a new, inclusive point of view. There's a lot of revision to be done in everything."

Toor tackled the political weight of seeing and being seen through a group of paintings that deal with the discomfort of crossing borders and dealing with immigration as a South Asian man. In these paintings, uneasy-looking travelers stand before their removed belts, shoes, and phones, nervously awaiting inspection. With these, he grapples with societal clichés rather than art world tropes.

"The language of clichés has to be used by the person manning the border to understand whether he should let you in or not. It's his job... If you're an immigrant, they have to use very facile signs to figure you out," he says. "The series is founded on this idea of the self-portrait imagined through the critical view of someone who was a gatekeeper, basically. And so there are many kinds of questions that can be funny that arise when that happens. It's like I'm asking questions about myself through his eyes—'Is he going to be a conservative Muslim type?' At the same time I ask myself, 'Should I act harmless or more queer? What if they're homophobic?' So I feel like it's a two-way sussing-out, because within a few sentences you have to really figure out who the other person might be.

"Whenever I go through that, on either side of the border... for a couple of hours after that I really know a reduction of myself and it's crazy. It's not really something to hold onto I guess, but I feel like I have a very good idea of how the world works for a couple of hours. And then I go back to being complex."

As a queer artist of color, Toor has discovered that centering one's work around a marginalized identity can be a double-edged sword. Art world gatekeepers, in their efforts to appear more diverse or inclusive, can be similarly reductive, pigeonholing artists based on their background or surface-level readings.

"That's pretty diminishing, yeah. And that's something that I fight against as well—and it can be fought

against. But that's the prerogative of the system: to try to make it easier for itself; to hashtag things and then curate shows based on a smorgasbord of social issues that it wants to attach itself to or that are hot or whatever.

"As an artist, it's a delicate interpretive dance that you have to have with the system, in which you move along with it, and if it stirs you too much, then you kick it a little bit. Then you move along. It's a negotiation that goes on and on. It doesn't end."

Robin
F. Williams

313

"I'm interested in making creepy women," says Robin F. Williams of her large-scale paintings. The Brooklyn-based artist's work does away with the impossible idealizations of women in fine art and pop culture, conjuring instead women protagonists who always have the last laugh.

A prime example is her 2017 show at P·P·O·W Gallery, New York, titled Your Good Taste is Showing. A nod to decades-old ads that show women finding pleasure in objects that represent or replace their true desires—like shampoo or cigarettes—Williams' characters look cool and detached in their shimmering sunglasses, but their poses are awkward; something feels off. "They are out at dusk and they're doing slightly sexually deviant or inappropriate things," Williams explains. "As a woman you're meant to be sexy but not sexual. There are these narrow definitions that are designed for us to fail at, so these women are doing it in the 'wrong' way. They can't be bothered to get things right."

In the show's namesake painting, a woman reclines while smoking two cigarettes at once, while flashing her underwear. In Spa Night (2016), three women bathe in a pond with the ominous glow of a car's headlights illuminating their watery rituals. In Salad Lover (2016), a naked woman hugs a large dish of lettuce between her legs.

"She's using a bowl of salad to masturbate," Williams clarifies. "There are certain things that women are allowed to desire and one of those is salad. It's acceptable. So, this woman is like, right, I'm in the clear, I'm just loving salad. But the sexual frustration goes too far and then she's outside and squatting over a bowl of salad. I fail to believe she is getting much pleasure out of this salad. But there's a lot of sexuality that's just performance. You're pretending and hoping to feel something. Especially for teenage girls, there's so much discomfort around your own erotic imagination and you're terrified of anyone knowing you have fantasies beyond giving blow jobs."

It should be said that not all of Williams' women are creepy. Some have transformed into mythical beings,

Vaping in the Rain, 2019
Acrylic and oil on canvas
54×70 inches

others are beautifully sullen. But they're all a clarion call for female agency, encouraging audiences to reflect on the way women are often represented either as pure love and moral high ground, or damned, scapegoated, and demonized when they fall short of expectations. But it's when women drop the standards that the fun starts on the artist's canvases: enter the flawed, the menacing, and the deliciously wild.

Robin Francesca Williams was born in Columbus, Ohio in 1984, where she was raised by liberal parents who encouraged her creativity. She has fond and wholesome memories of her father playing in bluegrass bands, and he was also the nerdy softball player at school. "We were Unitarian Universalist, which is a social justice-based new wave religion. My parents were free-spirited and so we

were in this funny little bubble in a suburban city that was actually very homogenous and Middle America. I remember being shocked when I met people who were conservative and homophobic, or just concerned with keeping up with the Joneses. I didn't realize it at the time, but mine was a very specific American experience."

Williams is thankful to her grandmother for enrolling her in a weekly art class aged five, which she diligently attended for the next ten years. "This woman ran an intergenerational art class out of the basement of a gift store. It was mainly older women and I was the youngest one so I hung around and listened to their conversations," she recalls. "The teacher started me off on oil painting straight away and I fell in love with it. Looking at some of the first paintings, they were pretty good skills-wise but I was so young I could barely write my signature on them."

Williams grew up with aspirations of being an illustrator because she didn't believe becoming a painter was a viable career option. During school she spent her free time writing and illustrating children's and poetry books. But once studying for her BFA at Rhode Island School of Design she veered back toward her initial passion for oil painting. Graduating in 2006 and moving to New York, her work featured young people in a relatively realist style and shied away from depicting adult women for fear of adding to the vast canon of male-dominated art history that objectified the female form. She also admits to suffering from her fair share of existential angst about calling herself an artist at all. "When I got out of school, I was grappling with questions of what being an artist means and how much authority we're supposed to have. Is this an emperor's new clothes thing? Am I supposed to be acting for the rest of my life? Is this ever going to feel real?"

The artist in fact found acclaim quickly but a more challenging period lay ahead. "I had a really weird trajectory in that I had all of this success right out of undergrad. I was selling my work and living off of it and was like, 'Oh,

Bechdel Yetis, 2020
Oil, acrylic, and Flashe on canvas
96×66 inches

Robin F. Williams

I made it. I'm going to coast on through like this for the rest of my life.' And then the economy crashed and, with that, life ebbs and flows, and your practice ebbs and flows."

Williams was forced to find several ways to make ends meet. "I was doing jobs that I hated for many years, like waiting tables, which wasn't suited to me. I wasn't used to being so bad at something, failing so hard and getting fired from places. I had this tortured artist idea that it would motivate me to do better at my work, but then I started to do other things on the side that didn't make me miserable." This included joining the adjunct faculties at the School of Visual Arts and at the New York Academy of Art.

By the mid 2010s, one of the artist's well-received exhibitions, Sons of the Pioneers, featured men only. Here the American dream, and the toxic urge to conquer that is often its driving force, is put into question by her cowboys in repose. "They were these quasi-frontier men going into western landscapes, and then when they get there, they just chill, as if they'd forgotten what their manifest destiny was. And so, there're just men having vulnerable, introspective moments," she says. "It was an observation on the limits put on men's masculinity. Everything is a competition, a badge of honor, an accomplishment. Your sexuality is something you're killing at. Nothing can be an internal, felt experience that is naturally blossoming inside of you."

As Williams' practice has matured, and her focus has turned more exclusively to painting women (men do still turn up—likely naked, dicks swinging), her technique and mediums of choice have blossomed, too. Oils are still in the mix but her vast arsenal now takes in acrylics, pencil, pastel, and vinyl paint. Each work involves a complex process that could include masking, scraping, marbling, tie-dyeing, pour-painting, and splattering. She's a huge fan of air-brushing and also reaches for house-painting rollers and foam. Some methods, such as stain-painting raw canvas, are a mark of influences from painters of the past, namely

Abstract Expressionist Helen Frankenthaler. Others are picked up from crafty YouTube tutorials. The result is a rich variety of textures forming a shallow sculptural relief that plays with all manner of illusions of perception.

"It's about building up different depths of paint to the point that they're sinking into the canvas. It's a fun puzzle for me to work out the order of operations and how it all comes together," she explains. "I'm working out these hacks with oil paints. In some places I'm using it for what it's meant for, that luminosity and transparency. In other places I'm trying to degrade it a little bit, or use it like cement. When I found airbrushing it opened up my world and brought with it so many signifiers. It has that out-of-focus photography thing but it also has that carnival T-shirt thing, you know those ones of race cars and sunsets. I love what it does with the depth of field, but it also has the trashy feeling I'm looking for."

Williams' layered multimedia approach is con-tinuously evolving, instilling a sense of wonder and experi-mentation into her work as she makes merry with her process. It also shows off her naturally gifted technical abilities, whether she likes it or not. "I often wrestle with my own gendered instincts to be good at something, to get a gold star, to put my hand up in class. For a while I felt embarrassed by that impulse, but now I'm trying to use it. Let me master all of these different techniques but at the same time make these imperfect women. I'm grateful that I've found some subject matter where that approach has some significance."

Williams is currently represented by P·P·O·W Gallery, New York, and Various Small Fires, Los Angeles/Seoul. Her work is in several collections including the Institute of Contemporary Art in Miami, the Brooklyn Museum, the CC Foundation in Shanghai, the Collection Majudia in Montreal, and the X Museum in Beijing. She's exhibited ex-tensively across the US including Bard College at Simon's Rock in Great Barrington and Columbus Museum of Art,

Siri Defends Her Honor, 2019
Oil and acrylic on canvas
40×60 inches

as well as further afield, most recently at Galerie Perrotin in Tokyo and Allouche Benias in Athens.

From a distance, or via social media, one of her paintings might seem flat or glossy, but get your nose up to it and the layers reveal themselves. Similarly, there is a seeming simplicity or naivety to her forms, but they invite you to unpack and confront many difficult questions. This is the result of Williams' far-reaching cerebral meditations. Just like her stylized characters, she lets her own imagination run amuck while considering a variety of cultural references.

Her contemplation on the gendered nature of the iPhone and Amazon virtual assistants became intertwined with famous female characters in cult films that were as trapped in their world as the AI personalities could be considered to be in theirs. Hence *Siri Calls For Help* (2018), which bears a resemblance to Mia Farrow in Rosemary's Baby, and *Alexa Plays* Ball (2019), in which a naked, grumpy

woman holds a football, herself held aloft by a naked, ecstatic man. Meanwhile *Siri Defends Her Honor* (2019) looks uncannily like Uma Thurman in *Pulp Fiction*, a film she vividly remembers watching at the tender age of ten. "My parents accidentally took me to see it and didn't realize what it was about. They kept covering my eyes so a lot of it went over my head until years later when I put it all together."

Other paintings will raise a wry smile or knowing nod. *Leave Britney Alone* (2019) can only be Ms Spears at her best, performing I'm A Slave 4 U at the 2001 MTV Video Music Awards wearing a live snake around her neck. In the same year, Williams worked on a painting of Gwyneth Paltrow in *The Talented Mr. Ripley*, her horrified face a reflection of the victims of Harvey Weinstein (who produced the film) and all the women who birthed the Me Too movement.

Some of these references may seem less than subtle, but subtleties and ambiguities abound in Williams' work. We're not being given a lesson in intersectional feminism or told how to feel. Her atmospheric paintings can be appreciated on numerous levels, from their virtuoso techniques and lush colors to the empowering themes and the body language of her intriguing women. "I don't know, there's just something fun about painting these women that can't be understood and are a little above the fray," she says. And then there's her occasional paintings of cats looking fluffy and adorable. A "just because" circuit breaker, perhaps.

Williams' most recent body of work swims into more mystical waters and represents another leap in her esthetic realm. Having received an A on the Bechdel test, the artist's latest women and non-binary bodies have left this world altogether for an astral plane where they can play by their own set of rules. In her 2021 show at P·P·O·W Gallery, Out Lookers, cartoon-like witches, ghosts, yetis, and trolls variously frolic through a meadow, hang upside down from a branch, play on a swing and lounge on a cloud. *Final Girl Exodus* (2021) defies the horror movie cliché of the lone

female victim left alive as the credits roll, as she joins her friends to saunter off into the sunset. And in *Stalkers* (2020), four figures lurk in plain sight behind a pole, each with a wide grin and glinting eyes. Behind them is the suggestion of a forest where more unbodied eyes burn brightly. Elsewhere in the show, figures wave excitedly at the viewer. All this makes the gaze ever-present. Are they staring out at you, or are you the pest who's trolling them?

These apparitions transcend their physicality, their often-transparent forms subverting the conventional figure–ground relationship to become windows onto a universe where female identities expand into infinity. Good luck objectifying these bodies as they envelope negative space or fill up with waves, disguising their selfhood with ease.

Bringing us back to Earth, the works are also informed by Williams' interest in climate activism. She's a founding member of Artists Commit, a coalition that took shape during the 2020 lockdown and advocates for sustainable practices such as asking galleries to be accountable for their carbon and waste footprints. *A Sound Around No One* (2021) presents a supernatural figure surrounded by dark smoke and screaming into the abyss. Whether raising the alarm about global warming or the innumerable concerns of women in this contemporary moment, her distress call falls on deaf ears.

These days you'll find Williams in her studio in Greenpoint, Brooklyn, where she's built up a supportive creative community. Of her work ethic she says she "likes to paint like I'm working on a show," and has continued to expand her horizons by learning monoprinting and etching. She says that she stays focused while in her studio by listening to podcasts, stand-up comedy, and NPR radio. But to get anything done she needs to steer clear of her favorite throwback singer-songwriters, including the likes of Aimee Mann and Fiona Apple. "I have to distract the logical part of my brain while I'm painting. I can't concentrate well if I'm listen to music but it's nice to hear something that makes you laugh. Things get heavy so I also limit the news."

Cold Brew, 2018
Oil and acrylic on panel
40×30 inches

Robin F. Williams

Sharing a name with the much-loved comedic actor Robin Williams, who died in 2014, has had a not-entirely unexpected effect on how the artist has been perceived from afar and on who's taken the efforts to reach out. His association has followed her around her whole life—hence why she added her middle name initial to her own—but that doesn't help much with Google analytics. "It's a little weird having his name. Sometimes it's been a fun ice breaker as people tend to expect me to be a man. And I used to get his fan mail, which was interesting. These were the sort of people who'd go to my webpage, see my art and still get in touch thinking it was him. He was a little xenophobic about immigration, so one guy was like, 'You're a bigot, and your paintings are embarrassingly vacant.' That hit a nerve, I'm embarrassed to admit," she jokes.

Today, such is Robin F. Williams' standing that she's search-engine proof and her work and achievements speak for themselves. She's on top because her paintings continue to create spaces for play and exploration, for humor and subversive sensuality, and, ultimately, for personal liberation. Whether you find her women creepy or not, they will go on winning at their own games all the same.

Sound & Vision
Guestbook

325

As I was about to leave after wrapping up a conversation with Chuck Webster at his Bed-Stuy studio, Chuck stopped me and hurriedly looked for something. Tucked away in the overcrowded studio, he found an empty orange Shinola notebook. He paused and wrote something in it, then took an old piece of printed paper and taped it in, painted a circuitous line with a dry brush and handed it off to me. When I looked down, I saw he had scribbled in it, "Sound & Vision Guestbook." A wonderful idea that I'm not sure I would have thought of myself. From then on, I carried that notebook to each podcast, asking each person I spoke with to do whatever they wanted in there. A scribble, a signature, a thought... anything. What I have as a result is an amazing collection of doodles, personal messages, reflections, and drawings which put a stamp on each episode. I love the casual nature of the doodles, which, week after week, seemed to inspire subsequent artists while making their own contribution. I wanted everything about the conversations to be casual, informal, and relaxed, in order to show a different side to artists whose work is mostly seen on austere white walls in galleries. These guestbook entries echo that atmosphere, and reveal a more intimate portrait of the artists I have spoken with. I really love these sketches and messages. They open a door into the playful heart of the artists, and I hope you find them as fun and thoughtful as I do.

Brian Alfred

So good to meet you. The podcast is an important thing. Thank you for including me.

Tom Aarholt

May 2018

XOXO thank you for having me

Rebecca Morgan

Thank you for the wonderful conversation and for making the podcast! I love it and look forward to every new episode!

Thanks Brian!

-John O'Brien

THANKS BRIAN.

AMAZING TO FINALLY BE
IN A PODCAST — I'VE LISTENED
TO A MILLION INTERVIEWS OVER
THE YEARS SO gratifying to
finally be in one. Great
chat — hopefully I made some
sense.
YOUR Ally BARNABY
FURNAS

I.W.F.. B.O.M

Tom Sachs

11 ·20 ·2018

God Bless the mice

I am spoken word from the soul Always!

brian Keep that torch—!
Real Human Fire Burning
Changing the World one conversation at a time!

OPEN WINDOWS
ALWAYS

THANKS SOUND AND
VISION!

GM 2018

Dewar Shimoyama 3-3-17

IM
UR WORST NIGHTMARE

April 10, 2017

Brian!
ONE YEAR!!!
Such an honor!
Thank you Thank you
Thank you Thank you
for including me and
for being so supportive
and for letting me
take up SPACE!!

YOU ARE SUPER
AWESOME
AND SO
FUN TO TALK WITH

Diana Hadid

Artist Index

Diana Al-Hadid
b.1981, Aleppo, Syria
Lives and works in Brooklyn, NY, USA
dianaalhadid.com

Jules de Balincourt
b.1972, Paris, France
Lives and works in Brooklyn, NY, USA
julesdebalincourt.com

Dove Bradshaw
b.1949, New York, NY, USA
Lives and works in New York, NY
dovebradshaw.com

Gregory Crewdson
b.1962, Brooklyn, NY, USA
Lives and works in New Haven, CT
and New York, NY
gagosian.com/artists/gregory-crewdson

Heather Day
b.1989, Ewa Beach, HI, USA
Lives and works in San Francisco, CA
heatherday.com

Inka Essenhigh
b.1969, Bellefonte, PA, USA
Lives and works in New York, NY
victoria-miro.com/artists/23-inka-
essenhigh

Amir H. Fallah
b.1979, Tehran, Iran
Lives and works in Los Angeles, CA
amirhfallah.com

Louis Fratino
b.1993, Annapolis, MD, USA
Lives and works in Brooklyn, NY
sikkemajenkinsco.com/louis-fratino

Dominique Fung
b.1987, Ottawa, Ontario, Canada
Lives and works in Brooklyn, NY
dominiquefung.com

Karel Funk
b.1971, Winnipeg, Manitoba, Canada
Lives and works in Winnipeg, Manitoba
303gallery.com/artists/karel-funk

vanessa german
b.1976, Milwaukee, WI, USA
Lives and works in Pittsburgh, PA
kasmingallery.com/artist/vanessa-german

Allison Janae Hamilton
b.1984, Lexington, KY, USA
Lives and works in New York, NY
allisonjanaehamilton.com

Loie Hollowell
b.1983, Woodland, CA, USA
Lives and works in New York, NY
loiehollowell.com

Kahlil Robert Irving
b.1992, San Diego, CA, USA
Lives and works in St. Louis, MO
kahlilirving.com

Clinton King
b.1976, Coshocton, OH, USA
Lives and works in Brooklyn, NY
clintonkingart.com

Chris Martin
b.1954, Washington, DC, USA
Lives and works in Brooklyn, NY
davidkordanskygallery.com/artist/
chris-martin

Tony Matelli
b.1971, Chicago, IL, USA
Lives and works in New York, NY
tonymatelli.com

Tomokazu Matsuyama
b.1976, Takayama, Gifu, Japan
Lives and works in New York, NY
matzu.net

Geoff McFetridge
b.1971, Calgary, Alberta, Canada
Lives and works in Los Angeles, CA
championdontstop.com

Maysha Mohamedi
b.1980, Los Angeles, CA, USA
Lives and works in Los Angeles, CA
parraschheijnen.com/artists/
maysha-mohamedi

Liz Nielsen
b.1975, Ashland, WI, USA
Lives and works in New York, NY
liznielsen.com

Helen O'Leary
b.1961, County Wexford, Ireland
Lives and works in Jersey City, NJ, and
Leitrim, Ireland
helenoleary.com

Carl Ostendarp
b.1961, Amherst, MA, USA
Lives and works in Ithaca, NY
elizabethdee.com/artists/carl-ostendarp

Hilary Pecis
b.1979, Fullerton, CA, USA
Lives and works in Los Angeles, CA
hilarypecis.com

Erin M. Riley
b.1985, Cape Cod, MA, USA
Lives and works in Brooklyn, NY
erinmriley.com

Devan Shimoyama
b.1989, Philadelphia, PA, USA
Lives and works in Pittsburgh, PA
devanshimoyamastudio.com

James Siena
b.1957, Oceanside, CA, USA
Lives and works in New York, NY
xippas.com/?page_id=6995

Cauleen Smith
b.1967, Riverside, CA, USA
Lives and works in Los Angeles, CA
cauleensmith.com

Salman Toor
b.1983, Lahore, Pakistan
Lives and works in New York, NY
salmantoor.com

Robin F. Williams
b.1984, Columbus, OH, USA
Lives and works in Brooklyn, NY
robinfwilliams.com

Brian Alfred (b.1974 in Pittsburgh, PA) received his BFA in 1997 from Pennsylvania State University and his MFA in 1999 from Yale University and attended the Skowhegan School of Painting and Sculpture in 1999. He has exhibited internationally, and his work can be found in many permanent collections, including the Solomon R. Guggenheim Museum in New York and the National Gallery of Victoria, Australia. He is represented by Miles McEnery Gallery and Maho Kubota Gallery. The Sound & Vision podcast was launched in 2016, since when over 300 episodes have aired. Alfred lives and works in Brooklyn, New York.

Hrishikesh Hirway (b.1979 in Peabody, MA) is a musician and podcast creator. He's the host, creator and producer of Song Exploder, an award-winning podcast and Netflix original television series, in which musicians break down the creative process behind their songs. He has released four albums under the moniker The One AM Radio, produced and hosted multiple award-winning podcasts, and has written and recorded original scores for movies and television. Hirway lives and works in Los Angeles, California.

Image Credits

p. 4
Courtesy of the artist
p. 12
Courtesy of the artist. Photo: Timothy Doyon
p. 16
Courtesy of the artist. Photo: Joshua White
p. 17
Courtesy of the artist. Photo: Tom Powell
pp. 25, 28
Courtesy of the artist
pp. 32, 37
Courtesy of the artist
pp. 41, 44, 45, 48
© Gregory Crewdson. Courtesy of Gagosian
pp. 53, 56
Courtesy of the artist
pp. 66, 67, 70–71, 73
Courtesy of the artist and Miles McEnery
Gallery, New York, NY
pp. 77, 80–81
Courtesy of the artist and Shulamit Nazarian,
Los Angeles
pp. 85, 88
Artwork © Louis Fratino. Courtesy of Sikkema
Jenkins & Co., New York
pp. 93, 96
Courtesy of the artist
p. 101
© Karel Funk. Courtesy of 303 Gallery,
New York. Photo: Julien Gremaud
p. 104
© Karel Funk. Courtesy of 303 Gallery,
New York. Photo: John Berens
pp. 113, 116, 120–121
Courtesy of the artist and Kasmin Gallery.
Photos: Diego Flores
p. 126
© Allison Janae Hamilton. Courtesy of the artist
and Marianne Boesky Gallery, New York and
Aspen. Photo: Peter Kaiser
p. 130
© Allison Janae Hamilton. Courtesy of the
artist and Marianne Boesky Gallery, New York
and Aspen.
p. 136
Courtesy of Pace Gallery. Photo: Rich Lee.
p. 137
Courtesy of Pace Gallery. Photo: Damian
Griffiths
pp. 143, 146–147
Courtesy of the artist. Photos: Dusty Kessler
pp. 151, 154
Courtesy of the artist
p. 160
Courtesy of David Kordansky Gallery,
Los Angeles, CA. Photo: Fredrik Nilsen Studio

p. 163
Courtesy of David Kordansky Gallery, Los Angeles.
Photography: Johansen Krause
p. 166
Courtesy of David Kordansky Gallery, Los Angeles.
Photo: Jeff McLane
p. 169
Courtesy of David Kordansky Gallery, Los Angeles.
Photo: Matt Grubb
pp. 178, 183
Courtesy of the artist
pp. 187, 188–189
Courtesy of the artist
pp. 194, 199
Courtesy of the artist
pp. 202, 206, 207, 210
Courtesy of the artist
pp. 220, 225
Courtesy of the artist
p. 229
Courtesy of the artist. Photo: Paul Takeuchi
pp. 232–233
Courtesy of the artist. Photo: Simon Mills
p. 237
Courtesy of the artist. Photo: Eva O'Leary
p. 238
Courtesy of the artist. Photo: Paul Takeuchi
pp. 243, 246
Courtesy of the artist
pp. 251, 254
Courtesy of the artist
p. 261, 263
Courtesy of P·P·O·W Gallery and the artist
p. 271
Courtesy of the artist
p. 274
Courtesy of the artist. Photo: Tom Little
p. 278, 280, 281, 284
Courtesy of the artist
pp. 293, 296
Courtesy of the artist and Corbett vs. Dempsey,
Chicago
pp. 301, 304, 306, 309
© Salman Toor. Courtesy of the artist and
Luhring Augustine, New York. Photos: Farzad Owran
pp. 315, 317, 320, 323
Courtesy of Robin F. Williams and P·P·O·W, New York

Acknowledgments

First, I would like to thank all the artists and musicians who took part in the Sound & Vision podcast to share their time and stories with me.

Many thanks to my support system in the world of art: Miles McEnery and all those at his gallery, who are like a family to me; Maho Kubota for her enduring support of my work in Tokyo; and Hélène de Franchis at Studio La Città in Verona.

I'd like to thank Atelier Éditions, and especially Pascale Georgiev, for supporting this project.

Many thanks to my colleagues at the Penn State University School of Visual Arts, and Dean Carpenter and all those in the College of Arts and Architecture. The continued support of the university has made many of my shows and projects more significant—and better realized—than they would have been otherwise.

On a personal note, I would like to thank the friends who have lent an ear and words of support over the years: Matt Phillips, Guy Yanai, Mimi Jung, Jason Irwin and Pam Serranzana, Betsy Campbell, Jeff and Eunice Groner, Glenna and Manny Dilone, Scott Zimmerman, Selin and Burak Emre, Michael Lovett, Emily Burns for designing the podcast logo and promo images, Mark Hansen for the gear and friendship, Shawn and Yoshimi Seymour, Dung Ngo, Eric Mast, Brijean Murphy, and David Ahuja.

Most of all I'd like to thank my family: my brother Darrin for advice and support, and the same from my mother, Sandy. I'd also like to thank the Kusadas, Reiko and Take, and especially my wife, Yoshika, and our son, Naoki. Without them, this would not have been possible.

This book is dedicated to the memories of two people I lost who were dear to my heart: my best friend, the amazingly talented painter Steven Walls, my sounding board and closest confidant in art and music;

and my father, Darrell Alfred, who instilled in me a curiosity that will never leave, and which directly resulted in me wanting to know people and their stories. I hope these conversations carry their voices too.

Brian Alfred

Based on the Sound & Vision podcast by Brian Alfred
soundandvisionpodcast.com

This project was made possible in part by a Faculty Research Grant
from the Penn State College of Arts and Architecture

Editorial director: Pascale Georgiev
Editor: Ananda Pellerin
Managing editor: Lucy Kingett
Contributing editor: Pac Pobric
Contributing writers: Allyssia Alleyne, Laura Allsop,
Oscar Holland, Helen Jennings, and Angel Lambo
Editorial assistant: Josephine Minhinnett
Proofreader: Helius
Design director: Capucine Labarthe
Design: Audrey Solomon

The publisher and editors would like to thank
Matt Schust and Penn State University for
their contribution to the project.

Published by
Atelier Éditions
Los Angeles, USA
www.atelier-editions.com

Distributed by
ARTBOOK | D.A.P.
75 Broad Street, suite 630
New York, New York 10004
artbook.com

First Edition of 3,000
Printed in Belgium on 100% ecological paper
from sustainable forests
ISBN 978 173362 209 7